Tony Renzoni has written a very thoughtful and well-researched tribute to the artists of Connecticut, and we are proud to have Gene included among them.

—Lynne Pitney, *wife of Gene Pitney*

• • •

An informative and entertaining musical journey through Connecticut's place in rock and roll history, including the beautiful doo-wop song "In the Still of the Night" by the Five Satins, the Playmates' novelty car tune "Beep Beep" and the creative cover of "Ding Dong! The Witch Is Dead" by the Fifth Estate. Tony Renzoni also highlights several established artists who achieved latter-day success after relocating to the state, including Meat Loaf with his number one comeback hit "I'd Do Anything for Love (But I Won't Do That)."

—Warren Kurtz, *contributing editor,* Goldmine, *the music collector's magazine*

• • •

Our Alice Cooper band recorded the Billion Dollars Babies *album in a mansion in Greenwich. Over the years, there have been many great musicians from Connecticut, and the local scene is rich with good music. Tony Renzoni's book captures all of that and more. Sit back and enjoy the ride.*

—Dennis Dunaway, *hall of famer and co-founder of the Alice Cooper band.*

• • •

Rock 'n' Roll music fans from coast to coast will connect to events in this book. Strongly recommended!

—Judith Fisher Freed, *estate of Alan Freed*

CONNECTICUT ROCK 'N' ROLL

A HISTORY

Rock On!!
Tony Renzoni

TONY RENZONI

FOREWORD BY KEN EVANS

Published by The History Press
Charleston, SC
www.historypress.net

Copyright © 2017 by Tony Renzoni
All rights reserved

Front cover, clockwise from bottom left: Jimi Hendrix's memorable performance at Yale's Woolsey Hall in New Haven, Connecticut; the Fifth Estate band standing in front of Alan Freed's mansion in Stamford, Connecticut; Rivers Cuomo (of Weezer); a teenage Bob Dylan performing outside the Montowese House as part of the Indian Neck Folk Festival in Branford, Connecticut; Dennis Dunaway (co-founder of the Alice Cooper band and member of the Rock 'n' Roll Hall of Fame); Christine Ohlman (lead singer of the Saturday Night Live band and the Rebel Montez band).
Back cover, bottom: The Highwaymen performing at a sold-out concert in the Montowese House as part of the Indian Neck Folk Festival in Branford, Connecticut;
Rockville's legendary Gene Pitney (member of the Rock 'n' Roll Hall of Fame); *inset*: Tina Weymouth (of Talking Heads).

First published 2017

Manufactured in the United States

ISBN 9781625858801

Library of Congress Control Number: 2017938333

Notice: The information in this book is true and complete to the best of our knowledge. It is offered without guarantee on the part of the author or The History Press. The author and The History Press disclaim all liability in connection with the use of this book.

All rights reserved. No part of this book may be reproduced or transmitted in any form whatsoever without prior written permission from the publisher except in the case of brief quotations embodied in critical articles and reviews.

This book is dedicated to the two loves of my life: my wife, Colleen, and my daughter, Kerry. I am so blessed to have them in my life.

CONTENTS

Acknowledgements	9
Foreword, by Ken Evans	11
Introduction	17
1. The Rock 'n' Roll Music Scene in Connecticut	19
2. Rock 'n' Roll Is Certainly Here to Stay: 1950–1959	49
3. From Classic Pop to Mop Tops to Classic Rock: 1960–1969	65
4. It's Still Rock 'n' Roll to Us: 1970–1979	110
5. Keep on Rockin' in the USA: 1980s to Present	117
Appendix A. A Tribute to Joe Sia, World-Renowned Rock Photographer (1945-2003)	147
Appendix B. Interviews with Connecticut Music Artists	151
Appendix C. Notable Connecticut Music Venues, Concerts and Rare Behind-the-Scenes Photos	195
Bibliography	215
Index	219
About the Author	223

ACKNOWLEDGEMENTS

This book has been a labor of love. Many friends and acquaintances have made this dream a reality. They have graciously shared their knowledge, provided valuable insight and, above all, have been greatly supportive to me and this endeavor. This book is infinitely better as a result of these wonderful people.

Grateful acknowledgements to Ken Evans, Christine Ohlman, Dennis Dunaway, Fred and Emma Parris, Ray Lamitola, Ryan Zipp, Kathy Kessler, Dick Robinson, Judith Fisher Freed, Franz Douskey, Emily Santanella, Paul Rosano, Ellen Sandhaus, Dick Sandhaus, Joe Sia, Dorothy Yutenkas, Melissa Mathers, Len Delessio, Jim Bozzi, Jane Bouley, Irene Liebler, Sandy Connolly, Gary DeCarlo, Randy L. Schmidt, Al Warren, Mike Dugo, Jean Luddy and Ray Zeiner.

Also, many thanks to Mary Ellen Blacker, Mike Lamitola, Dr. Kerry Renzoni, Colleen Renzoni, Ned Burt, Dan Mancinone, Doug Poskus, John Mathers, Nick Fradiani, the Reducers, Charles Amann, Walter and Ginny Quadrato, "Cousin" Tony, Marie Plunkett, Vince Renzoni, Meaghan McKeon, Stan Nimoroski, Rhoda Winik, Tim McHugh, Richard Brukner, Kevin Casini and Mary Stone.

A special thank-you to my book publisher, The History Press and, of course, editors Artie Crisp, Ed Mack and Abigail Fleming.

I am blessed to have so many friends, relatives and schoolmates who, over the years, have stood by me during this wonderful musical journey.

FOREWORD

In 1967, I had the good fortune of touring with the great Gene Pitney as a member of the band the Fifth Estate. The tour was called the Gene Pitney Show. On the same bill as Gene were the Fifth Estate, the Music Explosion, the Happenings, the Buckinghams and the EasyBeats. At the time, all the bands mentioned were at the top of their games. The tour took us to many venues throughout the United States. We kicked off the tour in August 1967 at the Bushnell Memorial in Hartford, Connecticut.

I have fond memories of Gene and all the other guys we performed with. Gene had that incredible voice and was famous for delivering those dramatic, piercing climactic endings to his songs. By the time Gene took the stage, all the other performers would be backstage. So during each performance, some of us would engage in a bet on whether or not Gene would hit the incredible high note on his hit song "I'm Gonna Be Strong." Betting against Gene would almost certainly mean losing money. Another somewhat insignificant but fond and funny memory for us is recalling how Gene would always play cards on the bus in his red polka-dot underwear. Gene was an extremely talented man yet a fun, down-to-earth guy.

Tony Renzoni, the author of this book, asked if I would write a foreword for his book. He asked if I would share my experiences with bands that I have been associated with and talk a bit about the music scene in Connecticut and elsewhere, especially during the '50s and '60s. And Connecticut was always our home base during our recording and performing career. Tony is aware of the fact that I, along with all the

Foreword

other members of the Fifth Estate, were born and raised in Stamford, Connecticut. And yes, he attended our concert that day in August 1967 at the Bushnell. Tony's interest in doing a book was intense and infectious from a fan standpoint and from a collectors' perspective.

Connecticut's contribution to the music scene has been significant and multifaceted, with many twists and turns along the way. To illustrate, I would first like to note a family connection to the popular music scene of Connecticut dating back to the '20s, '30s and '40s and to link it somewhat with the present day. But "What is the use of a book without pictures?" as Alice would say. So here is an old postcard image of the Rialto Theater in South Norwalk, Connecticut. This venue is where my great cousin Dwight Latham and his band the Jesters started out and would become nationally famous. A fun music scene for sure. The group performed many times in this theater as well as other venues in Connecticut.

Dwight and the Jesters became famous writing hit songs for a number of recording artists over the years. Bing Crosby liked recording with the Jesters, especially tunes such as "McNamara's Band" (written by Dwight). None other than Willie Nelson recorded one of Dwight's tunes on a recent album. So Connecticut's contribution to popular music goes back a very long way and still lives on. Going back to the photo, I would like to relate the music scene that took place long ago in the area of the Rialto with an event that happened recently. If you look a few storefronts down to the right of the theater, there is a popular music bar/restaurant where none other than Keith Richards in an unannounced appearance recently thrilled the audience when he jammed with one of the local bands. Richards is a longtime resident of Weston, Connecticut, and recently performed with his band the Rolling Stones in a 2016 concert in Cuba. Connecticut still rocks for sure! Always has as far as I am concerned.

Another connection with Keith Richards dates back to 1964. Prior to the Fifth Estate, our band was known as the D-Men. In 1964, the D-Men taped a performance on the popular Clay Cole TV show that also included a performance by Keith Richards and the Rolling Stones. It was our first TV appearance out of many. And it was the Stones' first East Coast TV appearance at the very beginning of an incredible career. But we're both still alive and playing—so that's cool—but probably just an accident in Keith's case, say many.

My music background and band experiences growing up are not unlike thousands of others who have picked up a guitar or a set of drumsticks. When I was nine or ten years old I had my first exposure to the world of rock-and-

Foreword

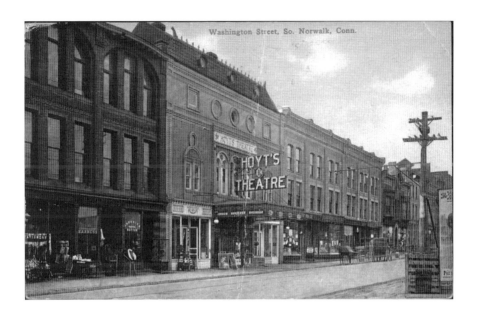

roll. I remember visiting my two older cousins who were both not old enough to drive a car but they did ride their motorcycles around in the backyard. Their hair and clothes were something foreign to me—blue jeans and hair slicked back. Fairly tough looking I thought for Fairfield, Connecticut. Then we went into a darkened room that evening and listened to an hour-long radio show of music that had not even been named rock-and-roll yet. I heard the music of Eddie Cochran, Bo Diddley and many other rockers of that era. Completely *new* and *different* from anything else we had ever heard. It was exciting! We bounced all over the place to the beat of those rocking sounds we heard that day. I still feel the same when I hear this music today. In fact, a great deal of my drumming over the years was influenced by Bo's drummer, Clifton James. And so, early on, this music was having an enormous effect on me and a very large cultural effect on the music scene in Connecticut and throughout the United States. So much so that it encouraged me to become a musician at age fourteen. It was then that I began my music career in earnest as a member of a rock group called the Coachmen. In 1963, I joined the D-Men, which was a very innovative rock band. Like so many local bands at the time, we had a very loyal following. In our case, we were popular throughout the East Coast. And like so many other local bands, we struggled, worked hard and performed wherever we could get a gig. Connecticut was embracing rock-and-roll, and many bands like ours began springing up. Record hops, high school dances, local concerts, you name it,

Foreword

Ken "Furvus" Evans backstage. *Courtesy of Ken Evans of the Fifth Estate.*

we were there. And I can't say enough about our local fans; they were intense and incredible. We changed the name of our band in 1966, and soon after, we achieved national and international fame with a major hit song that we recorded on a dare.

In 1967, music was evolving and so was our band. Take for example our hit song "Ding Dong! The Witch Is Dead." The song became a no. 11 national hit on the Billboard Charts and was a no. 1 song in Connecticut and in other parts of the United States, and even in parts of Canada.

While some music critics labeled the tune as a novelty hit, the song was actually so much more. Much to the credit of the Fifth Estate's founding member, Wayne Wadhams, many knowledgeable music critics have praised the song for its mix of pop, rock and classical baroque music genres. We incorporated all types and periods of music into our recordings and performances, even music from the Renaissance period hundreds of years ago. We didn't care. And we did it our way, which was important to us. Our innovative style caught the attention of Brian Epstein and George Martin. Epstein actually knew us before we were the Fifth Estate. He was the co-host when we appeared on the popular *Hullabaloo* TV show as the D-Men. Epstein was serious about signing us, but unfortunately, this was ended by Brian's untimely death.

Our band is just one of many groups from Connecticut who have "hit it big" on the national scale. And a good number of Connecticut solo artists have hit the big time as well.

But, in all honesty, I have known many other artists from Connecticut who certainly have the talent but, for whatever reason, were never able to achieve the fame they sought.

That's the beauty of this book. The author has gone out of his way to acknowledge the achievements of not only the "famous" artists but also the ones who worked very hard but never quite made it to "the big show."

This book is intended to be read not only by current or former musicians

Foreword

but, just as importantly, by the many fans of music not only here in Connecticut but everywhere. For all of us who have a love of music, a feeling for music or some relation to it, this is a book we can identify with.

Not only does this book bring a bit of a historical connection to the state's music scenes, with a nod to many of its artists, but also it goes deeper and reaches all of us because music has been such an integral part of our daily lives. This is *our* music! For those of you who have loved the music coming out of our state, who recall hearing songs on local radio stations by these great Connecticut artists or who have attended local concerts in this state, this book is a must read!

—KEN EVANS

INTRODUCTION

Rock 'n' roll is a river of music that has absorbed many streams:
rhythm and blues, jazz, rag time, cowboy songs, country songs, folk songs.
All have contributed to the big beat.
—Alan Freed, "Mr. Rock 'n' Roll"

Connecticut is a place I have called home for many years. The music that has emerged from this state has become, as the great disc jockey Cousin Brucie would say, the soundtrack to my life. Whether it was a school dance, a social gathering or a concert, music by Connecticut artists has become part of my and many other residents' collective music psyche. Whether or not the songs or artists were ever known outside Connecticut is not, in the long run, of major significance. What is important is the fond memories that will last a lifetime. Maybe it was such notable memories of a first date, a school crush, a high school breakup, a local concert or just background music when friends get together.

The purpose of this book is to give readers insight into the music scene in Connecticut throughout the years. The book also pays tribute to many of the rock 'n' roll and pop performers who have influenced the daily lives of Connecticut residents. The performers mentioned in this book run the gamut from the very famous to those in relative obscurity. All of these musicians' accomplishments, both great and small, have shaped Connecticut's music culture.

Connecticut has provided its share of music notables. Arguably, the most famous and most popular doo-wop song ever made was recorded in the

Introduction

basement of St. Bernadette Church in New Haven, Connecticut. The group is called the Five Satins, and the song was titled "In the Still of the Night." The great Gene Pitney, "The Rockville Rocket," hailed from Connecticut. Karen and Richard Carpenter were born and raised in Connecticut. Fast-forward to today, and Connecticut continues to play a significant role in the music scene, with great artists such as the legendary rocker Christine Ohlman and hall-of-famer Dennis Dunaway, of Alice Cooper fame. In the pop music field, Guilford's Nick Fradiani was the 2015 winner of the popular and influential TV show *American Idol*.

Most states have their own gems that were extremely popular within their individual state but, for whatever reason, never made it big on the national level. In Connecticut, one of those gems would have to be a group called the Wildweeds. The mere mention of this group to many Connecticut natives invokes many memories of school dances, proms and other special events during the formative years. How this group never hit it really big on a national level is still a mystery for many of us who grew up in this state. One of the possible contributing factors to groups such as this is the miscalculation on the part of the band's management and/or record label companies. It should be noted that the Wildweeds were very successful on a regional basis, such as the Northeast and the South. Groups such as the Wildweeds and other local gems continue to have a very loyal fan base, despite the fact they stopped recording and disbanded years ago. It could be argued that artists such as these were so popular that they are remembered by many more fondly than even major artists who have passed through Connecticut as part of a national tour. Therefore, local groups like these certainly deserve recognition in this book.

This book is not meant to be an all-inclusive list of Connecticut music performers, since there have been many thousands of bands and solo artists that have emerged in this state throughout the years. However, this book does provide a glimpse into the great talent that once existed and still continues to exist in Connecticut.

The back cover call out, "Rock"ville USA, has a dual meaning. Rockville, Connecticut, was the hometown of Gene Pitney. Moreover, it also pays homage to the many rock and pop performers who have called Connecticut their home and to the vibrant music scene over the years.

My goal and hope is to encourage all of you to think of Connecticut as a significant contributor to the history of rock 'n' roll music in the United States. And just maybe, as a tribute to the great Gene Pitney, we can think of Connecticut as "Rock"ville USA.

1
THE ROCK 'N' ROLL MUSIC SCENE IN CONNECTICUT

THE EFFECT OF ROCK 'N' ROLL ON SOCIETY

The effect of rock 'n' roll on our society cannot be overstated. All across the country, rock music has had a profound and distinct influence on our daily lives. Popular culture was forever changed. Nowhere was this more evident than in teenage culture—where everything from hairstyles to fashion, record buying, dance, television, movies and even everyday language was profoundly changed. The rock music scene became a national phenomenon, taking place in every state across the country. And Connecticut was no exception. Indeed, the music scene in Connecticut was a microcosm of what was happening throughout the United States.

FROM SOCK HOPS TO RECORD HOPS

In the mid-1940s, sock hops began emerging throughout the United States. Teenagers would congregate in local gymnasiums and dance halls to listen and dance to the music of popular recording artists of that era, such as Frank Sinatra. For the most part, the music that the teenagers would dance to was played on vinyl records, sometimes by local radio station disc jockeys. In an effort to protect the varnished floor of the gymnasium,

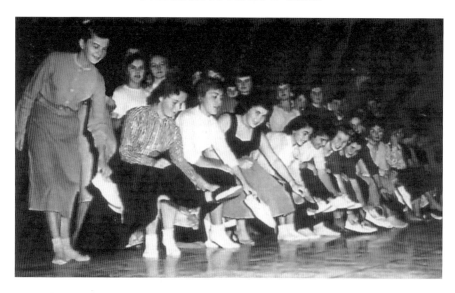

Above: Prior to dancing on hardwood floors at 1950s sock hops, teenagers were required to remove their shoes. *Unknown source.*

Below: A 1950s record hop. *Author's collection.*

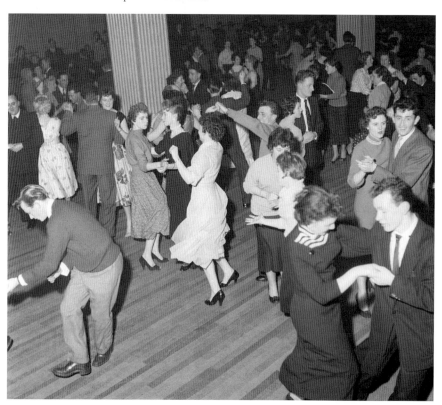

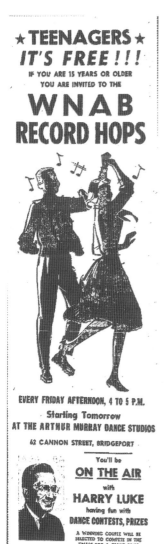

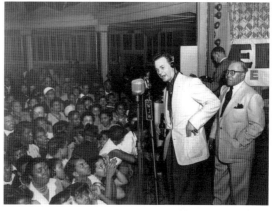

Left: A record hop sponsored by Bridgeport's WNAB as shown in the *Bridgeport Post* on October 1, 1959. *Courtesy of the* Connecticut Post.

Top: A 1957 record hop contest on Alan Freed's *Big Beat* TV show. *Courtesy of Judith Fisher Freed (estate of Alan Freed).*

Bottom: A 1951 record hop. Alan Freed broke down racial barriers with his record hops and concerts. *Courtesy of Judith Fisher Freed (estate of Alan Freed).*

teenagers were required to remove their shoes and dance in their socks, thus *sock hop*. The term "bobby soxer" grew out of the popularity of these sock hops, referring to teenage girls who would dance in their bobby socks because of the no-shoes requirement when dancing in gymnasiums. The bobby soxer was celebrated in hit songs such as Chuck Berry's "Go, Bobby

Soxer" and Frankie Avalon's "Bobby Sox to Stockings." The term was also popularized in movies like *The Bachelor and the Bobby-Soxer*, starring Cary Grant and Shirley Temple.

As music venues expanded to outdoor events and local clubs, the sock hop was replaced by the record hop. Local radio station and TV disc jockeys began hosting record hops and introduced local bands and solo recording artists who performed live at these events. Jim Gallant and other hosts of the popular *Connecticut Bandstand* TV dance show played host to many record hops throughout Connecticut.

Whether they were called sock hops or record hops, these events served as a way for teenagers to gather in one place and just have a fun experience.

STOP, LOOK, LISTEN AND BUY

THE EMERGENCE OF RECORD STORES

With the creation of the vinyl record, record stores began to emerge as a place to purchase popular songs that people would hear on their local radio stations or at local music venues. Some record shops provided listening booths for their customers to play vinyl records so they could decide whether or not to buy the records. There were even record stores that provided recording booths in which customers were able to record their very own records on vinyl. Eventually, record stores hosted local bands to play live for their fans, usually after business hours. And of course, record stores began selling music in formats other than vinyl (e.g., compact discs).

Every town and city in the United States had popular local record shops that were customer favorites. Record stores were an integral part of the fabric of the music scene in these towns and cities. They served as a place where

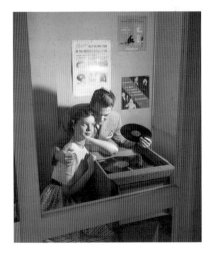

Record listening booths in music stores were very popular in the '40s, '50s and '60s. Customers were allowed to listen to 45rpm and 78rpm records before purchasing. *Author's collection.*

people, especially teenagers, would gather to casually browse through the store collection, compare notes on their favorite records and eventually buy a record or two. For record collectors such as myself, it was not uncommon to spend hours upon hours searching for those much sought-after rare 45s.

There were many popular record stores throughout Connecticut, especially in the '50s and '60s, including Mattatuck Music Record Store, the Music Box and Brass City Records.

MATTATUCK MUSIC RECORD STORE

One of my fondest memories growing up in Waterbury, Connecticut, was walking by the Mattatuck Music Record Store on East Main Street and seeing, for the first time, the iconic *Meet the Beatles* album cover in the store window. There had been so much anticipation swirling around the United States about this great group called the Beatles. We had never seen anything like them. We had never heard anything like them. The *Meet the Beatles* album in conjunction with the Beatles' appearance on *The Ed Sullivan Show* was, indeed, an earth-shattering experience. They far exceeded all the hype. Simply put, the Beatles would forever change the course of music. For me, it all began when I saw that album for the first time in the Mattatuck Music record store, walking into the shop, discussing this new phenomenon with my friends, buying the record and playing it over and over again on my record player at home. The Mattatuck Music store even had a listening booth at one time.

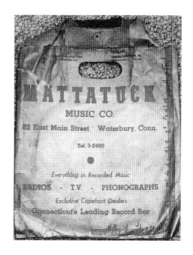

Vinyl records purchased at Waterbury's Mattatuck Music Record Store were placed in these record bags, which also served as advertising for the store. *Author's collection.*

BRASS CITY RECORDS

The Brass City Records store was located on Meadow Street in Waterbury, Connecticut. Brass City Records was an extremely popular store in Connecticut, boasting a fantastic assortment of rare and popular LP albums and 45rpm records. The owner of the store, Walter Quadrato, was very knowledgeable about the music scene in Connecticut. Brass City Records also played host to many live concerts by local bands.

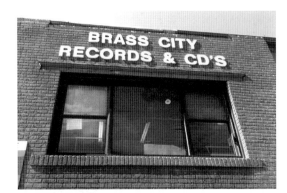

Left: Brass City Records on Meadow Street, Waterbury, Connecticut. *Courtesy of Ginny Quadrato.*

Below: Alan Freed was urged by a record store owner, Leo Mintz, to host his own radio program at Cleveland's WJW radio station. It was there that Freed coined the phrase "rock 'n' roll." *Courtesy of Judith Fisher Freed (estate of Alan Freed).*

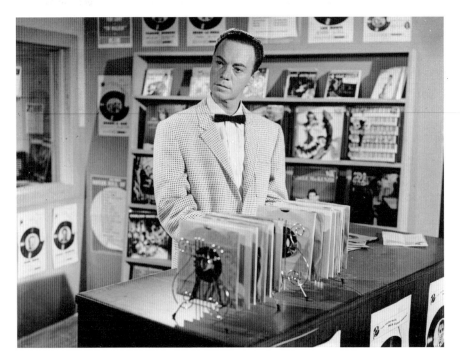

A History

TOP 40 COUNTDOWN: WHO'S NUMBER ONE?

RADIO STATIONS AND MUSIC SURVEYS

Popular *Nationwide* AM Radio Stations (1960s): **WABC, KHJ, WINS, WJW, WLS and WKBW**

Popular *Connecticut* AM Radio Stations (1960s): **WPOP, WDRC, WWCO and WAVZ**

In the 1960s, most radio music stations used a Top 40 format, listing the forty highest-ranking songs on the station's music chart. The term "Top 40" was developed, allegedly, when a radio pioneer observed that restaurant customers tended to play the same songs over and over on local jukeboxes—at the time many jukeboxes held forty singles.

Radio station music surveys were an important component in Top 40 music history. The one-page chart listings ranked the most popular songs based on a survey of local retail sales and listener requests. The surveys showed the current ranked position of the songs along with their previous

WDEE PACESETTER SURVEY		WEEK ENDING SEPTEMBER 3	
1. EVE OF DESTRUCTION	*BARRY MC GUIRE	36. Catch Us If You Can	Dave Clark Five
2. Like A Rolling Stone	+Bob Dylan	37. Take Me Back	*Little Anthony
3. Help	Beatles	38. You Better Come Home	*Petula Clark
4. Papa's Got A Brand New Bag	James Brown	39. A Little You	*+Freddie/Dreamers
5. It's The Same Old Song	*+Four Tops	40. Give All Your Love To Me	*+Gerry/Pacemakers
6. Nothing But Heartaches	Supremes	41. Close Your Eyes	*+The 3 Degrees
7. California Girls	*Beach Boys	42. Where The Music's Playing	+Drifters
8. You Were On My Mind	*We Five	43. Since I Lost My Baby	Temptations
9. I Got You Babe	*+Sonny & Cher	44. I'm A Happy Man	Jive Five
10. Unchained Melody	Righteous Bros.	45. I Don't Want To Lose You	Chad & Jeremy
11. It Ain't Me Babe	Turtles	46. I'll Make All Your Dreams	+Ronnie Dove
12. In The Eyes Of Love	+Gene Pitney	47. Roundabout	Connie Francis
13. Heart Full Of Soul	*+Yardbirds	48. Ride Away	Roy Orbison
14. Sad Sad Girl	*+Barbara Mason	49. Ju Ju Hand	*+Sam The Sham
15. Danger Heartbreak Ahead	Marvelettes	50. Heartaches By The Number	+Johnny Tillotson
16. Laugh At Me	*+Sonny	51. Me Without You	Mary Wells
17. Houston	Dean Martin	52. Seven Million People	George McCannon III
18. You've Got Your Troubles	Fortunes	53. Nervous	*Ian Whitcomb
19. Let Them Talk	Pearlean Gray	54. Baby Don't Go	+Sonny & Cher
20. I Want Candy	*Strangeloves	55. Soul Heaven	+Dixie Drifter
21. In The Midnight Hour	+Wilson Pickett	✓ 56. By My Side	The Shags ✓
22. Down In The Boondocks	+Billy Joe Royal	57. Keep On Dancing	*+The Gentrys
23. Save Your Heart For Me	*+G. Lewis/Playboys	58. Whenever You're Ready	+Zombies
24. Can't Let You Out Of My Sight	+Brown/Jackson	59. I'm Yours	+Elvis Presley
25. Got To Get Out	Animals	60. Sun Ain't Gonna Shine	Frankie Valli
26. Hang On Sloopy	McCoys	61. Respect	+Otis Redding
27. For Your Love	*Sam And Bill	62. An Angel Cried	*Castells
28. You've Been In Love	*Martha/Vandellas	63. Let's Move and Groove	*+Johnny Nash
29. You Better Go	+Derek Martin	64. I'm Still Loving You	+David & Coliath
30. All I Really Want To Do	Cher	65. Let The House Rock On	+Dr. Feelgood
31. I Need You	+Impressions	-PACESETTER PICKS-	
32. Don't Just Stand There	+Patty Duke	JOE D. DAY KANSAS CITY STAR	ROGER MILLER
33. We're Doing Fine	+Dee Dee Warwick	MIKE MY TOWN, MY GUY & ME	LESLIE GORE
34. Who'll Be Next In Line	*Kinks	TRACY RUN LIKE THE DEVIL	BOBBY VEE
35. High Heel Sneakers	Stevie Wonder	GRISELDA WHAT COLOR	BOBBY VINTON
* FORMER CHAMP RECORD	+ HEARD FIRST ON WDEE	-PACESETTER L.P. PICK- YES I'M HEADY	BARBARA MASON
WDEE 1220	**WDEE 1220**	**WDEE 1220**	**WDEE 1220**

An example of a *simple* music chart survey. This survey merely shows the song's current ranking, the date of the survey and the call letters of the radio station. *Author's collection.*

CONNECTICUT ROCK 'N' ROLL

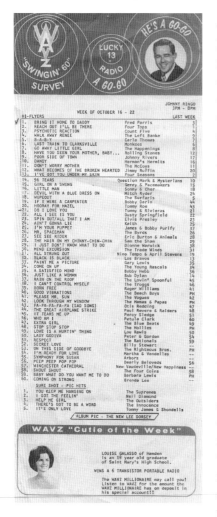

A more detailed and more colorful survey showing current song ranking, song ranking for the previous week, station's call letters, station's logo, disc jockey photo, a weekly contest and a WAVZ Millionaire contest. Hamden's Louise Galasso was the lucky winner of a transistor radio. *Author's collection.*

week's chart position. Each individual local radio station would have its own music survey. Thus the chart position of songs could vary somewhat from one radio station to another. For example, the ranking of songs on radio station WPOP in Hartford could differ a bit from radio station WWCO in Waterbury. The surveys were published weekly and designed to be distributed by local record stores to customers buying the latest 45rpm records. The radio chart listings were issued from the late 1950s to the early 1980s. The peak period of music surveys was the late 1960s. *Billboard* magazine used radio station music surveys as one of the ways to compile its Top 100 singles charts. *Billboard* eventually began using a computerized method to determine its Hot 100 charts. Some surveys were simple in format and color, simply ranking the radio station's forty (or more) most popular songs for the current week. Other surveys were more detailed and a bit more colorful, showing the current ranking, the previous week's chart position, a photo of one of the radio station disc jockeys and radio station contests. The radio stations were able to advertise on the survey form. Local disc jockeys would inform and entertain listeners using the music surveys to count down the most popular songs in the listening area. The record stores used the surveys, in part, to entice customers to purchase more records than they initially had in mind. The customers liked the surveys because they were able to track their favorite songs and had a keen interest in finding out the no. 1 song on the chart listing.

A History

The surveys pictured on the previous two pages are examples of simple charts and more detailed surveys. Other radio station music surveys are displayed throughout this book.

THE KINGS OF THE AIRWAVES

RADIO STATION DISC JOCKEYS

Popular *Nationwide* AM radio disc jockeys: "Cousin" Brucie (Morrow), Alan Freed, Murray the K (Kaufman), Wolfman Jack, Dick Biondi and Robert W. Morgan.

Popular *Connecticut* AM radio disc jockeys: Dick Robinson (WDRC), Joey Reynolds (WPOP), Ken Jordan (WAVZ, WELI), Ken Griffen, Lee "Baby" Simms, Dan Ingram, Bob Ruge and Al Warren and Joe Cipriano (aka "Tom Collins" and "Dave Donovan" at WWCO and WDRC)

The introduction of the pocket-size transistor radio in 1954 brought about a major change in popular music listening, allowing people to listen to their favorite radio station and disc jockcy whenever and wherever they went. Using earplugs, teenagers could secretly tune out their parents and (dare I say it) their classroom teachers. The transistor radio was immortalized in such songs as "Transistor Sister" by Freddy Cannon and Van Morrison's "Brown Eyed Girl."

Many disc jockeys in the '50s and '60s had a great deal of influence with their listeners. They were kings of the airwaves. Their ability to decide which records to play (or not play) had a direct effect on record sales for bands. Ken Evans (of the Fifth Estate) recalls an incident that illustrates this point:

> *At the time that our band was known as the D-Men, Murray the K* [WINS DJ] *had this weekly call in contest called "The Swingin' Soiree." The fans were to call in and vote for their favorite bands. One week the choice for best record was between the Animals, the Dave Clark 5 and the D-Men. Because we had such a large following in NYC and Connecticut, all our fans called in and flooded the lines. So we won the contest. However, Murray the K felt that we had somehow rigged the contest (which we didn't) and stopped playing our songs. This had a detrimental impact on our record sales in NYC. The*

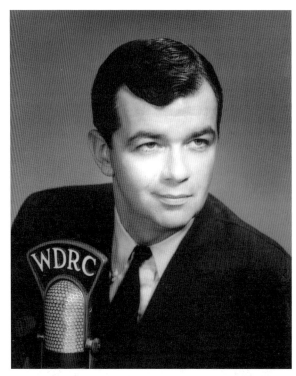

Left: Dick Robinson, a DJ at WDRC. *Courtesy of Robinson Entertainment, LLC.*

Below: Dick Robinson (WDRC DJ) involved in a Beatles press conference. *Courtesy of Robinson Entertainment, LLC.*

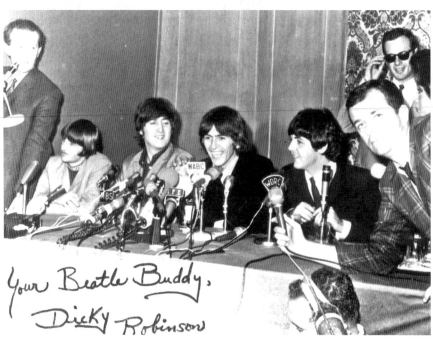

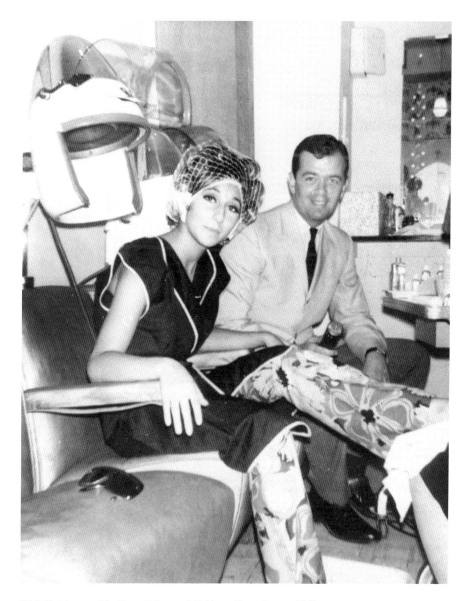

Dick Robinson with Cher. *Courtesy of Robinson Entertainment, LLC.*

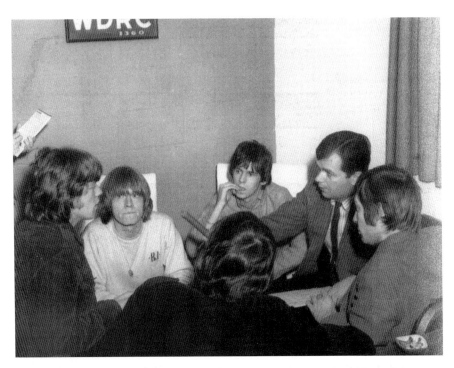

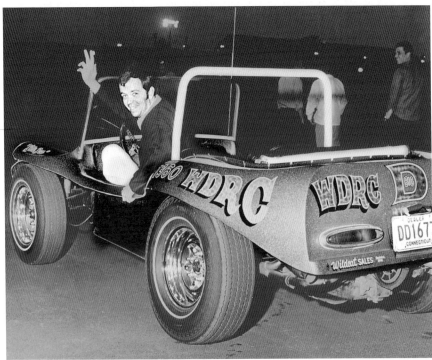

A History

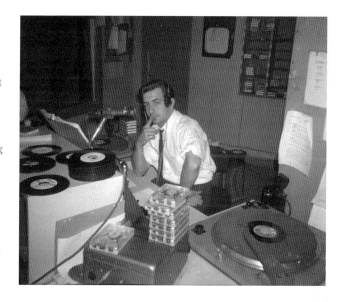

Right: Bob Ruge, DJ at Waterbury's WWCO. *Courtesy of Al Warren.*

Opposite, top: Dick Robinson interviewing the Rolling Stones at the WDRC studio. *Courtesy of Robinson Entertainment, LLC.*

Opposite, bottom: Dick Robinson in a WDRC dune buggy. *Courtesy of Robinson Entertainment, LLC.*

funny thing about all of this is that later on when our songs like "Ding Dong! The Witch Is Dead" hit it really big in New York, Murray the K loved them and played them constantly, not knowing that the Fifth Estate was really the D-Men band that he had previously banned on his station!

ALAN FREED

I hope you'll take my hand as we stroll together down our musical Memory Lane. The Big Beat in American Music was here a hundred years ago—it will be here a thousand years after we are all gone. SO—LET'S ROCK 'N' ROLL!
—Alan Freed, "Mr. Rock 'n' Roll"

One of the most popular and influential pioneers in the history of rock 'n' roll, Alan Freed gained legions of fans as a disc jockey, concert promoter, record hop emcee, TV host and film star. While at Cleveland's radio station WJW, Freed coined the phrase "rock 'n' roll." His fame grew while he was at WINS and WABC radio stations in New York City, when he earned the nickname "Mr. Rock 'n' Roll." For a time, Freed resided in Stamford, Connecticut, at his home, known as the Greycliff Manor. There, he hosted many music executives and made plans to bring rock 'n' roll to the big screen.

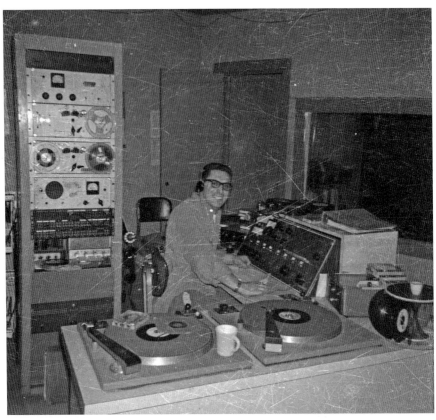

Above: Al Warren, DJ at WWCO in Waterbury, Connecticut, 1963. Warren went on to become a very well-known DJ at WICC in Bridgeport, Connecticut. *Courtesy of Al Warren.*

Left: My "pocket" transistor radio from long ago. A bit beat up but still works fine. *Author's collection.*

A History

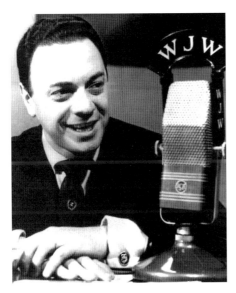
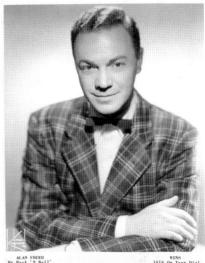

Left: Alan Freed at WJW in Cleveland. *Courtesy of Judith Fisher Freed (estate of Alan Freed).*

Right: Mr. Rock 'n' Roll. *Courtesy of Judith Fisher Freed (estate of Alan Freed).*

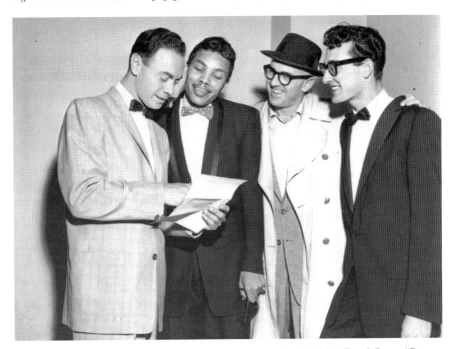

Pictured here at the Brooklyn Paramount Theatre are (*left to right*) Alan Freed, Larry "Bony Maronie" Williams, DJ Ben Acosta and Buddy Holly, September 8, 1957. *Courtesy of Judith Fisher Freed (estate of Alan Freed).*

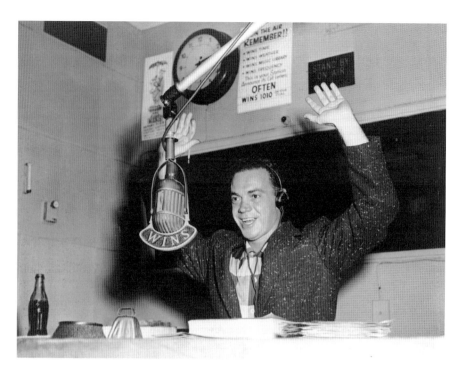

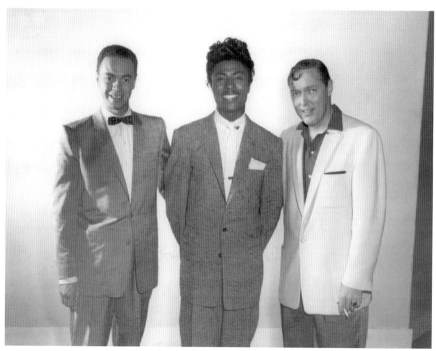

A History

Above: Chuck Berry, singer Sandy Stewart ("My Coloring Book") and Alan Freed. *Courtesy of Judith Fisher Freed (estate of Alan Freed).*

Opposite, top: Alan Freed at WINS in NYC. *Courtesy of Judith Fisher Freed (estate of Alan Freed).*

Opposite, bottom: Alan Freed with Little Richard and Bill Haley. *Courtesy of Judith Fisher Freed (estate of Alan Freed).*

Freed was one of the first inductees into the Rock and Roll Hall of Fame in 1986. In fact, Cleveland was chosen as the home of the Rock and Roll Hall of Fame as a tribute to Alan Freed.

AN OASIS FOR TEENAGERS

AFTER-SCHOOL HANGOUTS IN THE '50s AND '60s

In the '50s and '60s, thousands of small establishments across the United States became meccas for teenagers looking for a place just to hang out

after a rigorous day at school. Whether they were called malt shops, soda shops, hamburger joints, pizza joints or diners, these after-school hangouts served as oases for teenagers—places they could call their own, free of adult restrictions. These hangouts became a rite of passage for teens, where they could meet and discuss things that mattered most in their lives at that moment. Like every other state during this period of time, Connecticut had its fair share of these after-school hangouts throughout its communities.

Growing up in Waterbury, Connecticut, I have fond memories of meeting my fellow teenagers at such hangouts as the Handy Kitchen, Aldoron's, Ken's Campus and even New Haven's Clark's Dairy. A

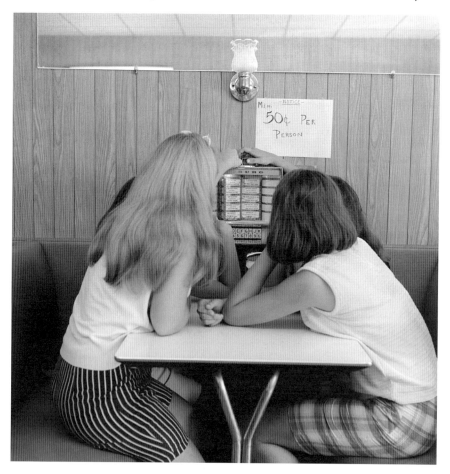

Four teenage girls putting coins in the slot of a wallbox at a soda shop booth, 1960s. *Author's collection.*

A History

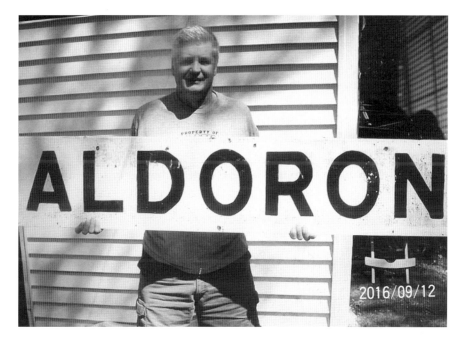

The Aldoron Soda Shop was located on Highland Avenue in Waterbury, Connecticut. The after-school hangout was named after the owner's three sons: Albert, Doug and Ron Poskus. *Courtesy of Doug Poskus.*

common factor among these hangouts was the music that was played in these diners—music that, in many cases, was initiated by the teenagers themselves. Proprietors of these establishments figured out that allowing teenagers to play their own music was a great boost for business. To facilitate this, many owners purchased jukeboxes, which held popular music of the day in the form of 45rpm records. Additionally, many owners installed jukebox wallboxes at each booth for teenagers to easily play their favorite songs without leaving their booth.

DANCE TO THE MUSIC

CONNECTICUT BANDSTAND TV SHOW

On July 9, 1956, Dick Clark took over as host of *American Bandstand* on WFIL-TV in Philadelphia, Pennsylvania. Later that same year (October 17,

1956), WNHC-TV in New Haven began airing *Connecticut Bandstand*. Both WFIL and WNHC were station affiliates under the Triangle Publications Radio and Television company.

For the most part, *Connecticut Bandstand* mirrored Dick Clark's national *American Bandstand*. The show's format featured teenagers in and around Connecticut who danced to hit songs that were popular at the time. Local pop artists from Connecticut performed on the show, lip-syncing to their recordings. Like *American Bandstand*, the *Connecticut Bandstand* show featured dance regulars who gained local fame and even had their own fan clubs. Two such regulars were a couple known as Cookie and Charley. Cookie Teznick and Charley (Charlie) Lent were a very popular dancing duo on the show in 1957. Later that year, Cookie and Charley recorded two singles—"Let's Go Rock and Roll" and "I Love You So"—that were popular on a local basis, charting in the Top 20 on Connecticut radio stations. Many of the teenagers appearing on the show were students at local New Haven high schools, such as Hillhouse High and Wilbur Cross High.

Local recording artists that performed on Connecticut Bandstand included Debbie and the Darnels, the Catalinas, the Academics, Ginny

Debbie and the Darnels on *Connecticut Bandstand*. *Courtesy of Dorothy Yutenkas, lead singer of Debbie and the Darnels.*

A History

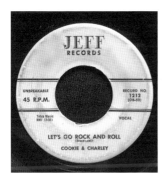

Connecticut Bandstand's dance regulars Cookie and Charley also had a Top 10 local hit: "Let's Go Rock and Roll." *Author's collection.*

Arnell, Andy Dio, Billy James, Roger Koob and the Premiers, the Van Dykes, the Reveliers, the Pyramids and Ron and His Rattletones. *Connecticut Bandstand* aired on WNHC-TV weekdays Monday through Friday at 3:30 p.m., immediately prior to *American Bandstand*. The show's first host was Jim Gallant. He hosted many record hops and outdoor shows featuring local performers. For example, Gallant hosted and produced concerts in 1959 at Marino's Danz-Er-Roll in Buckingham Hall in Waterbury, Connecticut. Also, it is purported that Gallant was in the running to host *American Bandstand*, but the job was awarded to Dick Clark. After allegations of payola arose, Gallant resigned, refusing to sign an affidavit admitting to receiving gifts in exchange for playing records. In March 1960, Elliot "Biggie" Nevins became the show's new host. Nevins also hosted local record hops. *Connecticut Bandstand* ended in 1962 with Mike Sapack as the last host of the show.

Connecticut Bandstand was a very popular TV show for viewers in and around the state.

BRANFORD VIBES

THE INDIAN NECK FOLK FESTIVAL

The Indian Neck Folk Festival in Branford, Connecticut, was an important music venue that holds a very special place in music history. The festival there attracted many of the leading folk singers of the time. It was there that a relatively unknown teenager by the name of Bob Dylan performed three Woody Guthrie songs outside the Montowese House as part of the Indian Neck Folk Festival. The date of this event was May 6, 1961. The audio of his performance in Branford is believed to be the earliest Bob Dylan audio recordings. You might say this was Bob Dylan before *the* Bob Dylan.

A year earlier, this same venue served as a launching pad for five Wesleyan University students who were just gaining popularity on the folk scene. The

Connecticut Rock 'n' Roll

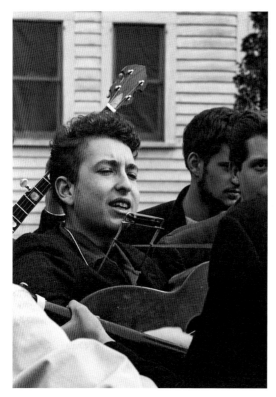

Left: A rare photo of Bob Dylan performing at the Indian Neck Folk Festival in Branford, Connecticut, on May 6, 1961. *Photo by Joe Alper; courtesy of Joe Alper Photo Collection LLC.*

Below: The Highwaymen performing in the Montowese House as part of the Indian Neck Folk Festival in Branford, Connecticut, on May 7, 1960. *Photo by Earl Colter; courtesy of the Branford Historical Society.*

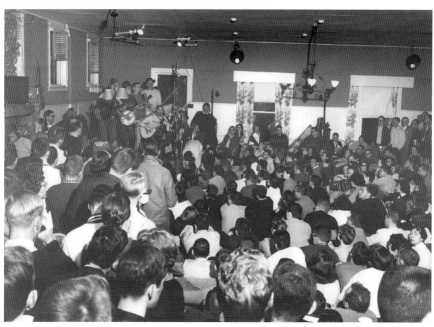

A History

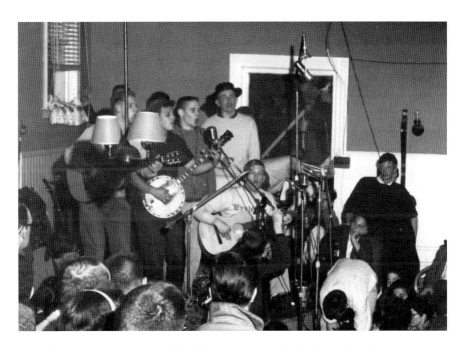

The Highwaymen at the Indian Neck Folk Festival, Branford, Connecticut. *Photo by Earl Colter; courtesy of the Branford Historical Society.*

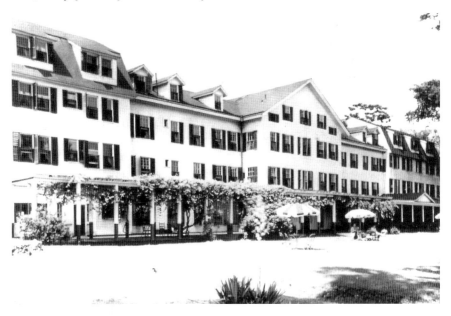

The Montowese House (aka "The Queen of the Sound"). *Courtesy of the Branford Historical Society.*

group was called the Highwaymen, and the members' performance in the Montowese House drew a large crowd as part of the Indian Neck Folk Festival. The quintet had just recorded a song to be released several months later that would become a huge no. 1 *Billboard* hit. The song was called "Michael, Row the Boat Ashore."

THE HISTORY BEHIND SEVERAL ICONIC SONGS

"IN THE STILL OF THE NIGHT"

It was in the winter of 1956 that the Five Satins, led by Fred Parris, recorded several songs in a makeshift studio in the basement of New Haven's St. Bernadette Church. One song was called "The Jones Girl," recorded as the A side. The B side of the recording was a ballad that Parris had written called "In the Still of the Night." The 45rpm single was initially released in 1956 on New Haven's Standard record label. The saxophone solo was recorded by Vinny Mazzetta of New Haven. Mazzetta was instrumental in convincing the pastor of St. Bernadette's church (Father Charles Hewett) to agree to have the Five Satins record their songs in the basement of the church. He also agreed to have the Satins use the church's piano for the recording. "The Jones Girl" began to get some airplay. Unexpectedly, disc jockeys across the country began playing the B-side ballad—to favorable reviews by both fans and critics.

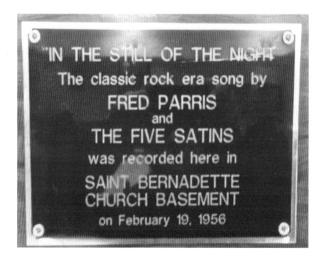

Plaque honoring Fred Parris and the Five Satins displayed in the basement of New Haven's St. Bernadette Church, actual site of the recording of the 1956 legendary song "In the Still of the Night." *Author's collection.*

A History

"In the Still of the Night" (aka "In the Still of the Nite" and "(I'll Remember) In the Still of the Night") became a smash hit record for the Five Satins, charting at no. 24 on the pop charts and no. 3 on the R&B charts. The song charted very well in Connecticut and also in various markets in the United States (No. 10 on Houston's KXYZ). Throughout the years, this beautiful ballad has had enormous staying power. The song not only has been considered one of the greatest (and largest selling) doo-wop records, but it is also considered by many as one of the greatest rhythm and blues ballads in music history. Remarkably, the song has been so popular with fans of all ages and musical tastes that it has charted on the Top 100 on three separate occasions (1956, 1960 and 1961), a historic accomplishment. "In the Still of the Night" ranked no. 90 on *Rolling Stone*'s list of the greatest songs of all time.

"DING DONG! THE WITCH IS DEAD"

"Ding Dong! The Witch Is Dead" was a 1967 smash hit for the Fifth Estate, reaching no. 11 on *Billboard*'s national charts. In Connecticut, "The Witch Is Dead" was a no. 1 hit record. The song was also a no. 1 hit on local radio stations across the country, such as Vancouver (Washington), Florida, Oklahoma City, Hartford and so on. Due to its popularity, the song was sung in five different languages.

Ken Evans, drummer for the Fifth Estate, describes the tune this way: "The song 'The Witch Is Dead' is a creative mix of pop, rock and classical baroque. It is the highest-charting song from the number 1 most watched movie *The Wizard of OZ*."

"(NA NA HEY HEY) KISS HIM GOODBYE"

The story behind the band Steam is somewhat complicated and mysterious. Steam's no. 1 hit song "(Na Na Hey Hey) Kiss Him Goodbye" also has a strange, legendary and almost mythical history to it.

The song can be traced back to 1961 when three teenagers co-wrote a song they called "Kiss Him Goodbye." The song was not recorded and never released. The three teenagers were Gary DeCarlo, Dale Frashuer and Paul Leka. All three had attended high schools in Bridgeport, Connecticut—Leka (Bassick High), DeCarlo (Central High) and Frashuer

(Roger Ludlowe High). Soon after, DeCarlo and Frashuer joined a group known as the Glenwoods. The other members of the group were Joe Reed, Johnny Castle (Castlelenetti) and Frank Borelli. The group's name changed several times, first to the Citations and then to the Chateaus. Leka sat in with the groups and played piano. DeCarlo describes the original version of the song as "a blues shuffle." After the Chateaus broke up, Leka, DeCarlo and Frashuer went their separate ways.

In 1969, Leka, DeCarlo and Frashuer got together again. At this time, Leka was producing records for DeCarlo, who used the stage name Garrett Scott. DeCarlo describes the making of "(Na Na Hey Hey) Kiss Him Goodbye" in this way:

> *I had cut four songs for Mercury records which Paul (Leka) and the executives felt were all great songs. Paul's favorite was "Workin' On A Groovy Thing" (written by Neil Sedaka). However, the 5th Dimension found out about this recording and put their version out one week before mine. The record executives and Paul then decided to put out the ballad "Sweet Laura Lee" (written by Larry Weiss). I wasn't too keen on leading off with a ballad but was assured that it would be promoted to everyone's satisfaction. So now we needed a B side. I always liked the song "Kiss Him Goodbye" that we wrote years before. So I told Dale to tell Paul I wanted to record it. When we went into the studio, Paul pulled up one of the four songs that I had worked on which was called "Sugar" (also written by Neil Sedaka). Hearing this song again, we made an 8-bar drum loop that became the drum track. We also used piano and organ overdubs as well as vibes—but no bass and no guitar. At one point, I noticed a piece of wood on the floor from one of the organ speakers in the studio, so I picked up a pair of drumsticks and began playing rhythm on this board. Paul said "Hey, let's include this in the recording." So, I put cloth around the tips of the drumsticks while Paul held the board up to the microphone, and that became the rhythm percussion that you hear on the song. I sang the lead on the song. Needing a chorus for the song, Paul began using "na na's" instead of real words. I added the "hey hey hey" chants. The recording took a fortuitous turn when a record executive decided to release the song separately as an A-side. Somewhat mysteriously, a fictitious group name was shown as the recording artist, instead of "Garrett Scott", which allegedly was the original plan. (Garrett Scott was my stage name at the time.) I was told by Paul that when both records were released they would both be mine, but that did not happen.*

Soon the song began to be played in one sports venue after another. The fans and the public embraced the song, especially the chanting chorus. "(Na Na Hey Hey) Kiss Him Goodbye" became a monster number 1 hit, with estimated sales of over seven million copies worldwide.

So now the trio had a major hit record but no band to promote the hit song. For a group, six Connecticut musicians were chosen to tour as the band and were given the group name Steam. According to DeCarlo, "Steam got its name when Paul, Dale and I were returning from lunch one day and we noticed steam shooting up from a NYC manhole."

Also, it was decided that a Steam album should be recorded, featuring their hit song. But who would sing on the album? As DeCarlo recalls, "Paul wanted me to sing all the songs on the album but have the tour group that was hired get the song credits. Of course I said no and that, unfortunately, led to a rift in our friendship and business relationship. The tour band came from the Bridgeport area."

Today, Gary DeCarlo is still doing what he loves—writing, recording, doing meet and greets and performing. He is also fighting his second battle with cancer. Gary has a new CD out called *Now and Then*. The CD includes nine songs from the '60s and early '70s, plus seven brand-new ones. The CD has received thirty-one favorable five-star reviews. DeCarlo's albums are available on CD Baby, Amazon and iTunes.

"(Na Na Hey Hey) Kiss Him Goodbye" has been covered by other artists over the years, including Bananarama (No. 5 in the United Kingdom in 1983) and the Nylons (No. 12 in 1987). Gary DeCarlo recorded and released a new version of this hit song on his 2014 album *Long Time Comin*.

MAKING SENSE OUT OF NONSENSE

CONNECTICUT NOVELTY SONGS

Novelty songs were in vogue in the 1950s and 1960s. Here are examples of popular novelty tunes performed by Connecticut artists:

"BEEP BEEP" BY THE PLAYMATES

In 1958, the Playmates had a huge hit with their novelty song "Beep Beep." Written by group members Carl Cicchetti and Donald "Conn" Claps, the song became a no. 4 hit million-dollar seller and remained on the *Billboard* Top 40 charts for twelve weeks.

The popularity of "Beep Beep" helped AMC motors set production and sales records for the Rambler car models. "Beep Beep" was an extremely popular song in Connecticut. Also, the song was a no. 1 hit in other areas of the United States (Buffalo's WKBW, Albany's WPTR and so on). "Beep Beep" was also a Top 10 hit in various parts of Canada. The Playmates were a pop vocal harmony trio from Waterbury, Connecticut.

"HIGH SCHOOL U.S.A. (HARTFORD, CONNECTICUT AREA)" BY TOMMY FACENDA

In an interesting and successful marketing scheme, Tommy Facenda recorded nearly thirty different versions of his song "High School U.S.A." using high school names in various regions of the United States. One of these versions was titled "High School U.S.A. (Hartford, Connecticut Area)."

While Facenda was not from Connecticut, "High School U.S.A. (Hartford, Connecticut Area)" certainly was considered a "Connecticut song," leading many in the state to believe that was the only version of the tune. The lyrics of this version of his song mentioned many Connecticut High Schools, including Bassick, Central, Hamden, Ludlowe Warde, Meriden, Hartford, Wilbur Cross, Staples, Norwalk, Manchester, Stamford, East Hartford, Rockville, Weaver, Plainville, Middletown, Farmington, Hillhouse High, Torrington, Conard, Bulkeley, New London, Norwich, East Haven, Maplewood Jr., Darien, Bristol, Greenwich, Danbury, Crosby and Wilby. Facenda was a former member of the rockabilly band Gene Vincent and His Blue Caps. "High School U.S.A. (Hartford, Connecticut Area)" was a no. 1 song in Connecticut in 1959.

"DOUG'S DRAG" BY RON AND HIS RATTLETONES

A disc jockey by the name of Doug Wardwell from Hartford's WPOP radio station used the instrumental "Doug's Drag" as his DJ theme. Thus, "Doug's

Drag" and "School Day Blues" (the A side) got plenty of airplay on this very popular radio station. Wardwell used Doug Ward as his radio name and was also referred to as "Doug the Bug." Ward was a radio personality at WPOP from 1957 to 1959. Ron and His Rattletones is the band that recorded "Doug's Drag" and "School Day Blues."

"ITSY BITSY TEENIE WEENIE YELLOW POLKA DOT BIKINI" BY TOMMY DAE AND THE HIGH TENSIONS

The popular novelty song "Itsy Bitsy Teenie Weenie Yellow Polka Dot Bikini" was covered in 1967 by Tommy Dae and the High Tensions. The difference between Dae's recording and the original tune was that Dae's version was done in a "Mitch Ryder" rocking style. The Tensions consisted of local performers, including Tommy Dae, Ernie Dae (Tommy's Brother), Tommy Dionne, Bernie Costello, Mike Garrison and Arno Groot. Tommy Dae and the High Tensions (aka Tensions) were from the Rockville and Vernon, Connecticut area.

"POOR BEGONIA (CAUGHT PNEUMONIA)" BY JERI LYNNE FRASER

Jeri Lynne Fraser's song "Poor Begonia (Caught Pneumonia)" was an "answer record" to Brian Hyland's novelty hit tune "Itsy Bitsy Teenie Weenie Yellow Polka Dot Bikini." Fraser's "Poor Begonia" charted in New England and in other markets, such as Salt Lake City's KMUR. Jeri Lynne Fraser was from Manchester, Connecticut, and she recorded "Poor Begonia (Caught Pneumonia)" in 1960.

"BEATNIK DJ" BY THE NITE NIKS

The very popular disc jockey Dick Robinson joined forces with a group known as the Nite Niks to record the 1964 novelty tune "Beatnik DJ." Robinson was a DJ on Hartford's WDRC in the mid-1960s. The song was released on Connecticut's Fun record label. "Beatnik DJ" appeared on Hartford's WDRC radio station survey for three weeks in 1964, peaking at no. 52.

The Nite Niks were actually the group Tommy Dae and the High Tensions.

"I'M MY OWN GRANDPAW" (AKA "I'M MY OWN GRANDPA") BY DWIGHT AND THE JESTERS

Dwight Latham co-wrote a novelty song that he and his group recorded known as "I'm My Own Grandpaw" (aka "I'm My Own Grandpa"). This novelty song was also recorded by major artists, including Willie Nelson and Ray Stevens. Dwight Latham was born and raised in New Britain, Connecticut. He formed the group known as Dwight and the Jesters (aka the Jesters Trio, the Jesters).

2
ROCK 'N' ROLL IS CERTAINLY HERE TO STAY

1950–1959

DECADE HIGHLIGHTS
Elvis · "I Like Ike" · the baby boomers · *I Love Lucy* · the Cold War · doo-wop · *American Bandstand*

The 1950s saw the emergence of rock 'n' roll. Teenagers across the country embraced this new phenomenon and treated it as their own. They even had their very own national dance show called *American Bandstand*, which spawned local teenage dance shows across the country. Rock 'n' roll was music by and for young people. Teenage doo-wop and R&B groups also sprang up throughout the United States and became part of the rock 'n' roll movement. Every aspect of teenage life was affected by rock 'n' roll, and teenagers loved the independence from adult authority that rock music represented. Many adults considered this new music as just a passing phase. But the young people knew better. Rock 'n' roll was here to stay.

CONNECTICUT NATIONAL/INTERNATIONAL HIT MAKERS

THE FIVE SATINS (AND THE SCARLETS)

Considered one of Connecticut's most well-known and successful vocal groups, the Five Satins were formed by singer-songwriter Fred Parris in New

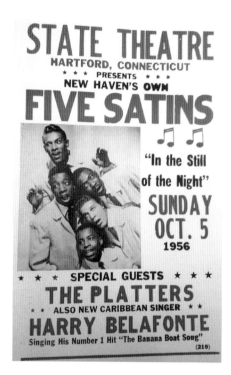

Left: The Five Satins performed at the State Theatre in Hartford, Connecticut. *Author's collection.*

Below: Special brochure from February 2016 signed by Fred Parris. Top two photos in center are of the Scarlets. The Five Satins and Fred Parris are shown in bottom center. *Author's collection. Used with permission from Emma Parris and Fred Parris.*

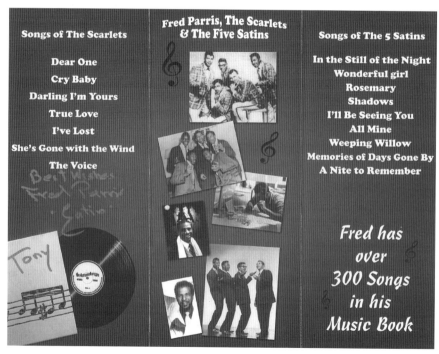

A History

Haven, Connecticut. The Five Satins achieved worldwide fame with their classic doo-wop tune "In the Still of the Night." The Five Satins' follow-up song was another beautiful ballad, "To the Aisle" (with New Haven's Bill Baker in the lead). "To the Aisle" was a Top 10 hit record.

Before forming the Five Satins, Fred Parris was the lead singer and songwriter of the 1950s group known as the Scarlets. The Scarlets were an R&B/doo-wop vocal group from New Haven, Connecticut. Fred Parris and the other group members were still students at Hillhouse High School when the Scarlets formed in 1953. "Dear One," written by Parris, became a local hit for the Scarlets in 1953. After the Scarlets disbanded, Fred Parris formed the legendary Five Satins in 1955.

West Haven's Bill Baker was an important member of the Five Satins. While Fred Parris was serving in the military, Baker took over lead vocals on the Five Satins' Top 10 hit "To the Aisle." The song also charted very well outside the United States (no. 5 on Toronto's CHUM radio). Baker passed away in Yale New Haven Hospital on August 10, 1994. He is buried in All Saints Cemetery in North Haven, Connecticut. On August 9, 1994, Baker received an honorary induction into the Doo-Wop Hall of Fame (Sharon, Massachusetts).

The Five Satins have shared the stage with other Connecticut artists, such as the Nutmegs (in New Haven) and Debbie and the Darnels (in Seymour). Over the years, the Five Satins have performed in a variety of music venues in Connecticut, including Hartford's State Theatre, Bridgeport's Kennedy Center, the New Haven Arena, Seymour's Actors Colony and so forth.

The Five Satins were inducted into the Vocal Group Hall of Fame in 2003.

FRED PARRIS

Fred Parris is an iconic figure born and raised in New Haven, Connecticut. He is a much-loved individual who has called Connecticut his home for many years. A talented singer-songwriter, Parris maintains a very loyal fan base. During the 1950s, Parris formed the doo-wop groups known as the Scarlets and the Five Satins.

In 1965, Parris formed another group called Fred Parris and the Restless Hearts. Their recording of "Bring It Home to Daddy" in 1966 reached no. 1 on local charts in Connecticut.

In 1975 and 1976, Parris recorded several songs with the soul/funk group Black Satin. The songs were written by Parris, produced by New Haven's

Marty Kugell and arranged by Bridgeport's Paul Leka. The recordings took place in Leka's Connecticut Recording Studios on Main Street in Bridgeport, Connecticut.

On April 23, 2015, Congresswoman Rosa DeLauro introduced into the Congressional Record a tribute to Fred Parris on the House floor:

> *Mr. Speaker, it is with great pleasure today that I rise to join Mayor Toni Harp and the City of New Haven as they pay tribute to New Haven native Fred Parris at the city's 377th anniversary celebration. Today, community leaders and residents will pay homage to the city's "deep roots" by recognizing one of our civic icons, Fred Parris. Founder and lead singer of the Five Satins, Fred's extraordinary story began in 1953 when he started singing as a student at Hillhouse High School in a group called the Scarlets. The group disbanded when its members joined the army in 1956 and Fred Parris found himself stationed at Philadelphia's Navy Yard. On weekends, Fred would often return to New Haven and sing for fun with a few friends from the neighborhood. In fact, they could often be found singing on street corners along bustling Dixwell Avenue. At the insistence of a local record company owner, Fred got together with Jim Freeman, Lou Peebles, Eddie Martin and Stanley Dortch to form the Five Satins—the era of doo-wop music was born. One night, while on guard duty at 4:00 a.m., Fred penned "In the Still of the Night," bringing a musical gift to the world. It has been over fifty years since they recorded "In the Still of the Night" in the basement of St. Bernadette's Church in New Haven. Just weeks later, Fred was shipped out. By the time the record made the national charts, he was stationed in Japan and had to be replaced by Bill Baker. When Fred returned from the army, he again became the group's lead, recording songs like "Shadows" and "I'll Be Seeing You." "In the Still of the Night" has sold millions of copies and is still one of the most requested golden oldies on almost every Top-40 radio station in the country. In fact, when* **Rolling Stone** *magazine released its list of "The 500 Greatest Songs of All Time" a few years ago, "In the Still of the Night" was right up there at no. 90—in between no. 89 "California Dreamin'" by the Mamas & the Papas and no. 91 "Suspicious Minds" by Elvis Presley. Fred and his Five Satins continued recording well into the 1980s and in 2003 were inducted into the Vocal Group Hall of Fame. Fred, along with his wife, Emma, continues to make the Greater New Haven community their home today, and Fred continues to perform. He is a true community treasure, and I am honored to join Mayor Harp and all of those gathered today in paying him tribute.*

A History

Fred Parris. *Copyright Peter Hvizdak and the* New Haven Register.

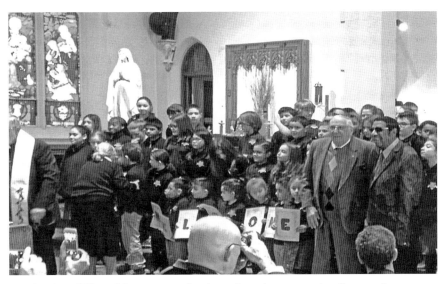

Fred Parris and Vinny Mazzetta pose for photos from the press and audience at St. Bernadette Church on February 22, 2016. Mazzetta was the man who played saxophone on the doo-wop classic "In the Still of the Night." *Author's collection.*

```
WDEE PACESETTER SURVEY              WEEK ENDING   OCTOBER 29

✓ 1. BRING IT HOME TO DADDY    F.PARRIS/HEARTS       36. Spin Out                        Elvis Presley
  2. Walk Away Renee            Left Bank            37. Got To Do A Little Bit Better   Joe Tex
  3. Dandy                      Herman's Hermits     38. Holy Cow                        Lee Dorsey
  4. Last Train To Clarksville  Monkees              39. Coming On Strong                Brenda Lee
  5. Have You Seen Your Mother Baby  Rolling Stones  40. Love Is A Hurting Thing         Lou Rawls
  6. Poor Side Of Town          Johnny Rivers        41. Louie, Louie                    Sandpipers
  7. Great Airplane Strike      Paul Revere/Raiders  42. Lady Godiva                     Peter & Gordon
  8. If I Were A Carpenter      Bobby Darin          43. Come Back                       Five Stairsteps
  9. B-A-B-Y                    Carla Thomas         44. Winchester Cathedral            New Vaudeville Band
 10. Hooray For Hazel           Tommy Roe            45. I Need Somebody                 Question Mark/
                                                                                         Mysterians
 11. Reach Out I'll Be There    Four Tops            46. I'm Ready For Love              Martha/Vandellas
 12. See See Rider              Animals              47. Stay With Me                    Lorraine Ellison
 13. All I See Is You           Dusty Springfield    48. There's Got To Be A Word        The Innocence
 14. Devil With A Blue Dress    Mitch Ryder          49. Devil With An Angels Smile      Intruders
 15. Good Vibrations            Beach Boys           50. Secret Love                     Billy Stewart
 16. Little Man                 Sonny & Cher                       PACESETTER PICKS
 17. Don't Know What To Do      Dionne Warwick
 18. It Tears Me Up             Percy Sledge
 19. Rain On The Roof           Lovin Spoonful
 20. Got You Under My Skin      Four Seasons         JOE D.  PLEASE SAY YOU'RE FOOLING   RAY CHARLES
                                                     DEL     BEHIND THE DOOR             CHER
 21. Paint Me A Picture         G.Lewis/Playboys     TRACY   THAT LUCKY OLD SUN          CASH McCALL
 22. I'm Your Puppet            James & Bob Purify   RUSTY   A HAZY SHADE OF WINTER      SIMON&GARFUNKEL
 23. What Becomes Of Broken Hearted  Jimmy Ruffin                PACESETTER L.P. PICK
 24. Go Away Little Girl        Happenings
 25. Come On Up                 Young Rascals        WARM AND TENDER SOUL                PERCY SLEDGE
 26. Hair On My Chinny Chin Chin  Sam The Sham                HOT NEW ATLANTIC SINGLES
 27. Psychotic Reaction         Count Five
 28. Stop Stop Stop             Hollies
 29. Black Is Black             Los Bravos           IT TEARS ME UP                      PERCY SLEDGE
 30. Ninteen Days               Dave Clark 5         IF I WERE A CARPENTER               BOBBY DARIN
                                                     B-A-B-Y                             CARLA THOMAS
 31. You Keep Hanging On        Supremes             LITTLE MAN                          SONNY & CHER
 32. I Can't Control Myself     Troggs               COME ON UP                          YOUNG RASCALS
 33. Pa Pa Pa (Sad Song)        Otis Redding
 34. A Satisfied Mind           Bobby Hebb
 35. Who Am I                   Petula Clark

       WDEE 1220        WDEE 1220             WDEE 1220       WDEE 1220
```

"Bring It Home to Daddy" by Fred Parris and the Hearts at no. 1, October 29, 1966. *Author's collection.*

On February 22, 2016, a tribute to Fred Parris and the Five Satins was held at St. Bernadette Church in New Haven, Connecticut. Fred Parris and his lovely wife, Emma, were in attendance. Also in attendance was Vinny Mazzetta, the man who played saxophone on "In the Still of the Night." Mazzetta was instrumental in convincing then pastor of St. Bernadette's (Father Charles Hewett) to agree to let the Five Satins record songs in the basement of the church. The program was a celebration of the sixtieth anniversary of the iconic song "In the Still of the Night" by the Five Satins.

THE PLAYMATES

Best known for their 1958 mega-hit song "Beep Beep," the Playmates were a pop/vocal harmony trio from Waterbury, Connecticut.

The group consisted of Donny Conn (born Donald Claps), Carl Cicchetti (aka Chic Hetti) and Morey Carr (aka Morey Cohen). Donny and Morey attended Waterbury's Crosby High School. They both were members of Crosby's High School Band. Chic attended Waterbury's Wilby High School. While still in high school, Chic joined Donny and Morey, forming a musical

trio. Together they played local school dances and YMCA socials in the Waterbury area. After graduating from high school, the trio attended the University of Connecticut (Storrs, Connecticut). While at UConn they formed a comedy and music trio called the Nitwits and started touring in 1952. Soon after, they graduated from UConn (1953).

Other national Top 40 hits for the Playmates included "Jo-Anne," "Don't Go Home," "What Is Love" and "Wait for Me." In Connecticut, "Little Miss Stuck-Up" was a Top 10 hit (WPOP radio). The group performed at numerous music venues in Connecticut, including the Actors Colony (October 4, 1961). The Playmates disbanded in 1964.

THE NUTMEGS

The Nutmegs had a major hit record in 1955 with their song "Story Untold." The tune peaked at no. 2 on the R&B charts and has become a doo-wop classic. Their other hit record was 1955's "Ship of Love" (no. 13 on the R&B charts). Also, "My Story" and "Whispering Sorrows" were local favorites in Connecticut and other U.S. markets ("My Story" was a Top 30 hit on Michigan's WKAR).

The Nutmegs performed at Hartford's State Theatre as part of the *Rhythm & Blues Revue* on November 20, 1955. They also performed at the Brooklyn Paramount as part of the Alan Freed First Anniversary show in 1957.

The Nutmegs hailed from New Haven, Connecticut. They named their group after the state's nickname, the Nutmeg State.

ROBERT MITCHUM

Although he is best known as a famous actor (ranking no. 23 on AFI's list of greatest male stars), Robert Mitchum was also a singer-songwriter. Mitchum co-wrote and sang "The Ballad of Thunder Road," which charted at no. 62 on *Billboard* (1958). In Connecticut, "Thunder Road" was a no. 2 hit song. The tune fared very well in other parts of the Northeast (no. 2 on Syracuse's WNDR radio station). Mitchum also had a hit with "Little Old Wine Drinker Me" that charted no. 9 on country charts and no. 96 on the *Billboard* Hot 100 Chart (1967).

Robert Mitchum was born and raised in Bridgeport, Connecticut. Mitchum's father, James, was an army private who was stationed in New

London, Connecticut. It was there that he met his future wife, Ann Harriet Gunderson. The couple married in 1913 and soon made Bridgeport their home. They moved into a house on 476 Logan Street, which is in the East End of Bridgeport. It was at this location that Robert Mitchum was born on August 6, 1917, and spent his childhood.

Ann worked for the *Bridgeport Post* newspaper and had several different jobs at the *Post*, including operating a line casting printing machine (linotype) and then proofreading for the editorial department. As early as age six, Robert showed his creativity by writing poems, short stories and even his own newspaper he called the *Gold Streak*. They were so good that the editor of the children's section of the *Bridgeport Post* published young Mitchum's works along with a profile. The exposure in the *Bridgeport Post* made young Mitchum a Bridgeport celebrity. His creativity at such an early age may help explain his musical accomplishments later in life, when he composed such works as "The Ballad of Thunder Road" (he also co-wrote the film *Thunder Road*) and an oratorio that was performed at the Hollywood Bowl.

GINNY ARNELL

Any of my records could be released and enjoyed today as well as they were 46 years ago. I believe my records are timeless and unforgettable once you hear them a few times.
—*Ginny Arnell*

Singer-songwriter Ginny Arnell began her professional career while still in high school. Arnell's recording career began in 1959 as one half of the singing duo Jamie and Jane. Jamie was actually recording star Gene Pitney. Jane was New Haven's Ginny Arnell (real name Virginia "Ginny" Mazarro).

The duo recorded several songs together. "Faithful Our Love" was co-written by Pitney, Mazarro and New Haven's Marty Kugell (a Connecticut producer who gained fame as producer of "In the Still of the Night" by the Five Satins). "Classical Rock and Roll" was written by Pitney. "Strolling (Thru the Park)" was co-written by Mazarro (credited as Ginny Mazzaro).

The duo's songs charted locally and in various parts of the United States ("Snuggle Up Baby" charted no. 29 in Pittsburgh). Jamie and Jane received favorable reviews in the July 29, 1957 edition of *Billboard* magazine, which gushed, "Material is imaginative…[and] the pair impress as new talent." The duo appeared in a number of Connecticut music venues, such as

A History

	WDEE PACESETTER SURVEY		WEEK ENDING JULY 23	
1.	I'M HENRY THE VIII	HERMANS HERMITS	36. Don't Just Stand There	+Patty Duke
2.	I Like It Like That	Dave Clark Five	37. Down In The Boondocks	+Billy Joe Royal
3.	Satisfaction	Rolling Stones	38. I Can't Help Myself	*+Four Tops
4.	Easy Question	Elvis Presley	39. Wonderful World	
5.	Save Your Heart For Me	*+G. Lewis/Playboys	40. Here Comes The Night	Them
6.	Let Them Talk	Pearlean Gray	41. I Got You Babe	+Sonny & Cher
7.	Yes I'm Ready	+Barbara Mason	42. Sitting In The Park	+Billy Stewart
8.	Take Me Back	Little Anthony	43. Give Us Your Blessings	Shangri-las
9.	I Want Candy	+Strangeloves	44. For Loving You	+Ronettes
10.	Sunshine Lollipops Rainbows	*+Leslie Gore	45. Loving You Too Long	+Otis Redding
11.	What The World Needs	Jackie DeShannon	46. You're My Baby	Vacells
12.	You Turn Me On	Ian Whitcomb	47. World Of Our Own	Seekers
13.	Girl Come Running	+Four Seasons	48. I Got The Blues	+Marvin Jenkins
14.	Seventh Son	Johnny Rivers	49. Wham	+Francettes
15.	In The Midnight Hour	+Wilson Pickett	50. Laurie	+Dickie Lee
16.	Again And Again	Van Dykes	51. You Better Go	+Derek Martin
17.	Theme From Summer Place	*+Lettermen	52. The Tracker	Sir Douglas Quintet
18.	Too Many Rivers	+Brenda Lee	53. After Loving You	+Della Reese
19.	Set Me Free	Kinks	54. He's Got No Love	Searchers
20.	All I Really Want To Do	Byrds/Cher	55. You Tell Me Why	Beau Brummels
21.	To Know Him Is To Love Him	*+Peter And Gordon	56. I'll Always Love You	Spinners
22.	Little Bit Of Love Can Hurt	Ginny Arnell	57. You Were On My Mind	+We Five
23.	You're My Girl	Roy Orbison	58. In The Eyes Of Love	+Gene Pitney
24.	A Little Bit Of Heaven	Ronnie Dove	59. A Little You	+Freddie/Dreamers
25.	Moon Is Shining Bright	+Dixie Cups	60. Where Were You	+Jerry Vale
26.	Nobody Knows	*+Chiffons	61. Candy	+Astors
27.	Pretty Little Baby	*Marvin Gaye	62. I Cried My Last Tear	O'Jays
28.	What's New Pussycat	Tom Jones	63. California Girls	*Beach Boys
29.	You've Never Been In Love	*+Unit 4 + 2	64. Ju Ju Hand	*+Sam The Sham
30.	A Little Bit Too Late	Wayne Fontana	65. You Can't Buy My Love	+Barbara Lynn
31.	Justine	*+Righteous Bros.		
32.	Unchained Melody/Hung On You	Righteous Bros.	-PACESETTER PICKS-	
33.	You'd Better Come Home	Petula Clark	TOM IF I DIDN'T LOVE YOU	CHUCK JACKSON
34.	Who's Cheating Who	+Little Milton	MIKE NOTHING BUT HEARTACHES	SUPREMES
35.	Chinatown	+Victor Knight	TRACY SUGAR DUMPLING	SAM COOKE
			GRISELDA IT'S THE SAME OLD SONG	FOUR TOPS
	* FORMER	+ HEARD FIRST	-PACESETTER L.P. PICK-	
	CHAMP RECORD	ON WDEE	MORE HITS FROM THE FOUR TOPS	FOUR TOPS
	WDEE 1220	**WDEE 1220**	**WDEE 1220**	**WDEE 1220**

Ginny Arnell's "Little Bit of Love Can Hurt" charting at no. 22, July 23, 1965. *Author's collection.*

Bridgeport's Pleasure Beach in July 1959. Jamie and Jane had a loyal fan club in the area.

Eventually, both Mazarro and Pitney recorded as solo artists. Mazarro changed her stage/recording name to Ginny Arnell. Several well-known songwriters (Carole King, Gerry Goffin, Teddy Randazzo, Jeff Barry and so on) penned some of her songs.

In 1963, Arnell recorded her highest-charting single, a tune called "Dumb Head." The song peaked at no. 50 on *Billboard*'s Top 100. Arnell performed this song on Dick Clark's *American Bandstand* TV show. She even re-recorded the tune in Japanese. "Dumb Head" fared even better in various U.S. radio markets (no. 3 on Chicago's WLS and Milwaukee's WRIT). In Connecticut, "Dumb Head" was a Top 10 hit (no. 8 on WAVZ).

Arnell's "I Wish I Knew What Dress to Wear," recorded in 1964, appeared on *Billboard*'s chart as a "bubbling under" song.

Ginny Arnell's "teenage pop sound" is reminiscent of such 1960s artists as Lesley Gore and Brenda Lee. One of her songs, "Look Who's Talkin'," appears on a 2013 CD titled *The Girl Group Sound: The Darlings of the 1960s, Volume 1.* Ginny Arnell toured nationwide. In Connecticut, she has shared

the stage with other state artists Debbie and the Darnels and the Hi-Lites (in Danbury, Connecticut). Arnell performed in Bridgeport, Connecticut, and at record hops at Fairfield's Roger Ludlowe High School.

For a complete interview with Ginny Arnell, see Appendix B.

LOCAL/REGIONAL HIT MAKERS AND FAN FAVORITES

THE BARONS

The Barons were very popular in the Connecticut area. They are best known for their songs "Pledge of a Fool," "Remembering Rita" and "Possibility." The song "Pledge of a Fool" was a no. 3 hit in New Haven. "Possibility" was actually recorded under the name of the Crowns. The group performed on the same bill with many major national recording artists.

 The Barons were formed by Jimmy Ienner while he and the other group members were still students at Stamford High School (Stamford, Connecticut). Ienner had previously attended K.T. Murphy Grammar School and was a schoolmate of Ken Evans of the Fifth Estate. He eventually became a well-known music producer. (Ienner was the music producer for the 1987 film *Dirty Dancing*.) Ienner also produced albums for Three Dog Night and was awarded Grammys and two Oscars.

ANDY DIO

Singer/songwriter Andy "Dio" Diotaiuto was a local legend in the New Haven area and even had a loyal fan club. Dio's songs were in the rockabilly R&B music genre. His great recording "Rough and Bold" did not chart nationally, but it was a no. 1 song in New Haven in 1961. Dio was also an excellent trumpet player. In 1965, he had a solo trumpet part in the no. 2 *Billboard* smash hit "Lover's Concerto" by the Toys. He also toured with the Toys. In 1967, Dio backed up the Bob Crewe Generation on trumpet on the no. 15 *Billboard* hit "Music to Watch Girls By." In addition, Dio recorded and toured with Mitch Ryder and the Detroit Wheels. He also appeared on Jim Gallant's *Connecticut Bandstand* show, as well as the *Merv Griffin* and *Mike Douglas* TV shows.

A History

THE PASSENGERS

The Passengers were previously known as the Melotones, a band that provided instrumentation on one of the Academics' recordings. The band hailed from New Haven, Connecticut. The Passengers were also known as Jerry Green and the Passengers and Pearlean Gray and the Passengers. Band member Jerry Green was actually New Haven's Jerry Greenberg, who founded the Passengers.

Jerry Greenberg co-founded the Green-Sea label along with Art DeNicholas (of the Catalinas and the Van Dykes). A number of Connecticut artists recorded on the Green-Sea label, including Fred Parris and the Restless Hearts. Greenberg went on to become the president of Atlantic Records. He signed many major artists to his record labels.

WDEE PACESETTER SURVEY — WEEK ENDING JULY 30

#	Title	Artist	#	Title	Artist
1.	I'M HENRY THE VIII	HERMANS HERMITS	36.	California Girls	*Beach Boys
2.	I Like It Like That	Dave Clark Five	37.	Nobody Knows	*+Chiffons
3.	Let Them Talk	Pearlean Gray	38.	Sitting In The Park	+Billy Stewart
4.	Satisfaction	Rolling Stones	39.	You've Never Been In Love	*+Unit 4 + 2
5.	Save Your Heart For Me	*+Gary Lewis/Playboys	40.	Yes I'm Ready	+Barbara Mason
6.	Take Me Back	Little Anthony	41.	Little Bit Of Love Can Hurt	Ginny Arnell
7.	I Want Candy	Strangeloves	42.	A Little Bit Too Late	Wayne Fontana
8.	Easy Question	+Elvis Presley	43.	You're My Baby	Vacells
9.	All I Really Want To Do	Byrds/Cher	44.	Wham	+Francettes
10.	Sunshine Lollipops Rainbows	*+Leslie Gore	45.	A Little You	+Freddie/Dreamers
11.	What The World Needs	Jackie DeShannon	46.	Justine	*Righteous Bros.
12.	In The Midnight Hour	+Wilson Pickett	47.	In The Eyes Of Love	+Gene Pitney
13.	Theme From A Summer Place	Lettermen	48.	You Better Go	+Derek Martin
14.	What's New Pussycat	Tom Jones	49.	I'll Always Love You	Spinners
15.	Unchained Melody	Righteous Bros.	50.	The Tracker	Sir Douglas Quintet
16.	Again And Again	Van Dykes	51.	After Loving You	+Della Reese
17.	You Turn Me On	Ian Whitcomb	52.	He's Got No Love	Searchers
18.	It's The Same Old Song	+Four Tops	53.	You Were On My Mind	+We Five
19.	Help	Beatles	54.	I Cried My Last Tear	O'Jays
20.	Nothing But Heartaches	Supremes	55.	Papa's Got A Brand New Bag	James Brown
21.	I Got You Babe	+Sonny & Cher	56.	You Tell Me Why	Beau Brummels
22.	Girl Come Running	+Four Seasons	57.	Sugar Dumpling	+Sam Cooke
23.	To Know Him Is To Love Him	*+Peter & Gordon	58.	Since I Lost My Baby	Temptations
24.	You're My Girl	Roy Orbison	59.	Where Were You	+Jerry Vale
25.	Seventh Son	Johnny Rivers	60.	Candy	Astors
26.	Too Many Rivers	Brenda Lee	61.	Ju Ju Hand	*+Sam The Sham
27.	Pretty Little Baby	*Marvin Gaye	62.	You Can't Buy My Love	Barbara Lynn
28.	Down In The Boondocks	+Billy Joe Royal	63.	We're Doing Fine	+Dee Dee Warwick
29.	You Better Come Home	Petula Clark	64.	Everything's Wrong	Chubby Checker
30.	Don't Just Stand There	+Patty Duke	65.	I'm A Happy Man	+Jive Five
31.	Set Me Free	Kinks		-PACESETTER PICKS-	
32.	A Little Bit Of Heaven	Ronnie Dove	Joe D.	Take You Where Music Playing	Drifters
33.	Moon Is Shining Bright	*+Dixie Cups	Mike	It Ain't Me Babe	Turtles
34.	Who's Cheating Who	+Little Milton	Tracy	Sad Sad Girl	Barbara Mason
35.	Chinatown	+Victor Knight	Griselda	Little Circus Clown	Christy Allen
	* FORMER CHAMP RECORD	+ HEARD FIRST ON WDEE		-PACESETTER L.P. PICK- Out Of Our Heads	Rolling Stones

WDEE 1220

Pearlean Gray and the Passengers' "Let Them Talk" charting at no. 3, July 30, 1965. *Author's collection.*

ROGER KOOB

Singer-songwriter Roger Koob was a member of a number of Connecticut groups: Roger Koob and the Premiers, Roger Koob and the Travelers and Roger Koob and the Frontiers. He also was a member of Roger Koob

WDEE PACESETTER SURVEY — WEEK ENDING SEPTEMBER 24

#	Song	Artist
1.	KEEP ON DANCING	*+GENTRYS
2.	Hang On Sloopy	McCoys
3.	Eve Of Destruction	*Barry McGuire
4.	You Were On My Mind	+We Five
5.	It Ain't Me Babe	Turtles
6.	Got To Get Out	Animals
7.	You've Got Your Troubles	Fortunes
8.	Laugh At Me	+Sonny
9.	Catch Us If You Can	Dave Clark Five
10.	Baby Don't Go	+Sonny & Cher
11.	It's The Same Old Song	+Four Tops
12.	Do You Believe In Magic	Lovin Spoonful
13.	Heartfull of Soul	+Yardbirds
14.	Just A Little Bit Better	Hermans Hermits
15.	Treat Her Right	Roy Head
16.	The In Crowd	+Ramsey Lewis
17.	I'll Make All Your Dreams	+Ronnie Dove
18.	Nothing But Heartaches	Supremes
19.	High Heel Sneakers	Stevie Wonder
20.	Papa's Got A Brand New Bag	James Brown
21.	I'm Yours	+Elvis Presley
22.	California Girls	*Beach Boys
23.	Danger Heartbreak Ahead	Marvelettes
24.	Houston	Dean Martin
25.	Hide Away	Roy Orbison
26.	Heartaches By The Number	+Johnny Tillotson
27.	My Town, My Guy & Me	+Leslie Gore
28.	Respect	+Otis Redding
29.	For Your Love	+Sam and Bill
30.	You've Been In Love	+Martha/Vandellas
31.	You're The One	+Vogues
32.	Act Naturally/Yesterday	Beatles
33.	Just You	Sonny & Cher
34.	Everybody Loves A Clown	G. Lewis/Playboys
35.	Sad Sad Girl	*Barbara Mason
36.	Like A Rolling Stone	+Bob Dylan
37.	Liar, Liar	Castaways
38.	Unchained Melody	Righteous Bros.
39.	What Color	Bobby Vinton
40.	Help	Beatles
41.	I Knew You When	*+Billy Joe Royal
42.	Cara-Lin	Strangeloves
43.	Tossing And Turning	Ivy League
44.	Sun Ain't Gonna Shine	Frankie Valli
45.	Right Now And Not Later	*+Shangri-las
46.	Some Enchanted Evening	Jay/Americans
47.	Little Miss Sad	Five Emprees
48.	Lifetime Of Loneliness	Jackie DeShannon
49.	By My Side	The Shags
50.	We Didn't Ask	Bobby Darin
51.	Let's Hang On	Four Seasons
52.	Only Those In Love	Baby Washington
53.	Ain't It True	Andy Williams
54.	I Live For The Sun	Sun Rays
55.	Positively Fourth Street	+Bob Dylan
56.	Get Out Of My Life	*Little Anthony
57.	Rescue Me	Fontella Bass
58.	Send A Letter To Me	*Freddie/Dreamers
59.	Kansas City Star	*Roger Miller
60.	I'm Still Loving You	+David & Goliath
61.	Roll Over Casanova	+Carl Hall
62.	Take Me In Your Arms	+Kim Weston
63.	She Needs Love	Wayne Fontana
64.	Stepping Out	+Paul Revere
65.	Not The Loving Kind	Dino, Desi & Billy

— PACESETTER PICKS —

JOE D.	SO LONG BABE	NANCY SINATRA
MIKE	RING DANG DOO	SAM THE SHAM
TRACY	I'M THE GUY	YEOMANS
GRISELDA	AIN'T THAT PECULIAR	MARVIN GAYE

* FORMER CHAMP RECORD + HEARD FIRST ON WDEE

— PACESETTER L.P. PICK —
THE RHYTHM AND BLUES ALBUM TRINI LOPEZ

WDEE 1220

David and Goliath's "I'm Still Loving You" charting at no. 60, September 24, 1965. *Author's collection.*

and the Herd, a group that performed at the Actors Colony, among other Connecticut music venues.

Koob also teamed up with New Haven's Bill Baker (of the Five Satins) to form the singing groups David and Goliath and also the Buddies. Koob and the groups he performed with were very popular in Connecticut, and their songs ranked high on local radio charts. They were also popular throughout the East Coast and even in Canada.

RON AND HIS RATTLETONES

Ron and His Rattletones recorded two songs that were released on Al Soyka's Glo record label in Somers, Connecticut. The group's first song was a rockabilly tune called "School Day Blues" (with lead vocals by Glastonbury's Rocky Hart). The flip side is an instrumental by Ron and His Rattletones called "Doug's Drag." The tune, written by Ron Comier, features great saxophone work by band member Charlie Foxe.

Ron and His Rattletones performed on Jim Gallant's *Connecticut Bandstand* TV dance show. While never reaching major success on

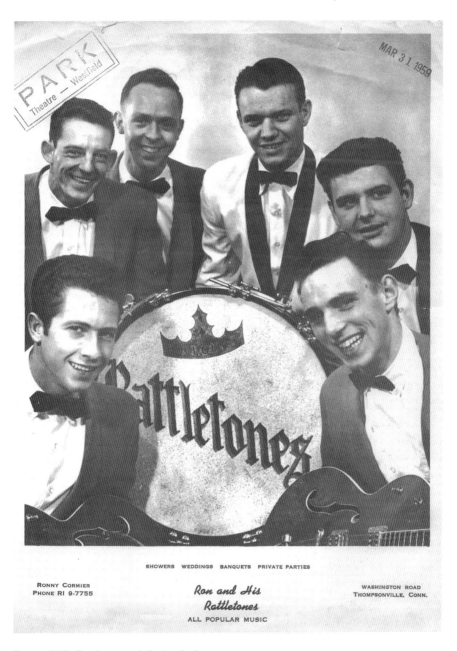

Ron and His Rattletones. *Author's collection.*

their own, Ron and His Rattletones did back up a number of major recording acts. In fact, the Rattletones were the first band that Gene Pitney performed with on stage. Ron Cormier formed the Rattletones in Rockville, Connecticut, in the late 1950s.

ROCKY HART

Rocky Hart was a rock 'n' roll singer from Glastonbury, Connecticut. His real name was Pierre Maheu (Mahieu). He sang lead on the rockabilly tune "School Day Blues" by Ron and His Rattletones.

Maheu also performed as a solo artist, recording under the name Rocky Hart. It is purported that the backup group on his recording "Come with Me" was the Mystics (of "Hushabye" fame). "I Play the Part of a Fool" was composed by Barry Mann. Hart's version of "Every Day" was done in a great doo-wop rockabilly fashion. The song charted no. 2 in Connecticut. Pierre Maheu (Rocky Hart) died in Colchester, Connecticut, and was buried in Moodus, Connecticut.

THE BARRIES

The Barries hailed from New Haven, Connecticut. After leaving Connecticut's Nobles, New Haven's Nicky DeLano joined the Barries. Their songs charted on local Connecticut radio stations (no. 28 on New Haven's WDEE and WAVZ).

New Haven's sixteen-year-old Richard Carpenter (of the Carpenters) made his recording debut when he joined the Barries for their songs "Why Don't You Write Me" and "Mary Ann." Richard played the piano on these recordings.

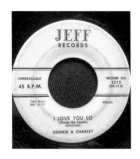

Cookie and Charley's "I Love You So." *Author's collection.*

COOKIE AND CHARLEY

Cookie Teznick and Charley (Charlie) Lent were classmates at Hillhouse High School in New Haven, Connecticut. They were also very popular regulars on the *Connecticut Bandstand* show in 1957. Later that year, Cookie and Charley recorded two singles (released in 1958): "Let's Go Rock and Roll" and "I Love You So." Lent co-wrote both songs. The recordings were popular on a local basis, charting in the Top 20 on several Connecticut radio stations.

A History

THE BALLADS

Dick Arnold Branford High School class of 1957. *Courtesy of the Branford Historical Library.*

The Ballads formed as a vocal harmony group in 1955 while attending Branford High School (Branford, Connecticut). The group also enlisted singers from other local high schools, including New Haven's Hillhouse High.

Their songs charted in the Top Ten on local radio stations. For example, "Somehow" by the Ballads reached no. 10 on New Haven's WNHC and also charted on several New York radio stations, such as WABC (no. 50).

The lead singer of the Ballads (Dick Arnold) later joined the Five Satins and sang lead on such recordings as "Do You Remember" and "No One Knows." Arnold also recorded as a solo artist.

THE PYRAMIDS

The Pyramids were an R&B vocal group that formed in New Haven in 1955. The teenage group backed New Haven's Ruby Whitaker in 1957 on her version of "I Don't Want to Set the World on Fire." They also performed on Jim Gallant's *Connecticut Bandstand* TV show, singing "At Any Cost." The Pyramids were popular in the New Haven area.

THE MARIE SISTERS

The Marie Sisters were a vocal harmony sister duo that performed on the same program as Rockville's Billy Bryan (aka Gene Pitney) and Glastonbury's Rocky Hart (Pierre Maheu). The two recordings by the Marie Sisters in 1959—"Oh Tony" and "Chica Chee Cha Cha"—were popular in the Connecticut area. The Marie Sisters were from the Hartford, Connecticut area.

THE BEAU-BELLES

The Beau-Belles consisted of sisters Vicky and Mary Ann (Pauline), along with friend Joe Dalla. The Beau-Belles performed at various local record hops, on local radio and at outdoor fairs (the Stratford Town Fair, Woolworth Record Department in Bridgeport and so forth). The Beau-Belles (aka Beau-Bells) were a vocal harmony trio from Bridgeport, Connecticut.

3

FROM CLASSIC POP TO MOP TOPS TO CLASSIC ROCK

1960–1969

DECADE HIGHLIGHTS
The Nixon/Kennedy debates · Vietnam · the Beatles · Muhammad Ali · assassinations of JFK, MLK and RFK · folk music · the moon landing · Woodstock

The 1960s music scene began innocently enough. Songs by teen idols like Bobby Rydell, Connie Francis and Bobby Darin were played on every jukebox and on every AM radio station in the United States. The music heard by teenagers was mainly in the form of male and female solo artists. But all that was about to change. We all heard enthusiastic accounts of four teenagers with mop top hairdos from Liverpool, England, causing a sensation throughout Europe. But was this hype or was it the real thing? On February 9, 1964, we received our answer. On that date, a record-setting seventy-three million viewers tuned in to hear Ed Sullivan, over the screams from his teenage audience, introduce these four young lads to all of America. The introduction was a simple five-word proclamation, "Ladies and Gentlemen—the Beatles!" This opened the floodgates for many other groups from the United Kingdom in what has become known as the British Invasion. More importantly, rock bands by the thousands began to spring up almost overnight across the entire country. Also, Bob Dylan shook up the folk world by going electric. Once again, rock music changed the course of history.

CONNECTICUT NATIONAL/INTERNATIONAL HIT MAKERS

GENE PITNEY, THE ROCKVILLE ROCKET

I sang in church and school and always had a love for music, but it wasn't until the mid-fifties, when the first rock 'n' roll came roaring out of the radio, that it really got inside my head and wouldn't let go.
—*Gene Pitney*

The pride of Connecticut, singer-songwriter Gene Pitney, "The Rockville Rocket," was born in Hartford, Connecticut, and raised in Rockville, Connecticut. While attending Rockville High School, Pitney formed a group called Gene and the Genials. In 1959, Pitney recorded four demo songs with a Hartford, Connecticut doo-wop group known as the Embers. The same year, he recorded a song under the name Billy Bryan. "Cradle of My Arms" by Billy Bryan (Pitney) was written by Winfield Scott, writer of the hits "Tweedlee Dee," "Many Tears Ago" and "Return to Sender." The song charted on several radio station surveys, including Syracuse's WNDR.

Pitney was also part of the duo Jamie and Jane. Jane was actually New Haven's Ginny Arnell. The duo recorded several songs that charted locally and in other parts of the United States. Ginny recalled, "It was fun working with Gene. He never went anywhere without his guitar. He was always thinking about new songs to write. He was a very slim, aggressive, handsome and talented young man who was going to achieve success at any cost."

Gene Pitney's music legacy is very impressive. As a recording artist, Pitney had sixteen Top 40 hits, four in the Top 10. In the United Kingdom, he had twenty-two Top 40 hits and eleven Top 10 hits. His recording of "Something's Gotten Hold of My Heart" (a duet with Marc Almond) was a no. 1 hit in the United Kingdom and several other European countries. An international sensation, Pitney recorded complete albums in Italian and Spanish.

In Connecticut, Gene's recordings consistently charted well on the state's radio station music surveys. For example, Pitney was well represented in Hartford's WDRC Best Selling Sixty of 1961 music survey with his own recordings at no. 44 and no. 50, plus his penned "Hello Mary Lou" at no. 2 on this same 1961 survey. Also, "It Hurts to Be in Love" charted no. 5 on WWCO's 1964 survey.

As a songwriter, Pitney wrote hit songs, such as "He's a Rebel" (no. 1 song for the Crystals) and "Hello Mary Lou" (no. 9 hit for Ricky Nelson),

and co-wrote "Rubber Ball" (no. 6 for Bobby Vee in the United States and internationally no. 4 in the United Kingdom, no. 1 in Australia).

Remarkably, Pitney's "Only Love Can Break a Heart" was a no. 2 *Billboard* hit record at the same time that his penned recording "He's a Rebel" charted at no. 1 on *Billboard*. Thus, he had the top two hit records in the nation, one as a songwriter and one as a singer.

Very early in the 1960s, Pitney befriended the Rolling Stones. He became the first artist to cover a Jagger/Richards composition with the Top 10 UK hit "That Girl Belongs to Yesterday" (no. 7 in United Kingdom). It was also the first Jagger/Richards composition to make the U.S. charts (No. 49). On February 28, 1964, Gene performed "That Girl Belongs to Yesterday" on the popular British show *Ready, Steady, Go*. Also, Pitney played piano on the Stones' "Little by Little" and is acknowledged (along with Phil Spector) on the Stones' "Now I've Got a Witness" in the subtitle "Like Uncle Phil and Uncle Gene."

Gene Pitney was so popular that he was among the very few early U.S. 1960s artists who continued to enjoy hits after the British Invasion in 1964.

Pitney performed in a number of Connecticut music venues, including the Mohegan Sun, Foxwoods, Seymour's Actors Colony and more. The first concert for the 1967 Pitney tour was held at Hartford's Bushnell Memorial (August 1967). Pitney also performed a number of times on the *American Bandstand* TV show.

Gene Pitney was inducted into the Rock and Roll Hall of Fame in 2002.

Throughout his entire life, Gene Pitney stayed true to his home state of Connecticut. Aside from his sensational music career, Gene was highly regarded as a true family man and a down-to-earth person to his family, friends and legion of fans.

Gene Pitney passed away on April 5, 2006. The funeral service for Pitney was held at All Saints Church in Somersville, Connecticut, on April 12, 2006. Included in the eulogy (given by a close friend) were references to several Pitney hit songs:

> *For all of us baby boomers who as teenage boys cruised up and down Main Street, USA listening to "If I Only Had a Dime" or the countless teenage girls who cried at the foot of their bed listening to "Only Love Can Break a Heart," it is now time to say goodbye to Gene Pitney and say to ourselves "I'm Gonna Be Strong."*

On October 19, 2016, Emily Santanella, on behalf of the Gene Pitney Commemorative Committee, paid tribute to a legend by dedicating a

marble bench in memory of the great Gene Pitney. Here is a portion of Emily's presentation:

> Today, I invite you to take a moment and really think about who he was. Listen to "I Wanna Love My Life Away" and marvel at the fact that he sang all of the harmonies and overdubbed instruments, something that has been called "a pioneering feat of record production." Listen to his songs in Spanish, Italian or German…because even in a foreign language, his voice will convey the emotion. Listen to his performance at Foxwoods in 2000 and appreciate the strength of his vocals, forty years after the start of his career. We all know that as a singer, songwriter and musician, he was incredibly talented. But let's also remember him as the man who held the door for you at the post office on Battle Street and who waved to let you turn ahead of him at an intersection and who invited students interested in music careers to see his home studio through the high school's School to Career Program.

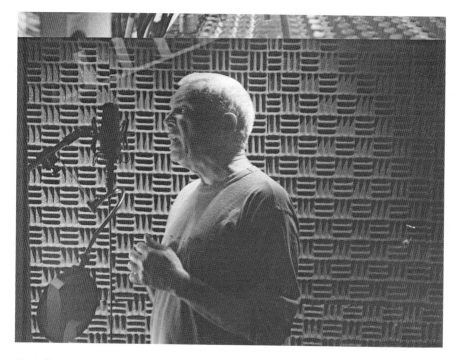

Gene Pitney recording at his home studio. *Courtesy of the Gene Pitney Commemorative Committee.*

A History

Left: Gene Pitney performing. *Courtesy of the Gene Pitney Commemorative Committee.*

Below: Singer/songwriter Gene Pitney writing lyrics to a song. *Courtesy of the Gene Pitney Commemorative Committee.*

Connecticut Rock 'n' Roll

Left: Gene Pitney's high school yearbook photo. *Courtesy of the Vernon Historical Society.*

Right: Gene Pitney, treasurer of his Rockville High School senior class, 1958. *Courtesy of the Vernon Historical Society.*

Gene Pitney's "Looking Through the Eyes of Love" charting at no. 25, September 10, 1965. *Author's collection.*

A History

Gene Pitney, member of a choral group in Rockville High School. *Courtesy of the Vernon Historical Society.*

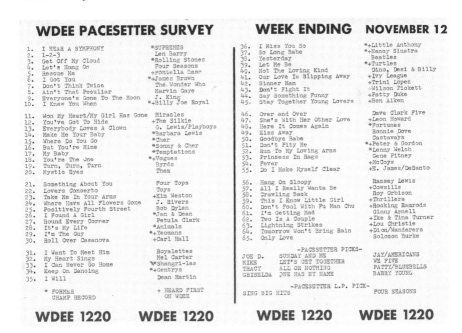

Gene Pitney's "Princess in Rags" charting at no. 53, November 12, 1965. *Author's collection.*

AL ANDERSON (THE WILDWEEDS, NRBQ AND SOLO CAREER)

Al Anderson, February 23, 2002.
Photo by Richard Brukner.

Singer-songwriter-guitarist Al Anderson (aka "Big Al") was born and raised in Windsor, Connecticut. Anderson's band experience began at age eleven with Connecticut bands such as the Visuals, followed by the high school bands the Altones, the Blues Messengers and the Six Packs. In 1966, the Six Packs were renamed the Wildweeds. Thanks to Anderson's distinctive lead vocals and great song lyrics, the Wildweeds remain one of Connecticut's most well-known and revered bands.

Having departed the Wildweeds, Big Al's next venture was joining the group the New Rhythm and Blues Quartet (NRBQ) at the end of 1971. Anderson's first major songwriting and vocal contribution to this group was the classic 1977 **NRBQ** song "Ridin' in My Car." The song became an instant classic and a staple at **NRBQ** concerts. Even during his stint with **NRBQ**, Anderson pursued a well-received solo career, beginning with the 1972 self-titled LP *Al Anderson*. The album was a Top 10 hit in Connecticut (no. 8 on Hartford's WDRC). He has recorded a number of solo albums since.

In 1993, Anderson wrote a tune called "Every Little Thing," which was recorded by Carlene Carter (daughter of June Carter). The song (co-written by Carlene) became a smash hit, reaching no. 3 on the country charts. After spending over two decades with **NRBQ**, Anderson decided to leave the group and concentrate most of his time and energy as a songwriter. Big Al is considered one of the most prolific songwriters in the music industry. Besides songs written during his Wildweeds and **NRBQ** days, Anderson's songwriting achievements resulted in hits for major artists, including Vince Gill, Tim McGraw, Trisha Yearwood, Jimmy Buffett, Bonnie Raitt, Alabama, the Oak Ridge Boys, George Jones, LeAnn Rimes and George Strait.

Among his many accolades, in 1993, Anderson was voted one of the top one hundred guitarists of the twentieth century by *Musician Magazine*. In 2000, Anderson was named BMI Songwriter of the Year. Al Anderson is a gifted singer, songwriter, guitarist and truly one of Connecticut's music gems.

A History

THE CARPENTERS

*[Karen Carpenter] has the best female voice in the world:
melodic, tuneful and distinctive.*
 —*Paul McCartney*

Both Karen and Richard Carpenter were born and raised in New Haven, Connecticut. The siblings were born at Grace–New Haven Hospital (renamed Yale–New Haven Hospital). Their father, Harold Bertram Carpenter, worked for the New Haven Pulp and Board Company. Their mother, Agnes, was a housewife. While in school, Agnes enjoyed playing various sports, with a keen interest in basketball and baseball. Harold and Agnes moved to New Haven in 1940, and the Carpenter family lived on Hall Street.

Richard attended Nathan Hale Elementary School (Townsend Avenue), which was right around the block from the Carpenters' home on Hall Street. He played music at a very early age, first the accordion (at age four) and then piano (at age eight). Richard attended New Haven's Wilbur Cross High School, where he displayed his musical talent. When he was fifteen years old, he studied piano at Yale Music School. At this same time, Richard formed his own group consisting of piano, bass and drums, and the trio played at local venues in and around New Haven. At age sixteen, Richard made his recording debut when he joined the Barries for their songs "Why Don't You Write Me" and "Mary Ann." Richard played the piano on these recordings.

Karen also attended Nathan Hale Elementary School. Unlike Richard, her concentration was on activities other than music. Just like her mother, Karen enjoyed playing sports, especially baseball. Along with her friends, Karen would participate in baseball games on the street in front of her Hall Street house or at New Haven's Nathan Hale Park. In the book *Little Girl Blue*, author Randy L. Schmidt writes, "A favorite was Wiffleball, a variation on baseball that used a perforated plastic ball invented just thirty miles away by a man in Fairfield, Connecticut. Karen pitched and sometimes played first base. 'I was a tremendous baseball fan,' she later said. 'I memorized all the batting averages long before I knew the first word to a song. The Yankees were my favorites.'" Karen also had a paper route; she delivered the *New Haven Register* newspaper on a daily basis. Karen and Richard's elementary school (Nathan Hale School) honored Richard and Karen Carpenter with the school's Hall of Fame Award.

In the summer of 1963, the Carpenters moved to Downey, California. Karen and Richard, of course, went on to become one of the bestselling

recording artists of all time with their group the Carpenters, selling a staggering number of records (well over 100 million) worldwide, including three no. 1 singles, five no. 2 singles and twelve Top 10 singles. They were the no. 1 music act of the 1970s.

The Carpenters' songs resonated with Connecticut residents and were consistently played on local radio stations. Their songs reached the Top 10 and even no. 1 on popular Connecticut radio stations, such as WAVZ, WNHC, WPOP and WDRC.

Note: There is a connection between New Haven's Karen and Richard Carpenter and Windsor's Al Anderson. When he was with the Wildweeds, Al Anderson wrote and recorded the song "And When She Smiles." The Carpenters (with Karen in the lead) performed this song at their concerts. Previously unreleased, the tune was finally released (with the title changed to "And When He Smiles") in 2004 on the CD titled *As Time Goes By*.

THE FIFTH ESTATE

The strength of the band was that we did things ourselves and in our own way. Whether it was the D-Men or the Fifth Estate bands, we did things on our own terms. Our sound evolved from surfing instrumentals in '63 to pop/rock tunes in '64 and edgier rock 'n' roll in '65, adding more R&B in '66 and adding more harpsichord and psych in '67. All without losing our rock 'n' roll dance band center ever—even today!
—Ken Evans of the D-Men and the Fifth Estate.

The Fifth Estate is a band that originated in Stamford, Connecticut. Wayne Wadhams (founding member), Ken Evans and Rick Engler all hailed from the Springdale section of Stamford. Bill Shute was from the Ridges section of Stamford. Doug Ferrara was from Stamford's Glenbrook section. Evans attended K.T. Murphy Grammar School and was a schoolmate of Jimmy Ienner (founding member of the Barons). Wadhams attended Stamford's Rippowam High, Ferrara went to Stamford High School and Evans and Engler attended Stamford Catholic High. Stamford's Chuck Legros was also a band member briefly in 1966.

At a very early age, child prodigy Wadhams played the organ between movies at the Paramount Theater on Temple Street in New Haven, Connecticut. In 1963, Wadhams enlisted Evans, Ferrara, Shute and Engler and formed the band called the Decadants. The group began as a garage/

A History

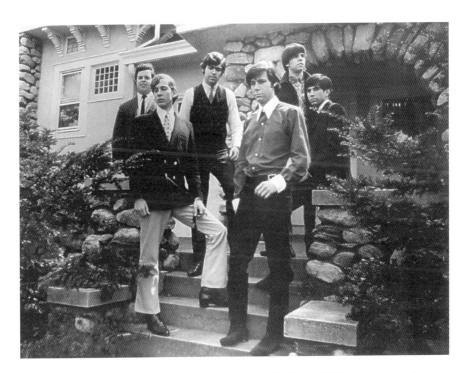

The Fifth Estate standing at the entrance to Alan Freed's Greycliff Manor residence in Stamford, Connecticut, 1966: (*left to right*) Wayne Wadhams, Chuck Legros, Bill Shute, Rick Engler, Ken Evans and Doug Ferrara. *Courtesy of Ken Evans of the Fifth Estate.*

The Fifth Estate promotional photo. *Courtesy of Ken Evans of the Fifth Estate.*

rock band that performed mainly in the Stamford area. The name of the band changed to the Demen and then to the D-Men. As the D-Men, the band signed with United Artists/VEEP recording label and released three songs that were played on East Coast radio stations. The D-Men gained national attention when they performed their song "I Just Don't Care" on the popular national music variety TV show *Hullabaloo*. In 1965, the band changed the name to the Fifth Estate.

In 1967, the Fifth Estate had a major hit with their signature song "Ding Dong! The Witch Is Dead," a tune that peaked at no. 11 on the *Billboard* charts. In Connecticut, "Ding Dong! The Witch Is Dead" was a no. 1 hit record. Throughout the years, the Fifth Estate has proven to be a multitalented band and covered a number of music genres, including rock, pop, folk/rock and classical baroque. In 2004, the band reunited. Since then, the band has released a number of albums. Two of the albums were co-produced by Ken "Furvus" Evans and famed producer Shel Talmy (who produced the Kinks, the Who and the EasyBeats).

INTERESTING FACTS

- Ken Evans managed the popular Connecticut band the Reducers in the 1980s.
- The Fifth Estate shared the stage with Windsor's the Wildweeds on several occasions.
- The Highwaymen recorded a song co-written by Wayne Wadhams. The song was also recorded by the Fifth Estate.

For more information regarding the Fifth Estate band see www.thefifthestateband.com and www.YouTube.com/TheFifthEstateBand.

For a complete interview with Ken Evans of the D-Men and the Fifth Estate, see Appendix B.

FELIX CAVALIERE

Felix Cavaliere lived in Danbury, Connecticut, from 1969 to 1986. During that period, Cavaliere recorded at least five albums and eleven singles with his legendary band the Rascals before the group's breakup in 1972. During this time, Cavaliere recorded and released at least four solo albums. In 1980,

A History

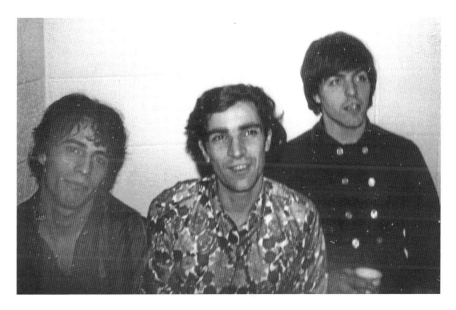

Young Rascals band members Felix Cavaliere, Eddie Brigati and Dino Danelli backstage after a concert at Westport's Staples High School, February 19, 1967. *Copyright Ellen Sandhaus.*

his solo recording "Only a Lonely Heart Sees" was a Top 40 hit on *Billboard* (no. 36), a no. 2 hit on the Adult Contemporary chart and a Top 20 song on local Connecticut radio stations (no. 14).

Prior to moving to Connecticut, Cavaliere was familiar with this state, having performed in Connecticut on several occasions with the Young Rascals, including concerts at the New Haven Arena on Saturday, May 7, 1966, and at Westport's Staples High School on February 19, 1967.

In 2013, Cavaliere reunited with his original Rascals bandmates (Eddie Brigati, Dino Danelli and Gene Cornish) and appeared on Broadway in their production of *Once Upon a Dream*.

Felix Cavaliere has been voted into the Rock and Roll Hall of Fame (with the Rascals), the Songwriter's Hall of Fame, Vocal Group Hall of Fame (with the Rascals) and Grammy Hall of Fame (with the Rascals).

As noted above, Felix Cavaliere and his band the Rascals recorded a number of hit records during Cavaliere's residence in Connecticut (1969–86). To give you an idea of how some of these recordings fared on Connecticut radio surveys versus how the songs charted on *Billboard*, here are comparisons:

- "A Ray of Hope": *Billboard* ranking no. 24. Connecticut peak position no. 2.
- "Heaven": *Billboard* ranking no. 39. Connecticut peak position no. 3.
- "See": *Billboard* ranking no. 27. Connecticut peak position no. 7.
- "Carry Me Back": *Billboard* ranking no. 26. Connecticut peak position no. 3.
- "Hold On": *Billboard* ranking no. 51. Connecticut peak position no. 14.
- "Glory Glory": *Billboard* ranking no. 58. Connecticut peak position no. 28.
- Solo hit recording by Felix Cavaliere: "Only the Lonely Heart Sees": *Billboard* ranking no. 36. Connecticut peak position no. 14.

THE HIGHWAYMEN

The Highwaymen folk group was formed by New Haven singer-songwriter Dave Fisher. Prior to the Highwaymen, Fisher was the founding member of a vocal harmony group called the Academics. Fisher formed the Academics when he was a student at New Haven's Hillhouse High School. He adopted the name of the group after the Hillhouse High students' nickname, the Academics.

The appearance by the Academics on Jim Gallant's *Connecticut Bandstand* TV show helped their 1957 tune "Too Good to Be True" to become a no. 1 song in the New Haven area.

In the fall of 1958, Dave Fisher left the Academics to attend Wesleyan University in Middletown, Connecticut. It was there that Fisher—along with four other Wesleyan freshmen—formed the folk group the Highwaymen.

In 1961, the Highwaymen released their mega-hit record "Michael, Row the Boat Ashore" (aka "Michael"). The song rose to the top of the *Billboard* charts and was the no. 1 song in the United States for two weeks. The song was also no. 1 in the United Kingdom and a Top 10 hit in other parts of Europe. In Connecticut, "Michael" was named the no. 1 song of 1961. Aside from "Michael," the Highwaymen had a no. 13 hit with "Cotton Fields." The group's other contributions to the folk scene included "The Gypsy Rover," "I'm On My Way," "Whiskey in the Jar" and "I Know Where I'm Going." In Connecticut, "The Gypsy Rover" charted in the Top 10 (no. 5 on WDRC) and "Cottonfields" charted in the Top 20 (no. 5 on WDRC,

A History

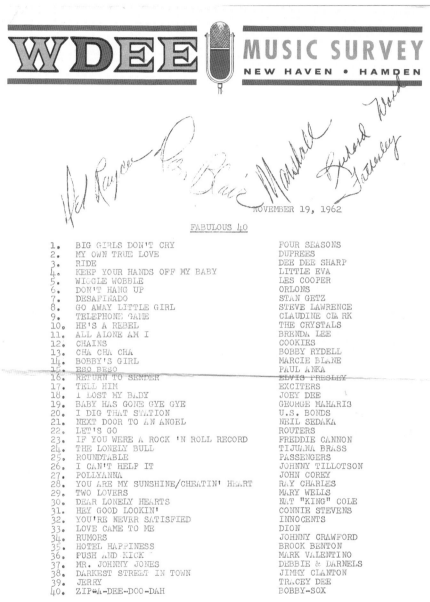

The Highwaymen's "Well, Well, Well" charting as a Big Dee Disc-covery. *Author's collection.*

no. 17 on WNHC). The group's self-titled LP album also charted very well in various markets, including Connecticut. (*The Highwaymen* peaked at no. 4.) The group appeared on such major network shows as *The Ed Sullivan Show* and Johnny Carson's *The Tonight Show*. The Highwaymen performed numerous times in Connecticut, including a concert at Fairfield University on August 24, 1963.

THE RAMRODS

The Ramrods were a Connecticut instrumental rock band formed in 1956 by Claire Lane (born Claire Litke) and her brother Rich Litke. The Ramrods are best known for their major hit recording "(Ghost) Riders in the Sky." The song was recorded in 1960 and stayed on the charts until early 1961 when it became a no. 30 *Billboard* hit in the United States and a no. 8 hit in the United Kingdom. In Connecticut, "(Ghost) Riders in the Sky" was a Top 20 hit. In addition, the song was a Top 20 and Top 40 hit in radio markets throughout the United States (no. 1 in Colorado) as well as in Canada. Their follow-up songs did not fare as well nationally, but they did chart in Connecticut and in other parts of the United States (and Canada). These included "Zig Zag" (1960), "Take Me Back to My Boots and Saddle" (1961), "Loch Lomond Rock" (1961), "War Cry" (1962) and "Boing!" (1962).

The Ramrods were unique in that they featured a female rock drummer (Claire Lane), which was almost unheard of in those days. Lane also composed and arranged songs for the band, including "War Cry" and "Boing!" Claire had a fine singing voice and recorded as a solo artist before and after the Ramrods.

The original members of the Ramrods were Claire Lane (drummer, songwriter, arranger), Rich Litke (saxophonist), cousin Gene Moore (guitar) and Vinny Bell Lee (lead guitar). Later, band replacements were Russ Cook (guitar), Bernie Moore (guitar) and George Sheck (guitar).

Vinnie Bell Lee (born Vincent Gambella) recorded as a soloist under the names Vinnie Lee and Vinnie Bell. In 1958, Vinnie Lee composed and recorded an instrumental rock tune called "Mule Train Rock" (aka "Whipper Snapper"). In 1961, Vinnie Lee and the Riders released a fine instrumental rock version of "Mule Train" (featuring Frank Salvo on tenor sax). The flip side was "Gambler's Guitar." Vinnie became a very respected session guitarist and recorded with major stars, such as Frank Sinatra ("New York, New York"). Vinnie's guitar and sitar work can be heard on such hit

songs as the Lemon Piper's "Green Tambourine" and the Box Tops' "Cry Like A Baby." Vinnie's 1970 "Airport Love Theme" (from the film *Airport*) became a million-dollar international gold record. In Connecticut, the song was a Top 40 recording.

CLAIRE LANE

Connecticut's Claire Lane (born Claire Litke) was an accomplished singer, drummer, composer and arranger. As the drummer of the early '60s band the Ramrods, Lane paved her own way in the male-dominated world of rock drummers. In the book *Women Drummers: A History from Rock and Jazz to Blues and Country*, author Angela Smith notes, "Three of the first female drummers to receive any kind of mention in historical references were Claire Lane of the American instrumental pop group The Ramrods, Tina Ambrose of the British pop group The Ravens, and Honey Lantree of the London band The Honeycombs." The Ramrods are best known for their no. 30 *Billboard* instrumental rock hit "(Ghost) Riders in the Sky," recorded in 1960.

Prior to the Ramrods, Lane was a member of a mid-1950s high school country and western group known as Gino and the Homesteaders, in Torrington, Connecticut. The group also featured Torrington's Bob French on steel guitar. Claire recorded over eight solo pop singles between 1959 and 1967. In 1959, she wrote and recorded a doo-wop ballad called "The Boy Next Door." She also recorded at least seven other singles and was the songwriter for three of these songs. In 1967, Lane recorded an album of pop songs titled "Drummer Girl Sings." Claire Lane also composed and arranged songs for the Ramrods, including "War Cry" and "Boing!"

PAUL LEKA

Connecticut has played a prominent role in both the personal and professional life of Paul Leka. After all, he was born and raised here, made his home here, married here, worked at a manufacturing company here, began his songwriting and vocal group career here, owned a recording studio here and, at the end, was buried here.

Born and raised in Bridgeport, Connecticut, Paul Leka became proficient in piano at an early age, with a concentration on classics. He soon learned to play multiple instruments, which would serve him well later in his career.

Leka attended Bridgeport's Bassick High School. In 1961, while still a student at Bassick High, Leka and two other high school friends wrote a song they called "Kiss Him Goodbye." The song was not recorded and never released. The three teenage songwriters were Gary DeCarlo, Dale Frashuer and Paul Leka. In a twist of fate, this song would re-emerge eight years later and become a no. 1 smash hit record.

Leka worked for a time as an expediter at Avco Lycoming Manufacturing in Stratford, Connecticut. In 1964, Leka married his first wife, Rosemary Angela Gajnos. The marriage ceremony took place in St. Rafael's Church in Bridgeport. Leka also was in the wedding party for his friend and Chateaus co-founder Dale Frashuer. The wedding took place in Bridgeport.

Leka eventually decided to concentrate on songwriting and the arranging and producing side of the music business.

In 1966, Leka composed "Falling Sugar," which was recorded by the pop-rock band the Palace Guard. The song fared well in several markets (Top 20 on KUTY in Palmdale, California). Note: one of the group members of the Palace Guard was Don Grady (aka Don Agrati), who later starred as Robbie Douglas on the *My Three Sons* TV show.

Paul Leka is probably best known for his association with the groups the Lemon Pipers and Steam. Leka co-wrote and produced the million-dollar seller and no. 1 *Billboard* hit "Green Tambourine" for the Lemon Pipers.

In 1969, Leka (along with DeCarlo and Frashuer) took their 1961 song "Kiss Him Goodbye" and turned it into the no. 1 monster hit "(Na Na Hey Hey) Kiss Him Goodbye."

Paul Leka opened his own recording studio, Connecticut Recording Studio, on Main Street in Bridgeport. He produced and arranged for many major recording artists, including REO Speedwagon, Harry Chapin, the Left Banke, Steam and others.

In 1975 and 1976, Leka arranged songs at his studio for the soul/funk group Black Satin featuring Fred Parris. Paul Leka died at age sixty-eight on October 12, 2011. He was buried in Sharon, Connecticut.

KRIS JENSEN

Peter "Kris" Jensen hailed from New Haven, Connecticut. In 1962, Jensen recorded "Torture," which peaked at no. 20 on the *Billboard* charts. In Connecticut, "Torture" charted no. 3 on WDRC's Top 100 Songs for 1962. The song also charted very well on other Connecticut stations.

A History

JERI LYNNE FRASER

A childhood friend of Gene Pitney, Jeri Lynne Fraser was born and raised in Manchester, Connecticut. She began her singing career when she was only six years old, performing at a local talent show in Bolton, Connecticut. At age eleven, she appeared three times on the nationally televised *Ted Mack Amateur Hour* show, winning all three times. At age twelve, she performed at Madison Square Garden. Jeri Lynne was signed to a recording contract in 1959, when she was only thirteen. Her first record was "Now I'm of Age" with the B side "If." In 1960, Fraser charted with "Poor Begonia (Caught Pneumonia)." In Connecticut, her 1962 song "Take It Easy Baby" appeared on Hartford's WDRC as a Pick Hit.

Eventually, Fraser and her family moved to New York City. In 1962, the fifteen-year-old Fraser landed a role in the movie *Two Tickets to Paris*, starring opposite Joey Dee (of Joey Dee and the Starliters fame). Fraser appeared in two additional movies, *Mike and the Mermaid* (1964) and *Lord Love a Duck* (1966). At age seventeen, Jerri Lynne performed in Las Vegas, where she was booked for an entire year. She even appeared in a number of TV shows, including *Bewitched*.

Fraser has performed with many famous singers, including her lifelong friend Gene Pitney.

LOCAL/REGIONAL HIT MAKERS AND FAN FAVORITES

THE WILDWEEDS

For Connecticut residents growing up in the 1960s, the Wildweeds (of Windsor, Connecticut) were one of the most popular and admired bands from their state.

The band's 1967 song "No Good to Cry" was certainly a fan favorite among Connecticut residents and has become a cult classic. Even to this day, the mere mention of "No Good to Cry" will put a smile on the face of many baby boomers who grew up listening and dancing to the song in the 1960s. The record received extensive airplay throughout the Northeast region and was the no. 1 song on Connecticut radio stations. The tune charted no. 15 on WWCO's Top 100 songs for 1967. The song also fared very well in other markets in the United States, such as New Orleans (no. 5), Cleveland (no.

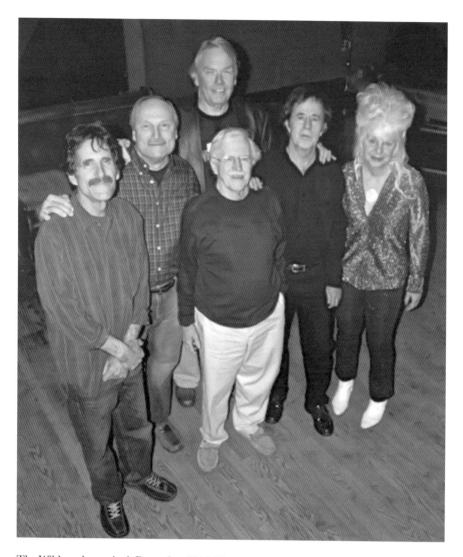

The Wildweeds reunited, December 2011. Shown are (*left to right*) Andy Lepak, Alex Lepak, Big Al Anderson, Ray Zeiner and special guests Jeff Potter and Christine Ohlman. *Photo by Joe Lemieux; used with permission from Christine Ohlman and Ray Zeiner.*

5) and many areas in the South. While "No Good to Cry" did make the national charts (no. 87), the feeling (at least in the Connecticut area) was that the song deserved a much better fate. Given the enormous popularity of the song in the regions mentioned, many people are still bewildered why the tune never achieved greater national success or became a major hit for the band.

A History

Ray Zeiner (formerly of the Wildweeds). *Photo by Joe Lemieux.*

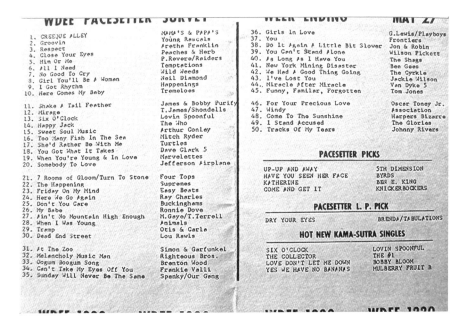

Wildweeds' "No Good to Cry" charting at no. 7 on May 27, 1967. It eventually became a no. 1 hit. *Author's collection.*

The Wildweeds recorded at Doc Cavalier's Syncron Studios (later named Trod Nossel Studios) in Wallingford, Connecticut. They also shared the stage on several occasions with Stamford's Fifth Estate.

The band members included Al Anderson (lead vocals, guitar), Ray Zeiner (organ, vocals), Bob Dudek (bass, vocals), Skip Yakaitis (percussion, vocals) and Andy Lepak (drums). The Wildweeds used musicians from the Hartt School of Music (Hartford, Connecticut) on some of their recordings.

The band's follow-up songs included "Someday Morning," "It Was Fun (While It Lasted)," "And When She Smiles" and "I'm Dreaming." These songs were Top 10 hits in Connecticut. Also, the Wildweeds album *The Wildweeds Greatest Hits & More* was very popular in the Connecticut area. As was the case with "No Good to Cry," the follow-up singles did well in the rest of the Northeast and in other markets around the country. ("And When She Smiles" was a Top 10 hit in Tulsa, Oklahoma.) Several of these songs appeared on *Billboard*'s "bubbling under" charts. The Wildweeds shared the stage with Jim Morrison and the Doors for two sold-out concerts at Wallingford's Oakdale Theatre on September 23–24, 1967.

At the end of 1971, Al Anderson joined NRBQ and became an integral part of that great band. He has also had a very successful solo career. Big Al now is one of the most sought-after songwriters because of the many hit songs he has written for other recording artists. Also, after the Wildweeds, Ray Zeiner's "I Had a Girl" charted at no. 14 on Waterbury's WWCO on February 4, 1972.

The Wildweeds reunited on several occasions in recent years. Christine Ohlman performed with a reunited Wildweeds band in their 2011, 2014 and 2015 concerts. Ohlman sang the harmony parts with the Wildweeds' bassist Bob Dudek. She has had a long association with Al Anderson and the Wildweeds. Christine, along with her band the Wrongh Black Bag, had opened for the Wildweeds very early in her career.

THE D-MEN

In 1963, Wayne Wadhams formed a garage rock band in Stamford, Connecticut, called the Decadants. The group consisted of Wadhams, Ken Evans, Doug Ferrara, Bill Shute and Rick Engler. Their first gig was at Ezio Pinza Theater in Stamford. The group performed in a number of other music venues in Connecticut and New York. In 1964, the band signed with the UA/VEEP record label, and their group name was changed to the D-Men.

A History

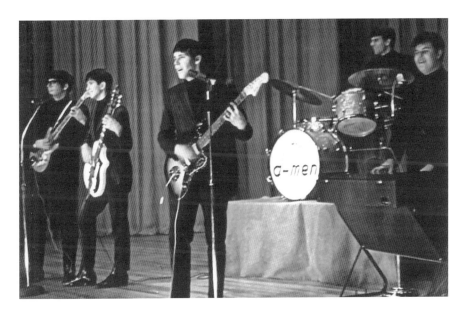

The D-Men performed on national TV shows, such as the popular hit *Hullabaloo*. In the front are *(left to right)* Bill Shute (guitar), Doug Ferrara (bass) and Rick Engler (guitar); behind are Ken Evans (drums) and Wayne Wadhams (organ/keys). *Courtesy of Ken Evans of the D-Men and Fifth Estate.*

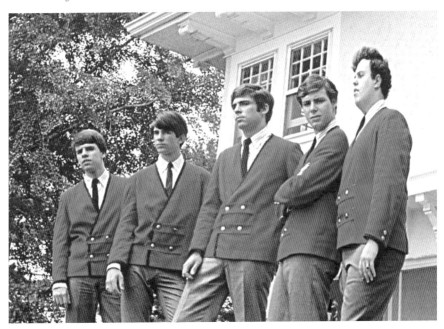

The D-Men at Alan Freed's Greycliff Manor in Stamford: *(left to right)* Ken Evans, Doug Ferrara, Bill Shute, Rick Engler and Wayne Wadhams. *Courtesy of Ken Evans of the D-Men and Fifth Estate.*

The band recorded three singles that received great airplay on East Coast radio stations. The D-Men appeared on the highly regarded *Hullabaloo* national TV show and performed their song "I Just Don't Care." They also appeared several times on Clay Cole's popular 1960s TV show. Wadhams, Evans and Engler wrote songs for the D-Men. In 1965, the band name changed to the Fifth Estate. In 1967, the band hit it big with "Ding Dong! The Witch Is Dead," which became a no. 11 *Billboard* song.

For a complete interview with Ken Evans of the D-Men and the Fifth Estate, see Appendix B.

THE WRONGH BLACK BAG

The Wrongh Black Bag was Christine Ohlman's first band and the beginning of an amazing music career for the iconic "Beehive Queen." Christine was the band's lead singer, and her brother, Vic (Steffens), played the drums. The Wrongh Black Bag charted with the singles "Wake Me Shake Me" and "I Don't Know Why" in 1968.

For a complete interview with Christine Ohlman of the Wrongh Black Bag, see Appendix B.

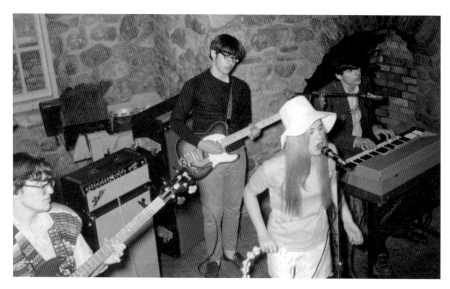

The Wrongh Black Bag with lead singer Christine Ohlman. *Photo by David W. Robb; used with permission from Christine Ohlman.*

A History

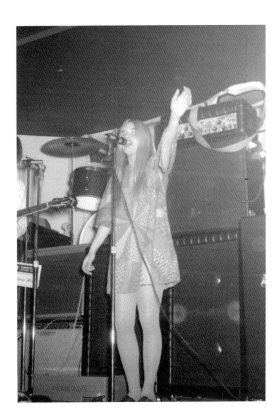

Right: The Wrongh Black Bag's lead singer, Christine Ohlman. *Photo by David W. Robb; used with permission from Christine Ohlman.*

Below: The Wrongh Black Bag. *Photo by David W. Robb; used with permission from Christine Ohlman.*

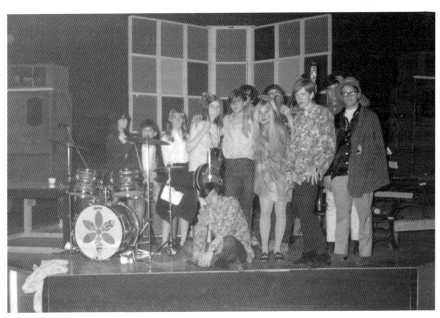

Connecticut Rock 'n' Roll

DEBBIE AND THE DARNELS

I first heard our song on the radio while I was riding in a car on a date. My sister Joan was in the backseat. Our song comes on the car radio and we just went crazy—screaming and singing along with the song. I thought to myself, "Now we made it." I so remember that moment. It doesn't get any better than that!
—Dorothy Yutenkas of Debbie and the Darnels

Debbie and the Darnels hailed from New Haven, Connecticut.

Dorothy Yutenkas, her sister Joan and a friend, Maria Brancati, made up the singing trio. In 1962, the group was known as the Teen Dreams. Later that year, the trio's name was changed to Debbie and the Darnels.

Their upbeat tune "Mr. Johnny Jones" was a Top 40 hit on local Connecticut radio stations. The trio's Christmastime offering was a lively and catchy tune called "Santa Teach Me to Dance."

Dorothy was the lead singer and wrote the group's first recording: "Why Why."

The trio was discovered by New Haven's Jerry Greenberg, who also wrote "The Time" for the group. Backing up the trio was Greenberg's instrumental band the Passengers. The group was managed by Sam Goldman (manager of the Five Satins).

Debbie and the Darnels toured up and down the East Coast and were a very popular girl group in the early '60s. In Connecticut, Debbie and the Darnels shared the stage with other well-known state artists. For example, Debbie and the Darnels performed on the same bill as the Connecticut groups the Five Satins and the Passengers at Seymour's Actors Colony as part of a Twist-A-Rama show. The trio was also on the same bill as New Haven's Ginny Arnell.

Songs by Debbie and the Darnels can be found on recent compilation CDs, such as *A Million Dollars Worth*

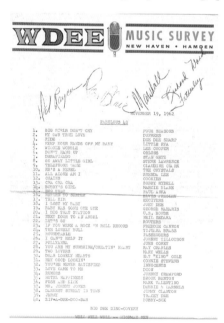

Debbie and the Darnels' "Mr. Johnny Jones" charting at no. 37, November 19, 1962. *Author's collection.*

Debbie and the Darnels (*left to right*) Joan Yutenkas, Dorothy Yutenkas and Maria Brancati. *Used with permission from Dorothy Yutenkas of Debbie and the Darnels.*

of Girl Groups (released in 2000), *Christmas Doo-Wop & Pop Vol 3* (released in 2013) and *Christmas Classics for Kids* (released in 2014).

For a complete interview with Dorothy Yutenkas of Debbie and the Darnels, see Appendix B.

THE SHAGS

The Shags formed in West Haven, Connecticut, in 1965. The co-founders of the Shags were Carl Augusto and Tom Violante. The two were schoolmates at West Haven's Notre Dame High School.

The origin of the Shags can be traced back to 1962 with the formation of a group known as the Deltons. In 1963, the Deltons were asked by manager/producer Sam Goldman to tour with and back up the Five Satins for a short period of time. In 1964, the Deltons recorded a doo-wop tune called "The Glory of Love."

In November 1964, Augusto and Violante formed a group called the Hollywood High Drop Outs (HHDO). Like many groups, HHDO had

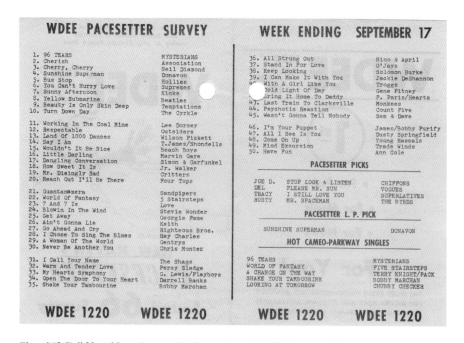

Shags' "I Call Your Name" at no. 31, September 7, 1966. *Author's collection.*

A History

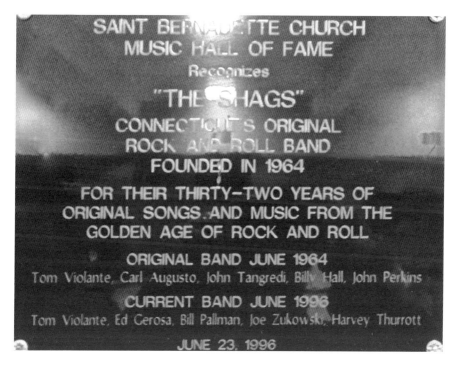

Plaque honoring the Shags displayed in the basement of St. Bernadette Church in New Haven, Connecticut. *Author's collection.*

many different incarnations. In 1965, the HHDO band changed its name to the Shags. The HHDO lineup that ultimately became the Shags were Carl Augusto (lead guitar, vocals), Tom Violante (rhythm guitar, vocals), Johnny Tangredi (drums) and Billy Hall (bass). Note that Carl, Tom and Johnny took stage names: Carl "Donnell," Tommy "Roberts" and Johnny "Stanton," respectively.

Also, in 1965, the Shags recorded their first single "Wait and See" with the B side "It Hurts Me Bad" (released on Sam Goldman's Nutta record label). Both sides were hits on the local charts. "Wait and See" became a no. 5 hit in Connecticut. "Don't Press Your Luck" was one of the best-known songs by the Shags. The song is featured on the very popular Sundazed double LP/CD release *Don't Press Your Luck! The IN Sound of 60s Connecticut.* The group's cover of the Beatles' "I Call Your Name" was the Shags' highest national charting single, reaching no. 72 on the *Billboard* charts.

One of the highlights for the Shags was when the band performed at Wallingford's Oakdale Theatre and very nearly sold out the venue. The Shags opened for major artists, including the Rascals (New Haven Arena),

WDEE PACESETTER SURVEY		WEEK ENDING	JUNE 18
1. STRANGERS IN THE NIGHT	FRANK SINATRA	36. Ninety-Nine And A Half	Wilson Pickett
2. Did You Ever Have To	Lovin Spoonful	37. Muddy Water	Johnny Rivers
3. I Am A Rock	Simon & Garfunkel	38. My Hearts Not In It	Steinways
4. Sweet Talking Guy	Chiffons	39. Dedicated Follower Of Fashion	Kinks
5. Red Rubber Ball	The Cyrkle	40. You Waited Too Long	Five Stairsteps
6. Barefootin	Robert Parker	41. Neighbor, Neighbor	Jimmy Hughes
7. Opus 17	Four Seasons	✓42. Rock-A-Bye-Girl	Van Dykes
8. Paperback Writer/Rain	Beatles	43. Past, Present, And Future	Shangri-Las
9. You Don't Have To Say	Dusty Springfield	44. Along Comes Mary	Association
10. Paint It Black	Rolling Stones	45. Off And Running	Leslie Gore
11. Cool Jerk	Capitols	✓46. Hey, Little Girl	Shags
12. Love Is Like An Itching	Supremes	47. It's That Time Of Year	Len Barry
13. Hold On	Sam & Dave	48. Happy Summer Day	Ronnie Dove
14. Ain't Too Proud To Beg	Temptations	49. Don't You Just Know It	Challengers Four
15. Let's Go Get Stoned	Ray Charles	50. Hand Jive	Stangeloves
16. Hanky Panky	T. James/Shondells	**PACESETTER PICKS**	
17. Oh, How Happy	Shades Of Blue		
18. The Letter Song	Joe Tex		
19. Little Girl	Syndicate Of Sound	JOE D. YOU CAN"T ROLLER SKATE	ROGER MILLER
●20. He	Righteous Bros.	DEL I PUT A SPELL ON YOU	ALAN PRICE SET
		TRACY WE'RE GONNA GET MARRIED	BO DIDDLEY
21. Green Grass	G. Lewis/Playboys	RUSTY TELL HER	DEAN PARRISH
22. Groovy Kind Of Love	Mindbenders	**PACESETTER L. P. PICK**	
23. Road Runner	Jr. Walker		
24. Have I Stayed Too Long	Sonny & Cher	THIS OLD HEART OF MINE	ISLEY BROS.
25. Please Tell Me Why	Dave Clark 5		
26. You Better Run	Young Rascals	**ATLANTIC RECORDS BEST L. P. BUY**	
27. When A Woman Loves A Man	Esther Phillips		
28. Don't Bring Me Down	Animals		
29. Oh What A Feeling	James Phelps		
30. It's A Man's, Man's World	James Brown		
31. Crying	Jay/Americans	WHEN A MAN	PERCY SLEDGE
32. Come On, Let's Go	McCoys	THAT LOVIN FEELING	KING CURTIS
33. Younger Girl	Hondells	GOOD LOVIN	YOUNG RASCALS
34. Take This Heart Of Mine	Marvin Gaye	WONDEROUS WORLD	SONNY & CHER
35. Teenagers Prayer	Joe Simon	SOUL	OTIS REDDING
WDEE 1220	**WDEE 1220**	**WDEE 1220**	**WDEE 1220**

Shags' "Hey Little Girl" charting at no. 46, June 18, 1966. *Author's collection.*

Gene Pitney, Dion, Simon & Garfunkel (Hartford's Bushnell Memorial), Righteous Brothers (Bridgeport's Kennedy Stadium) and B.B. King (Stamford, Connecticut). The Shags were one of the featured bands at the Teen Tempo '66 show in Milford, Connecticut. The band also appeared on local TV in Connecticut and Vermont.

In 1966, the Shags were selected to appear on the pilot of a New Haven TV show (WNHC/WTNH) called *The Show with the Very Long Title*. Also appearing with the Shags on this scheduled TV pilot were the Bram Rigg Set. However, the show was never aired.

As a tribute to the band's popularity, a plaque honoring the Shags is displayed in the basement of St. Bernadette Church in New Haven, Connecticut, alongside the Five Satins' plaque.

THE BLUE BEATS

The Blue Beats are probably best known for their rock song "Extra Girl," an extremely popular Top 10 song on Connecticut radio stations and at local dance clubs. Their follow-up recording "Born in Chicago" and its B

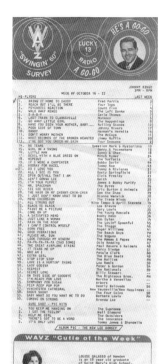

The Blue Beats' "Extra Girl" charting at no. 47, October 22, 1966. *Author's collection.*

side "I Can't Get Close (To Her at All)" were also well received in the Connecticut area.

The Blue Beats appeared on Brad Davis's dance show in Hartford, Connecticut. The band also performed as backup for major artists (Four Tops, Herman's Hermits at Hartford's Bushnell Memorial, Hollies at Hartford's Armory and others).

The Blue Beats were a popular garage rock band that originated in Ridgefield, Connecticut. Band members hailed from the Ridgefield, Danbury and Westport, Connecticut areas. After the Blue Beats disbanded, several members reunited and joined a band called the No. 1.

THE BRAM RIGG SET

Connecticut's Bram Rigg Set (BRS) was a garage rock band with a loyal local following. BRS's Beau Segal and Bobby Schlosser were previously in a band called George's Boys. "I Can Only Give You Everything" by BRS charted locally and appeared in other markets,

Bram Rigg Set's "I Can Only Give You Everything" charting at no. 27, March 25, 1967. *Author's collection.*

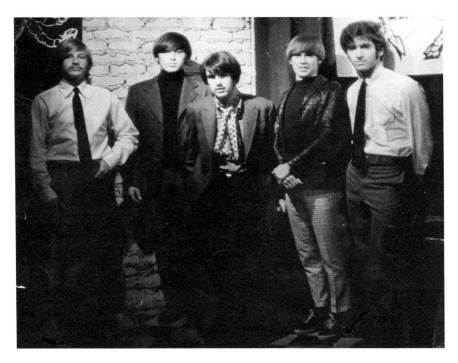

Bram Rigg Set at West Haven's House of Zodiac: (*left to right*) Rich Bednarczyk, Peter Neri, Beau Segal, Bobby Schlosser and Paul Rosano, 1967. *Courtesy of Paul Rosano.*

such as Columbus, Ohio, and Providence, Rhode Island. The tune also appeared as a "bubbling under" song on *Billboard*'s Hot 100. The band recorded at "Doc" Cavalier's Syncron Studios (later named Trod Nossel Studio) in Wallingford, Connecticut.

BRS songs appeared on a compilation album titled *Don't Press Your Luck! The IN Sound of 60s Connecticut* (2008). The album features a number of great rock and garage rock bands from Connecticut, including the Bram Rigg Set. BRS opened for a number of national recording acts, including the Dave Clark Five at Wallingford's Oakdale Theatre on July 9, 1967.

In 1967, members of two popular Connecticut groups—the Bram Rigg Set and the Shags—formed a band called the Pulse.

PULSE

In August 1967, the Pulse came together as a merger of two very popular Connecticut rock bands: the Shags and the Bram Rigg Set (BRS). This

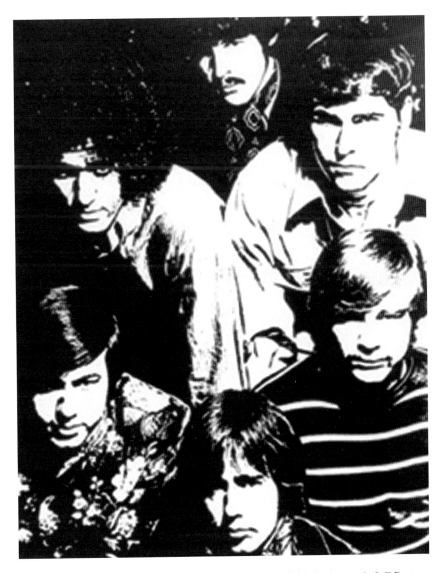

Pulse members (*clockwise from top*) Beau Segal, Carl Augusto, Rich Bednarczyk, Jeff Potter, Peter Neri and Paul Rosano, early 1968. *Courtesy of Paul Rosano.*

new group consisted of the Shags' Carl Augusto "Donnell," Tom Violante "Roberts", Lance Gardiner and the Bram Rigg Set's Beau Segal, Peter Neri and Rich Bednarczyk.

In January 1968, the band's name was changed to Pulse. There were also personnel changes. Pulse now consisted of Segal, Neri, Bednarczyk,

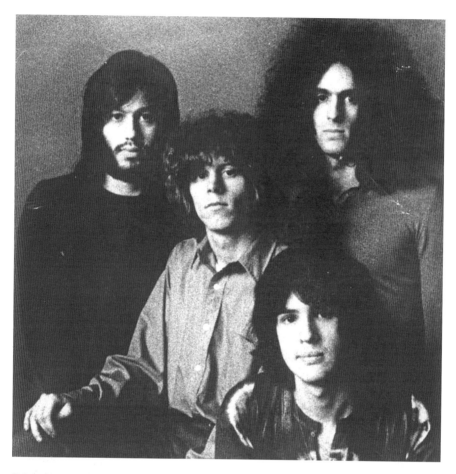

Pulse, the second version of the band: (*left to right*) Peter Neri, Harvey Thurott, Beau Segal and Paul Rosano. *Courtesy of Paul Rosano.*

Donnell, Jeff Porter and Paul Rosano. Pulse played its first gig at Watertown's Shack. During their career, the band opened for recording artists such as the Lovin' Spoonful. "Another Woman" by Pulse was written by Rosano and charted no. 52 on New Haven radio in 1969.

"My Old Boy" was a no. 52 hit in Springfield, Massachusetts. Pulse was managed by Doc Cavalier, owner of Syncron Recording Studios (later called Trod Nossel). The group disbanded at the very end of 1970. After Pulse, Paul Rosano joined the Connecticut band Napi Browne. Eventually, Rosano, Segal and Neri formed the band Island. The original Pulse album has recently been remastered and includes bonus tracks. Pulse was a very popular blues-rock group, known for live performances and rock album compositions.

A History

BILL DURSO

Billy Durso was the linchpin of the Hartford music scene. He was a jazz guy who could also play guitar like Hendrix or Santana. A great talent and an amazing, amazing guitar player.
—Christine Ohlman

Bill Durso was a talented and innovative musician, songwriter, composer and guitarist who had a profound influence on the Connecticut music arena, particularly in Hartford.

Durso was the lead singer and guitarist for the Connecticut band US69 (previously known as the Mustard Family). The US69 band members consisted of Bill Durso (lead vocals, guitar, songwriter, arranger), Don DePalma (piano, trumpet), Bob DePalma (sax), Bill Cartier (drums) and Gil Nelson (bass, flute). US69's album *Yesterday's Folks*, released in 1969, is a mix of psychedelic rock, eastern sitar music, jazz, funk and soul. US69 recorded at Wallingford's Syncron Studios. Durso was also a composer and arranger for many other rock, blues and jazz bands.

Bill Durso was a native of Hartford, Connecticut, and a graduate of East Hartford High School.

Bill Durso. *Courtesy of Ray Zeiner.*

Connecticut musicians (*left to right*) Phil Gallupe, Bill Durso, Richard Delorso and David Stolz. *Courtesy of Ray Zeiner.*

NORTH ATLANTIC INVASION FORCE (NAIF)

The North Atlantic Invasion Force (aka NAIF) was formed in West Haven, Connecticut, in 1964 by lead singer-songwriter George Morgio. A number of the group's songs were hits on the local charts in Connecticut, and a few were regional hits. The NAIF's biggest song was "Black on White," recorded in 1966 and released in 1968. "Black on White" became the no. 1 song in parts of Connecticut (e.g., WAVZ). It appeared on the national music charts and was successful in a number of different markets in the United States (no. 2 song in Flint, Michigan, a popular tune in Detroit, parts of Kentucky and so on). The song was even played on the nationally televised show *American Bandstand*. NAIF was the opening act for many major recording bands.

THE FLARES

The Flares were a rock cover band formed in 1964 by Mario Infanti in the Town Plot section of Waterbury, Connecticut. The band played mainly

A History

Left: Ray Lamitola of the Flares. *Courtesy of Ray Lamitola.*

Below: The Flares (*left to right*) Ron Migliarise, Carmen Farino, Ray Lamitola and Mario Infanti, 1966. *Courtesy of Ray Lamitola.*

in clubs in the Waterbury area. The band consisted of Mario Infanti (lead guitar, vocals), Ray Lamitola (rhythm guitar, vocals), Carmen Farino (drums) and Ron Migliarise (bass). After the Flares dissolved in 1967, Ray Lamitola joined the band South Michigan Avenue.

SOUTH MICHIGAN AVENUE

I'm just a typical small-time musician. I guess my story is similar to many many others throughout the United States who wanted to play in a band just for the love of it. I started a long time ago, went through a lot of phases, worked hard at it, played with a lot of good musicians and loved doing it. I always considered myself to be a decent musician. I never thought I was in the same category as some of the greats from our state and never pretended to be anything other than what I am. I'm just proud to be among the many thousands of good musicians that came out of Connecticut.
—*Ray Lamitola*

South Michigan Avenue was a rock band formed in Waterbury, Connecticut, by Jerry Rorabach. Previously known as the Metones, the band was renamed after the song by the Rolling Stones. The group's touring area was mainly New York and Connecticut. The band once opened for the Chambers Brothers and the Happenings. South Michigan Avenue was a popular cover band known for fine renditions of songs by groups like Grand Funk Railroad, Santana and CCR. Band members Jerry Rorabach, Ray Lamitola and Thom Serrani attended Sacred Heart University in Fairfield, Connecticut. Years later, Serrani became the mayor of Stamford, Connecticut.

Over the years, the band members included Jerry Rorabach (founding member, drums), Ray Lamitola (lead guitar, vocals), Thom Serrani (vocals), Joe Mullen (bass) and Ray Garbitini (keyboards). Also, Carmen Farino, formerly of the Flares, replaced Rorabach on drums, and Peter Kucas (keyboards) replaced Garbitini.

For a complete interview with Ray Lamitola of the Flares and South Michigan Avenue, see Appendix B.

Opposite, top: Ray Lamitola of South Michigan Avenue. *Courtesy of Ray Lamitola.*

Opposite, bottom: South Michigan Avenue. *Courtesy of Ray Lamitola.*

A History

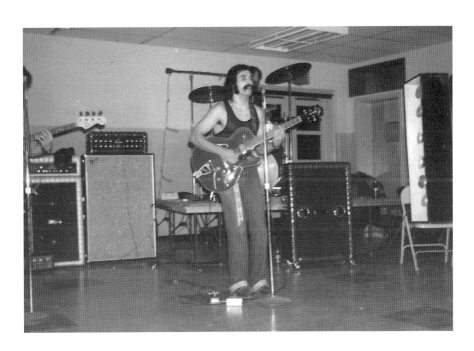

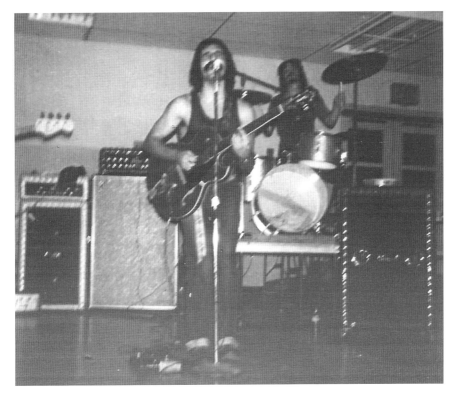

YESTERDAY'S CHILDREN

Yesterday's Children (aka the Children) hailed from the Cheshire, Prospect and Waterbury, Connecticut areas and formed in 1966. The band's music style was garage rock, psych and hard rock. The 1966 single "To Be or Not to Be" was very popular in Connecticut and a Top 40 hit on major Connecticut radio stations (WPOP, WWCO and more). The tune charted no. 41 on WWCO's Top 100 songs for 1967. The recording also did well in several other markets (Top 30 hit in Flint, Michigan).

The band's self-titled *Yesterday's Children* album received very good reviews. The Children's single and album are viewed by some as cult classics, especially in the garage/punk circles. "To Be or Not to Be" also appeared on the compilation album *Psychedelic Unknowns Volume 2*. Yesterday's Children regularly played at music venues in Connecticut, such as Seymour's Actors Colony (1967). The group disbanded in 1969.

ART DENICHOLAS

A native of New Haven, Connecticut, Art DeNicholas has had a long and impressive career in the music business.

Early on, DeNicholas was in a group called the Emeralds. He then co-founded a group with Tommy Juliano called the Hill Aces. (The name references the section of New Haven where they lived, known as the Hill.) DeNicholas and Juliano were classmates at New Haven's Hillhouse High School.

In 1957, while still in school, DeNicholas and Juliano formed the Catalinas (aka the Buddies). At the end of 1963, DeNicholas and Juliano formed the Van Dykes (aka the Van Dyke Five) in New Haven, Connecticut. The group's music style was similar to the Four Seasons. The Van Dykes were extremely popular in the Connecticut area. They were the only Connecticut group to have three no. 1 songs in New Haven. The Van Dykes appeared on the same bill as the Shags and Fred Parris and the Restless Hearts in 1966 at the Teen Tempo '66 show in Milford, Connecticut. The group also performed at other Connecticut music venues, such as Seymour's Polynesian Room (1967).

Later on, DeNicholas became the manager of the 1960s West Haven band Bridge. Also, Art DeNicholas and Jerry Greenberg formed the Green Sea record label.

A History

Above: Van Dykes' "Again and Again" charting at no. 8, July 9, 1965. *Author's collection*.

Left: "Love Is There" by Bridge, charting at no. 1, June 27, 1970. *Author's collection*.

THE DOWN BEATS

The Down Beats were a very popular 1960s R&B/soul group from Hartford, Connecticut. The group charted in the Top 40 on local Connecticut radio stations (no. 29 on WDRC).

BRIDGE

West Haven's Bridge was best known for their local hits "It's a Beautiful Day" and "Love Is There." The song "Love Is There" was a no. 1 hit on local radio (WAVZ). Much of the

band's original material was written by group members Dennis D'Amato and Charley Claude. Bridge recordings took place at Wallingford's Trod Nossel Studios.

The manager of Bridge was Art DeNicholas, the co-founder and group member of the bands the Van Dykes and the Catalinas.

Bridge was popular in the New England region. The group opened for the Young Rascals at the New Haven Arena and also performed on Brad Davis's TV show in Hartford, Connecticut. Bridge broke up in 1971. Paul Tortora of Bridge went on to become West Haven Schools superintendent.

THE REMAINS

The Remains was an extremely popular rock band and had a very impressive history. Among the members' many accomplishments were opening for the Beatles, performing on *The Ed Sullivan Show* and appearing on the national *Hullabaloo* TV show.

Three members of the Remains were Connecticut residents: Barry Tashian (Westport), Bill Briggs (Westport) and Rudolph "Chip" Damiani (Waterbury). The fourth original group member was New Jersey's Vern Miller. Later on, N.D. Smart replaced Damiani. Tashian graduated from Westport's Staples High School in 1963. Bill Briggs also attended Staples High School and graduated in 1964. The band actually formed in Boston, Massachusetts, while attending Boston University.

BILLY JAMES

Billy James was born Bill Nosal in Glastonbury, Connecticut. James was a 1963 graduate of Glastonbury High School (Hubbard Street, Glastonbury, Connecticut).

In 1961, sixteen-year-old Billy James wrote and recorded "My Prayer." The song was released by Billy James and the Stenotones (aka Billy and the Stenotones). The record did very well on New England charts, staying on the charts for thirteen weeks and peaking at no. 2. The Stenotones consisted of several Connecticut female singers.

In 1962, "Meant for Me" and its B side "It's the Twist" was recorded by Billy James and the Crystal Tones. The Crystal Tones were a doo-wop vocal harmony group from New Britain, Connecticut.

A History

James was also a member of the Connecticut band the Reveliers. In 1964, the Reveliers released the rocking instrumentals "Part III" and "Maureen." The band was led by Jerry Crane (guitar) and Billy James (organ). The Reveliers instrumentals were recorded at the Al Soyka Studios in Somers, Connecticut.

Billy James appeared on *Connecticut Bandstand* and the *Brad Davis Show*. In the '70s, James began using his real name (Bill Nosal) when he was an on-air radio personality for a few Connecticut radio stations and then program director for Hartford's WCCC radio station.

ME AND THE REST

Me and the Rest's "Mark Time." *Author's collection.*

Me and the Rest was a 1960s garage rock band from Waterbury, Connecticut. Band member Lou Laudate graduated from Waterbury's B.W. Tinker Elementary School and was a 1968 graduate of Kennedy High School (Waterbury). He also attended Waterbury's Mattatuck Community College.

The group recorded on the Brass City Record Label. (Brass City is the nickname for Waterbury, Connecticut.) "Mark Time" is a garage/rock recording. The flip side, "Dark Clouds," is a slow, soft ballad.

"Dark Clouds" by Me and the Rest charted at no. 75 on Waterbury's Top 100 for 1967. The song was played often on WWCO, as well as on other local stations.

TOMMY AND THE RIVIERAS

Tommy and the Rivieras were founded by Tommy Janette in 1963 in West Haven, Connecticut. In 1965, the band toured with the Beach Boys and appeared on the Dick Clark Cavalcade of Stars. They have performed throughout the United States and have appeared with many top recording acts. Their song "Do I Love You," co-written by Janette, charted in the Top 40 in Connecticut.

Connecticut Rock 'n' Roll

THE SATURDAY KNIGHTS

"Ticonderoga" by the rock band the Saturday Knights was a Top 20 song in Connecticut (no. 20 on WDRC) and also a Top 20 tune in Canada (no. 19 in Vancouver). The song fared very well in other U.S. markets, such as Cleveland. "Texas Tommy" was a Top 40 tune in Connecticut (no. 35 on WDRC).

The band also recorded under the group name Van Trevor and the Saturday Knights. "Satisfaction Is Guaranteed" by Van Trevor and the Saturday Knights (recorded in 1964) was a Top 20 hit in Connecticut and in several other parts of the United States (no. 12 on WDRC in Hartford and no. 11 on WGH in Virginia). Van Trevor was the stage name of singer-songwriter Robert "Bob" Boulanger. Van Trevor also wrote and recorded many songs as a solo artist. He performed and recorded in various music genres (rock 'n' roll, rockabilly and country). "Christmas in Washington Square" by Van Trevor was a Top 20 song in Connecticut (no. 20 on WPOP). "I Want to Cry" was a Top 40 hit in several markets (West Springfield's WSPR).

The Saturday Knights backed up Freddy "Boom Boom" Cannon on his song "Buzz Buzz A-Diddle It." Also, the Saturday Knights backed up Connecticut's Rick Sheldon on his song "Why Does My Baby Cry."

The Saturday Knights formed in New Britain, Connecticut. The band was previously known as the Joy Riders. Band members were from New Britain, Southington and Meriden.

THE SQUIRES

The Squires were a garage rock band that formed in Bristol, Connecticut, in 1965. Three of the band members were 1965 graduates of Bristol Eastern High School. Another member graduated from Torrington High School in 1965. The group's 1966 recording of "Going All the Way" appeared on a compilation of garage rock recordings titled *Pebbles, Volume 1*. "Going All the Way" charted on Connecticut radio stations (no. 58 on WPOP). The Squires had a loyal following in the local area.

A History

TOMMY DAE

Singer-songwriter Tommy Dae (born Frank Draus Jr.) performed in a variety of music genres, including rock, pop, ballads, garage rock, novelty, country and psych rock. Dae recorded with his groups the High Tensions (aka the Tensions), the Tensionettes and the Nite Niks. The Tensionettes consisted of Annette Lettendre and Linda Draus (Tommy's sister). The ballad "It Was a Lie" received airplay on local radio stations. The flip side, "You Made Me Cry," was a Top 40 song by the Tensionettes on several radio stations in Connecticut.

Dae also recorded as a solo act. "Find a Little Happiness" appeared on Connecticut radio stations (a "bubbling under" tune on WPOP). He and his groups have recorded on several Connecticut record labels, including Vernon's Hitt and East Hartford's South Sea. Tommy Dae and his groups were popular on a local basis, receiving good airplay on Connecticut radio stations. They also fared well in other U.S. markets such as the Philadelphia/Reading, Pennsylvania areas. Tommy Dae hailed from the Rockville/Vernon area.

4
IT'S STILL ROCK 'N' ROLL TO US

1970–1979

DECADE HIGHLIGHTS
Kent State • Watergate • the Beatles break up • first mobile phone call • Elvis dies • Iran hostages • former Beatles' solo albums • progressive rock

In the 1970s, music took a number of twists and turns. The decade began with the public announcement that the Beatles had disbanded in 1970. The rock world was stunned that same year by the death of Jimi Hendrix on September 18. Just sixteen days later came news of the untimely death of Janis Joplin on October 4, 1970. The following year, we learned of the death of former Doors lead singer Jim Morrison (July 3, 1971). Tragically and ironically, all three of these iconic figures—Hendrix, Joplin and Morrison—died at the tender age of twenty-seven.

Carole King released her groundbreaking album *Tapestry* on February 10, 1971. The early 1970s were dominated by soft rock music, followed by the disco movement. Bob Marley introduced reggae/rocksteady music to a worldwide audience. The decade also featured the popularity of progressive rock and arena rock. All four former Beatles released solo albums during the 1970s. Finally, the rock world was shocked once again with the news that "The King" (Elvis Presley) had died.

A History

CONNECTICUT NATIONAL/INTERNATIONAL HIT MAKERS

MICHAEL BOLTON (MICHAEL BOLOTIN)

Singer-songwriter Michael Bolton was born Michael Bolotin in New Haven, Connecticut. Bolton's father, George, and mother, Helen, were also born in New Haven. As a boy, he lived with his family in several New Haven locations, including homes on Whalley Avenue, Elm Street and Ella Grasso Boulevard.

Prior to becoming the singing sensation known to millions of his loyal fans, Bolton was very active in the New Haven music scene. At a very early age, Bolton began composing songs. As a teenager, he performed and recorded as a solo artist under his given name Bolotin. He then became a member of a garage rock group called Joy, under the name Bolotin. "Bah Bah Bah" by Joy was a Top 40 hit in Connecticut. Bolotin (Bolton) was also the lead singer of the heavy metal band known as Blackjack. "Love Me Tonight" by Blackjack was a Top 20 hit on Buffalo's WYSL radio station and in several other markets. Recordings took place at Wallingford's Trod Nossel studios (formerly Syncron). The band opened for major artists, such as Peter Frampton. Blackjack performed in various music venues in the New Haven area, such as the legendary Toad's Place (previously known as Hungry Charlie's), located on York Street in New Haven, Connecticut.

Bolton went on to become the rock/soul icon Michael Bolton. Bolton has sold over seventy-five million records and won numerous impressive awards, including Grammys.

There is somewhat of a connection between Michael Bolton and the very popular 1960s band the Shags. Michael's older brother Orrin was a roadie for the Shags, and Orrin introduced Michael to the band. Allegedly, Carl Augusto/Donnell (a member of the Shags) helped teach young Michael how to play the guitar.

MEAT LOAF

Meat Loaf, one of the bestselling music artists of all time, lived in Connecticut from 1979 to 1988 (Stamford, Westport, Redding). During that time, the singer released five albums and twenty-one singles and had six major tours. Also, during this period, Meat Loaf appeared in six feature films and was involved in three TV shows (including a *Saturday Night Live* musical guest appearance).

Meat Loaf is the stage name of Michael Lee Aday (born Marvin Lee Aday). He is probably best known for his monster *Bat Out of Hell* album trilogy consisting of *Bat Out of Hell*, *Bat Out of Hell II: Back into Hell* and *Bat Out of Hell III: The Monster Is Loose*.

Meat Loaf's recordings charted very well on Connecticut radio charts, especially "Two Out of Three Ain't Bad," which was a no. 1 hit in Connecticut (WAVZ).

PETER McCANN

Singer-songwriter Peter McCann was born and raised in Bridgeport, Connecticut. He attended Fairfield University in Fairfield, Connecticut. In 1966, he and another freshman student, Jim Honeycutt, formed a folk/country rock group called the Repairs. The group also featured Mike Foley from Enfield, Connecticut (also a Fairfield University student); Larry Treadwell from West Haven, Connecticut (a fellow Fairfield student); Timothy "Ace" Holleran from Bridgeport; and Sukie Honeycutt. The Repairs were well known for their live performances in the local Fairfield County area, including a well-received 1971 concert on Westport's Jesup's Green.

In 1974, McCann left the Repairs to concentrate on songwriting. He achieved fame in 1977 when two of his songs became major hits. First, "Right Time of the Night" (written by McCann) became a Top 10 hit for Jennifer Warnes. It was also a Top 20 hit on Connecticut local radio stations (no. 17 on WDRC). Then, "Do You Wanna Make Love" (written and sung by McCann) was a *Billboard* Top 5 song and an international hit. The tune also was a Top 20 hit in Connecticut (no. 11 on WDRC). Numerous major artists have recorded McCann's songs.

LOCAL/REGIONAL HIT MAKERS AND FAN FAVORITES

FAMINE

Famine was composed of former members of the Steam tour band along with a few other musicians.

The no. 1 hit song "(Na Na Hey Hey) Kiss Him Goodbye" was written and recorded by Paul Leka, Gary DeCarlo and Dale Frashuer. Once the

tune became a smash hit, a group needed to be assembled to promote the record and tour as a band known as Steam. Six Connecticut musicians were hired to tour as the Steam band.

The group consisted of Bill Steer (lead singer), Jay Babins (guitar), Mike Daniels (bass), Ray Corries (drums), Tom Zuke (guitar) and Hank Schorz (keyboards). Prior to touring as Steam, the six band members had performed as a group under the name the Special Delivery. The Special Delivery played on a local basis in the Bridgeport, Connecticut area (the Bridgeport Armory). The group members of the Steam tour band were all graduates of high schools in Stratford and Bridgeport, Connecticut. Steer, Babins, Corries, Zuke and Schorz graduated from Bunnell High (Stratford), while Daniels graduated from Warren Harding High School (Bridgeport). As noted in the *Bridgeport Post* newspaper, the six members of the Steam tour band previously held jobs in various parts of Connecticut. Schorz was a junior physicist at a laboratory in Stamford, Babins had a job in advertising, Corries was a drum teacher at Bob Weller/LeDonne's Music Box in Bridgeport, Daniels was a manager at Bob Weller/LeDonne's Music Box, Steer worked in a laboratory in the Springdale area of Stamford and Zuke worked for a fish place in the Bridgeport area. The Steam tour band appeared on various TV shows, most notably Dick Clark's *American Bandstand*. Clark displayed Steam's gold record on his podium during the band's performance. The Steam tour band performed at Connecticut music venues, including the Candlelite in Bridgeport, Connecticut. The band's music style differed greatly from that of the hit single "(Na Na Hey Hey) Kiss Him Goodbye." Eventually, most of the group members (along with a couple of new members) formed a new rock band known as Famine.

JASPER WRATH

Jasper Wrath was an extremely popular progressive rock band in the New Haven area. The 1975 song "You" was written by band members Jeff Cannata and Michael Soldan—a no. 1 song in the New Haven region. "Did You Know That" also charted well in the New Haven region.

Jasper Wrath formed in 1969 in Hamden, Connecticut. The band was founded by Cannata and Robert Giannotti. The other original members of the band were Soldan and Phil Stone. Also joining the band were James Christian, Scott Zito and Jeff Batter. Jasper Wrath disbanded in 1976.

After the dissolution of Jasper Wrath, Cannata and Soldan formed the band Arc Angel. Cannata left Arc Angel to pursue a solo career. Band members Christian, Batter and Stone formed the Connecticut band Eyes. Christian then left Eyes to become a member of the rock/metal band House of Lords. Zito recorded with and wrote songs for Grace Slick and other artists.

MIDNITE MOVERS

The Midnite Movers were an R&B/soul band from Windsor, Connecticut. The group was founded by Windsor's Ralph DeLorso Jr. in 1968. DeLorso was a 1972 graduate of Windsor High School. The Midnite Movers appeared on Brad Davis's dance show in 1969. The band released six songs and recorded at Wallingford's Syncron Studio and studios in New Haven and Hartford. The band toured throughout the Northeast. The Midnite Movers disbanded in 1971. DeLorso went on to study advanced music theory at Berklee School of Music (1979–83).

NAPI BROWNE

Napi Browne was a hard rock band formed in New Haven, Connecticut, in 1976. The band included North Haven's singer-songwriter Paul Rosano, who was previously a member of two popular Connecticut bands: Bram Rigg Set and Pulse. Band members included Rosano (bass, vocals), Vic Steffens, (drums, background vocals), Nick Bagnasco (guitar, vocals) and Dan Gulino (guitar, background vocals). Steffens is the brother of rocker Christine Ohlman.

Napi Browne performed at numerous music venues in Connecticut, including New Haven's legendary Toad's Place. The band's touring area included New England and New York. Napi Browne recorded tunes at Paul Leka's Studios in Bridgeport, Connecticut. Songwriters for the band included Rosano, Bagnasco and Gulino. Their song "Let's Get Right to It" was a track on WHCN's *Homespun* album (1980).

Napi Browne was a very popular band in the late 1970s and early 1980s.

A History

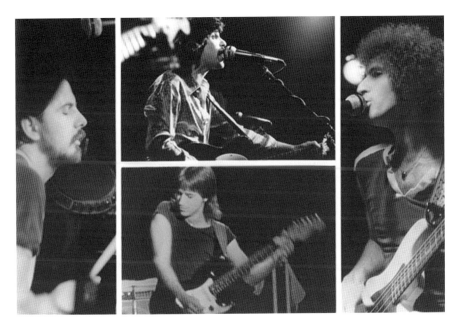

Bagnasco (*top*), Gulino (*bottom*), Steffens (*left*) and Rosano (*right*). *Courtesy of Paul Rosano.*

SIMMS BROTHERS

In 1979, the very popular New Haven radio station WPLR conducted a poll of its listeners to determine the best band in Connecticut. The Simms Brothers Band was voted Connecticut's number one act. The group's self-titled album did well on the East Coast (no. 18 on Boston's radio station WBCN). The band performed at various Connecticut music venues, such as Westport's Players Tavern (1976). The Simms Brothers formed in 1976 in Stamford, Connecticut.

STONEHENGE

"Tragedy" by the rock band Stonehenge was a Top 40 hit on radio stations in the Waterbury, Connecticut area (WWCO). The song was recorded on Watertown's Damsl Record Label. "Tragedy" along with "Gone" (side B) were written by Stonehenge band members Mario DiMichele, Lee Ingala, Ed Aureli, Russ Martinsen, Mickey DiMichele, Fred Lanosa and Jim Stone. Stonehenge performed in numerous local venues, including

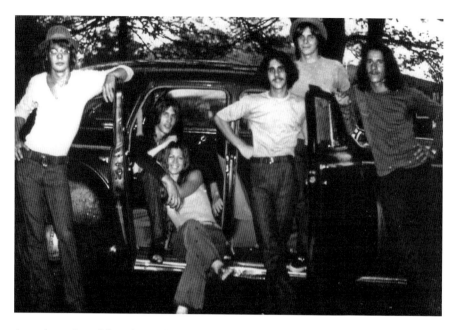

An early version of Stonehenge, including vocalist Tony Renzoni (*second from right*), the author's cousin. *Used with permission. Courtesy of Tony J. Renzoni.*

Gugie's Supper Club on West Main Street in Waterbury, Connecticut. Stonehenge formed in Waterbury in the 1970s and was popular on a local basis. There were several personnel incarnations of the band.

5
KEEP ON ROCKIN' IN THE USA

1980s TO PRESENT

DECADE HIGHLIGHTS
John Lennon's assassination • Princess Diana's death •
the Y2K scare • Internet boom • Facebook • 9/11 •
Chicago Cubs end 108-year drought • George Harrison's death

From 1980 to the present, the music world has seen a wide variety of music styles and events. The 1980s began tragically with the John Lennon assassination on December 8, 1980. Two years later, Michael Jackson released his critically acclaimed album *Thriller*. The rap and hip-hop music styles rose in popularity. Notable music events during this period include concert tours by Paul McCartney, the Rolling Stones, Bruce Springsteen, Elton John and Billy Joel. In 2016, Bob Dylan received the Nobel Prize for Literature. After six decades, rock music is alive and well.

NATIONAL/INTERNATIONAL HIT MAKERS

TINA WEYMOUTH AND CHRIS FRANTZ

Tina Weymouth and her husband, Chris Frantz, have been longtime residents of Fairfield, Connecticut. Tina, Chris and David Byrne formed the new wave band Talking Heads in 1975. The Talking Heads consisted of Byrne (lead vocals, guitar), Weymouth (bass) and Frantz (drums). Jerry

Connecticut Rock 'n' Roll

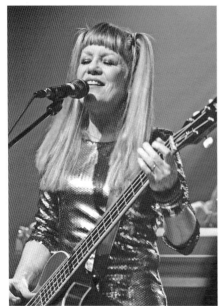
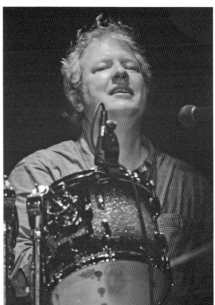

Left: Tina Weymouth. *Courtesy of Billy Green.* *Right*: Chris Frantz. *Courtesy of Billy Green.*

Harrison (keyboards, guitar) joined the group in 1977. The band was very influential in defining the new wave sound and achieved international success in the 1970s and '80s.

The extensive list of accolades for the Talking Heads is impressive. In 2002, the band was inducted into the Rock and Roll Hall of Fame. *Rolling Stone* magazine has included the Talking Heads in its lists of greatest rock bands, greatest albums and songs that shaped rock 'n' roll.

Even before the Talking Heads disbanded, Weymouth and Frantz formed the new wave band Tom Tom Club in Greenwich, Connecticut, in 1981. The Tom Tom Club has recorded numerous singles, as well as (studio and live) albums. "Wordy Rappinghood" (1981) by the Tom Tom Club achieved international success (no. 1 U.S. Dance, no. 1 Belgium, no. 2 Netherlands, no. 3 Spain, no. 7 United Kingdom and so on). "Genius of Love" (1981) was a no. 31 *Billboard* hit (and also an international hit). Also, the Tom Tom Club's version of "Under the Boardwalk" (1982) and "The Man with the Four Way Hips" (1983) were international hits.

Chris Frantz has been a programmer at radio station WPKN in Bridgeport, Connecticut, for over three years. The name of his radio show is *Chris Frantz the Talking Head*.

A History

CHRISTINE OHLMAN, "THE BEEHIVE QUEEN"

Whatever I am and whatever I have become as a musician is the sum total of all the different musical influences that I have absorbed in my life.
—Christine Ohlman

Singer, songwriter and guitarist Christine Ohlman has called Connecticut her home for many years. She attended Notre Dame Academy in Waterbury, Connecticut. Her brother, Vic Steffens, went to Cheshire Academy.

Nicknamed the "Beehive Queen," Ohlman has been involved in a number of bands and projects in her career. Her music genre is mainly soul and R&B.

When she was only sixteen years old, Ohlman, then a high school student, was a member of a New Haven, Connecticut blues/rock band called the Wrongh Black Bag. Ohlman was the band's lead singer, and her younger brother, Vic, was the group's drummer. Ohlman's next band that she and Vic formed was called Fancy. They released an LP album, *Fancy Meeting You Here*, and a 45rpm, *All My Best*, on the Poison Ring record label. The band recorded at Thomas "Doc" Cavalier's Trod Nossel Studios (formerly Syncron). Later, Steffens joined the Connecticut band Napi Browne. He also formed his own recording studio.

Once Fancy disbanded, Ohlman formed the Scratch Band, which was very popular in the Northeast, most notably their live performances. The Scratch Band included famed Hall & Oates and *SNL* guitarist G.E. Smith along with New Haven's drummer-vocalist Mickey Curry. Curry has worked with a number of major stars, including Hall & Oates, Bryan Adams, David Bowie, the Cult and Alice Cooper. After the Scratch Band, Ohlman founded the group Christine Ohlman and the Soul Rockers.

In 1991, Ohlman reunited with G.E. Smith when she joined the Saturday Night Live Band as the lead singer.

Ohlman currently is the lead singer of Christine Ohlman and Rebel Montez. Christine has recorded six CDs with Rebel Montez and toured throughout the Northeast with the band. She has also performed with several other bands, including an all-star band at Cleveland's Rock & Roll Hall of Fame, the NYC Hit Squad and the Decoys, in Muscle Shoals, Alabama.

Two of the studios in which Ohlman has recorded her music are located in Connecticut. One studio belongs to her brother, Vic Steffens (Horizon Music Group in West Haven). The other studio belonged to her longtime mate "Doc" Cavalier (Trod Nossel Studios in Wallingford). Ohlman has

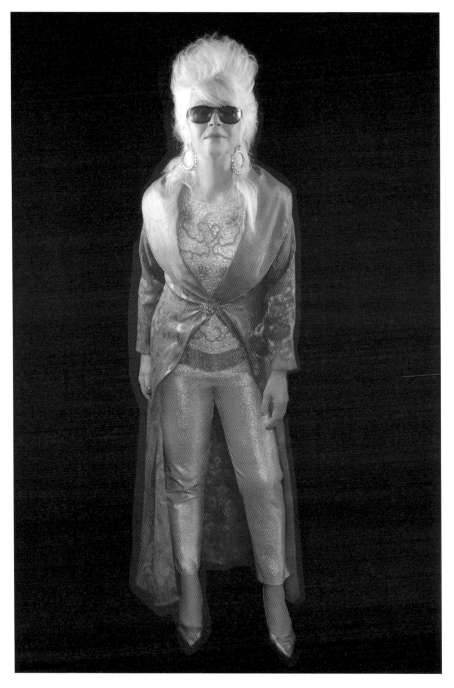

Christine Ohlman. *Photo by Irene Liebler and Sandy Connolly at Super9Studios.com.*

been backed up by the Sin Sisters when performing in Connecticut shoreline towns.

Christine Ohlman, along with her band the Wrongh Black Bag, opened for the Wildweeds very early in her career. Things came full circle when Christine performed with a reunited Wildweeds band in their 2011, 2014 and 2015 concerts. She sang the harmony parts of the Wildweeds' bassist Bob Dudek.

Christine Ohlman is an iconic musical artist and performer, especially in the Northeast and her two "second musical homes" in New Orleans and Muscle Shoals. Christine is working on an album called *The Grown-Up Thing*.

For more information about Christine Ohlman and her recordings see christineohlman.net.

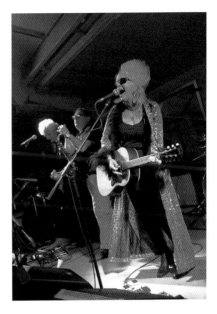

Christine Ohlman in concert. *Courtesy of Melissa Mathers and Madison Beach Hotel.*

For a complete interview with Christine Ohlman, see Appendix B.

DENNIS DUNAWAY

The power of music—for people to associate it with their youth—is a forever thing.
—Dennis Dunaway, co-founder of the Alice Cooper Band

Connecticut's Dennis Dunaway was inducted into the Rock & Roll Hall of Fame in 2011 as a founding member of the band named Alice Cooper. Dennis also won a Grammy for co-writing "School's Out." The original Alice Cooper group sold millions of singles and albums and was on the cover of *Forbes* for having the largest grossing tour in 1973 over Led Zeppelin and the Rolling Stones. The *Billion Dollar Babies* album (recorded in Greenwich, Connecticut) reached no. 1 in America and Britain, and the group is recognized as the innovators of theatrical rock shows, which included giant balloons, hangings, snakes and spidery eye makeup. The group's movies are *Diary of a Mad Housewife*, *Good to See You Again: Alice Cooper* and *Super Duper*

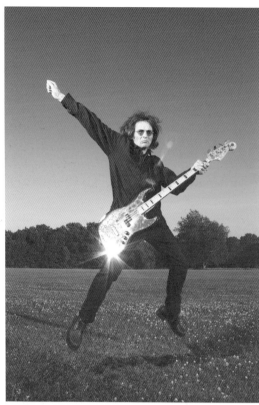

Left: Dennis Dunaway. *Copyright Len DeLessio, www.delessio.com.*

Below: The original Alice Cooper band (*left to right*) Neal Smith, Michael Bruce, Alice Cooper and Dennis Dunaway (co-founder). *Copyright Len DeLessio, www.delessio.com.*

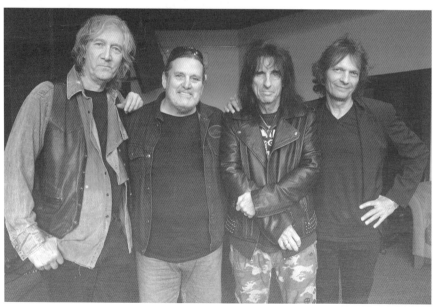

A History

Max Creek. *Courtesy of JMS Art & Photo.*

In 1972, fifteen-year-old guitarist Scott Murawski joined Max Creek. Murawski is not only a great guitarist but also an accomplished drummer and pianist. It was Scott's involvement in the Creek that encouraged the band to change musical direction and move into the rock genre. Moreover, Murawski is the lead guitarist of Mike Gordon's solo band. (Gordon was the founder and bassist of the band Phish.) Max Creek had

a great influence on Phish, and Gordon has regarded the Creek as one of his favorite bands.

The Creek was the recipient of the 2015 Connecticut Music Award for "Best Jamband." Max Creek has a very loyal fan base.

JOSÉ FELICIANO

There's so many great musicians in Connecticut.
This state has a tremendous history.
—José Feliciano

International recording star José Feliciano has been a resident of Connecticut since 1990. He currently resides in Weston, Connecticut. Feliciano's achievements include forty-five Gold/Platinum records, nineteen Grammy nominations and nine Grammys.

His rendition of "Light My Fire" reached no. 3 in the United States (and no. 1 in Canada and the United Kingdom). The song was a major hit on Connecticut radio stations. Feliciano's "Feliz Navidad" has become a holiday classic. During the time he has been a Connecticut resident, Feliciano has recorded over twenty singles and albums in English and Spanish.

Feliciano has performed in various Connecticut music venues, including Wallingford's Oakdale Theatre (July 1–5, 1969).

On January 16, 2014, José Feliciano was one of ten famous Connecticut musicians honored by the Fairfield Museum & History Center at an event referred to as Fairfield's Rockin' Top 10. In a *Connecticut Post* article by Scott Gargan on March 27, 2014, Feliciano was asked how it felt to be celebrated as one of the region's most influential musicians (as one of Fairfield's Rockin' Top 10). José Feliciano responded, "It's a wonderful thing. I never thought I'd be included. There's so many great musicians in Connecticut. This state has a tremendous history."

JOHNNY WINTER

Blues legend Johnny Winter was a guitarist, singer, songwriter and producer who moved to Easton, Connecticut, in 1999. He lived in Easton for fifteen years prior to his death in 2014. During the period that Winter lived in Connecticut, he released nine albums (studio and live) and seven compilation

A History

Johnny Winter. *Photo by Tom Williams (CC BY 2.0).*

albums. In 2003, Winter was recognized by *Rolling Stone* magazine as one of the greatest guitarists in the United States. In 2004, his *I'm a Bluesman* album received a Grammy nomination. And in 2015, *Step Back*, released posthumously, won the Grammy for "Best Blues Album."

Winter is probably best known for his electrifying live performances and his high-energy blues/rock albums. Johnny Winter performed for over an hour on Day 3 of the original Woodstock Festival in 1969. At Woodstock, he performed such songs as his amazing "Mean Town Blues" and "Tobacco Road" (with his brother Edgar Winter as lead singer). During his incredible career, Winter recorded nearly thirty studio and live albums and earned numerous Grammy nominations (plus a 2015 posthumous Grammy Award). He also produced three Grammy Award–winning albums for the legendary Muddy Waters. In 1988, he was inducted into the Blues Foundation Hall of Fame. Recognized as one of the all-time great slide-guitar players, Winter collaborated with such guitar legends as Jimi Hendrix, B.B. King and Eric Clapton. He also performed numerous times with his close friend Janis Joplin.

A number of his albums and singles have charted on *Billboard*. Some recordings have also charted well in various local markets throughout the United States. For example, "Rock and Roll, Hoochie Koo" charted no. 7 on

San Jose's KLIV in 1970, and "Jumpin Jack Flash" reached no. 7 in 1971 on Erie, Pennsylvania's WJET. In Connecticut, "Eternally" charted at no. 57 in 1964, his album *Live/Johnny Winter And* charted no. 15 and his *Still Alive And Well* album charted no. 4.

Johnny Winter is buried in Easton, Connecticut, at Union Cemetery.

THURSTON MOORE

Singer, songwriter and guitarist Thurston Moore moved with his family to Bethel, Connecticut, when Thurston was nine years old. He and his family lived on Codfish Hill in Bethel. He spent his childhood and high school years in Connecticut. Moore attended St. Joseph School in Danbury but then transferred and graduated from Bethel's St. Mary Elementary School. At a very early age, Thurston was involved in social activities in and around the Bethel area. According to the May 12, 1970 edition of the *Bridgeport Post*, fifth grader Thurston Moore volunteered to clean up a park at the intersection of Codfish Hill and Wolfpits Road as part of Bethel's "Operation Clean Up" initiative. He was also a Cub Scout at the time. According to the July 1, 1971 edition of the *Bridgeport Post*, Thurston participated in a St. Mary

Thurston Moore at Route du Rock, August 2007. *Photo by Wikicommons contributor Bertrand (CC BY 2.0).*

School project in which he helped produce a film on the drug problems in and around Bethel.

Thurston then attended and graduated from Bethel High School, class of 1976. It was in high school that Thurston developed his musical tastes and passion for rock 'n' roll. His high school yearbook writeup referred to him as a "rock & roll animal." Thurston applied and was accepted to Danbury's Western Connecticut State University (WCSU) in 1976. After spending a semester at WCSU, Moore moved to New York City, where he became actively involved in the progressive rock music scene there.

In 1981, Moore formed the alternative rock band Sonic Youth along with Kim Gordon and Lee Ranaldo. Thurston and Kim married in 1984. Sonic Youth consisted mainly of Moore (singer, songwriter, guitarist), Gordon (vocals, bass guitar) and Ranaldo (guitar, vocals). Over the years, other members of Sonic Youth have been Steve Shelley, Richard Edson, Mark Ibold, Anne DeMarinis, Bob Bert, Jim O'Rourke and Jim Sciavunos.

Sonic Youth disbanded in 2011. During the period between 1981 and 2011, Sonic Youth released an extensive number of singles, albums, EPs and compilation albums. Thurston Moore has been recognized several times in *Rolling Stone* magazine as one of the top guitarists in the United States.

LIZ PHAIR

Liz Phair in Seattle, Washington, *Exile in Guyville* fifteenth anniversary release at Showbox. *Photo by Flickr user Lana (CC BY 2.0)*.

Singer/songwriter Liz Phair was born in New Haven, Connecticut at Yale–New Haven Hospital (previously known as Grace–New Haven Hospital). She was adopted by Nancy and John Phair. Her adopted mother was a graduate of Wellesley College in Wellesley, Massachusetts. At the time, her adopted father was a doctor at Yale–New Haven Medical Center. Because Dr. Phair received a microbiology fellowship, it meant that the Phair family (including Liz) would need to relocate several times. Liz is unaware of her biological parents. As noted in an archived oocities.org article, Liz Phair feels that her songwriting and her music career

have been motivated by her adoption. "It [being adopted] motivates my songwriting. It gives me that free space—I've got this mental idea that I'm not really, deep-down, fully attached to anything, like that floatable world that artists create for themselves. I'm a member of that world, intrinsically."

Liz Phair is best known for her critically acclaimed indie-rock debut album *Exile in Guyville*. The 1993 album quickly became a fan favorite, especially among alternative rock fans, and eventually was certified gold in 1998. Rolling Stone included *Exile in Guyville* in its list of the top 500 albums of all time. Prior to her debut album, Phair recorded a number of songs on cassettes in 1991, using an alias (Girly-Sound). These songs became prized alternative rock bootlegs.

Phair has composed songs for film soundtracks, including *Chasing Amy* (1997), *High Fidelity* (2000), *Love & Other Drugs* (2010) and *People Like Us* (2012). Liz Phair was among VH1's 1999 list of the greatest women of rock 'n' roll.

RIVERS CUOMO

Singer, songwriter and guitarist Rivers Cuomo has a personal and musical connection to Conncticut. According to his bio (www.riverscuomo.com/bio), his mother named him after the East and Hudson Rivers near the Manhattan hospital where he was born. Soon after, the Cuomo family moved to an ashram farm in Pomfret, Connecticut (within a Hindu community referred to as Yogaville), and he attended Pomfret Community School on the ashram. The family later moved to Storrs-Mansfield (Connecticut), where Rivers attended Mansfield Middle School (public school). While at Mansfield Middle School, Rivers went under the name Peter Kitts (named after his stepfather). In eighth grade (1984), Rivers and his schoolmate Justin Fisher decided to form their own band, which they called Fury. The band Fury consisted of Rivers (guitar, vocals), his brother Leaves Cuomo (rhythm guitar), Justin Fisher (bass) and Eric Robertson (drums). After rehearsing for a few months, Fury played its first gig in the fall of 1984. According to the website www.weezerpedia.com, the first song Rivers wrote was "Fight for Your Right," and an extract of a 1984 Fury rehearsal can be heard on the "I Wish You Had an Axe Guitar" track on the album *Alone: The Home Recordings of Rivers Cuomo*.

Rivers attended E.O. Smith High School (Storrs-Mansfield), class of 1988, under the name Peter Kitts. Rivers would later use E.O. Smith as the name of his music publishing. In high school, Rivers had a role in his

A History

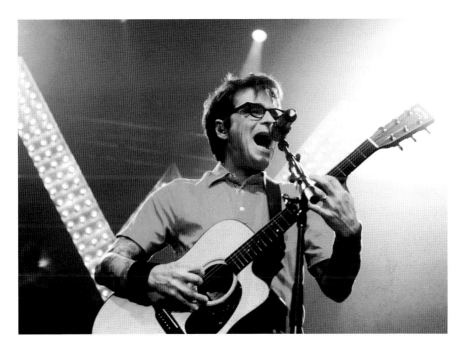

Rivers Cuomo. *Photo by Flickr user Tankboy (CC BY-SA 2.0).*

high school production of *Grease*, playing the part of Johnny Casino. At this time, Rivers and Justin formed the band Avant Garde (1985). Avant Garde consisted of Cuomo, Fisher, Michael Stanton, Kevin Ridel, Eric Ridel and Bryn Mutch. The band recorded their own songs, and they used the Cuomo house as their headquarters. For a time, Cuomo took guitar lessons from Jim Matheos of the Hartford, Connecticut band Fates Warning. According to weezerpedia.com, Stanton said that Rivers became a "rock star in the area."

In 1989, Rivers moved from Connecticut to Los Angeles along with Avant Garde, where he changed the name of the band to Zoom. Cuomo was involved in several other bands known as Fuzz and 60 Wrong Sausages. Rivers Cuomo eventually achieved international fame with his rock band Weezer (formed in 1992).

DEEP BANANA BLACKOUT

Deep Banana Blackout (DBB) grew out of a merger of two bands: Tongue and Groove and Pack of Matches. DBB formed in Connecticut's Fairfield

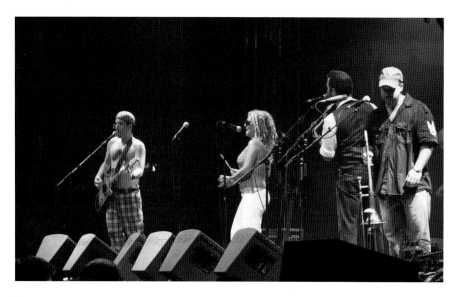

Deep Banana Blackout at Gathering of the Vibes. *Photo by Matt Tillett (CC BY 2.0).*

County in 1995. Group members hailed from Bridgeport, Fairfield and New Haven. DBB boasts a wide variety of music genres, including funk, soul, rock, jam-rock and R&B. Deep Banana Blackout has performed a number of times at Bridgeport's popular Gathering of the Vibes music festival, as well as other Connecticut music venues, such as New Haven's Toad's Place.

JOHN MAYER

Singer, songwriter and guitarist John Mayer was born in Bridgeport, Connecticut, and raised in Fairfield, Connecticut. His father, Richard, was the principal of Bridgeport's Central High School. His mother, Margaret, was a middle school English teacher in the Bridgeport area.

Mayer attended a magnet program at Norwalk's Brien McMahon High School called the Center for Japanese Studies Abroad. Mayer graduated from Fairfield High School (now Fairfield Warde High). At seventeen, Mayer became a member of a Connecticut band called Another Roadside Attraction. The band played clubs in the local area and recorded some demos. In 1995, Mayer and his Connecticut band known as Villanova Junction (a high school band) recorded a number of songs at Pulse Wave Recording Studios in Trumbull, Connecticut.

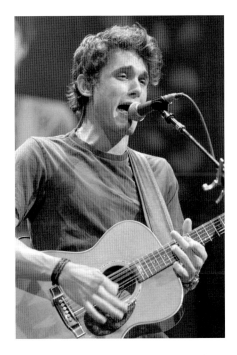

John Mayer, Oakdale Theatre, 2002. *Courtesy of Live Nation/Oakdale vice president of marketing, Connecticut and Upstate New York, Jim Bozzi.*

Of course, John Mayer has gone on to achieve fame as a major recording artist. His current band experience is with Dead & Company. In a *Rolling Stone* article by David Fricke on June 21, 2016, "John Mayer on Playing with Dead & Company: 'It's Like Catching Air'," Mayer shares his thoughts on performing with members of the Grateful Dead as part of the Dead & Company concerts during the summer of 2016. Mayer reflects on what an honor it is to be associated with these great musicians and his excitement at the prospect of one day recording with members of the Dead. When asked about his earliest impressions of the Dead as a high school student at Fairfield High School, Mayer responded, "I knew the Grateful Dead as a cultural assignment. I didn't know it as a musical thing. Where I lived, in Fairfield, Connecticut, if you liked the Dead, it was like you were issued clothing. I was going to school with the Deadheads' younger brothers. I never looked down on it. I was just into Eric Clapton, Jimi Hendrix and Stevie Ray Vaughan." Mayer has since become immersed in the music of the Grateful Dead and considers his association with the band members to be a major highlight of his career. When asked for his thoughts on John Mayer's participation in Dead & Company, Bob Weir responded, "He gets what we're up to. It appeals to his sense of fun and adventure. Then he brings his musical personality."

An article in the March 20, 2015 edition of the *Connecticut Post* ("Born and Raised: 10 Things You May Not Know about John Mayer" by Scott Gargan) cites further connections that John Mayer has with his hometown state of Connecticut:

- Mayer's first time on stage was at the Westport Central School talent show.

- He was inspired by his father, Richard, who used to play piano at their home.
- When Mayer was fifteen, he took guitar lessons from Al Ferrante, owner of the Fairfield Guitar Shop.
- Fairfield's Grand Central supermarket was his first ever employer.
- After graduating from Fairfield High School, Mayer spent fifteen months working as an attendant at the Mobil gas station (corner of Fairfield Woods Road and Stratfield Road—across the street from Fairfield's Grand Central Supermarket).
- Mayer donated a guitar to benefit the families of Newtown's Sandy Hook Elementary School.
- In interviews, Mayer has referred to himself as just another "dude from Fairfield."
- He has returned several times to his high school alma mater Fairfield High School (now Fairfield Warde High School), one of which was to attend the ten-year reunion of his graduating class.
- Mayer has performed in the Bridgeport/Fairfield area, most recently on December 16, 2015, at Bridgeport's Webster Bank Arena.

MGMT

During their freshman year (2002) at Middletown's Wesleyan University, Ben Goldwasser and Andrew VanWyngarden formed the psychedelic/indie rock band Management, later changed to MGMT. In a short period of time, MGMT has released an impressive number of well-received singles, EPs and albums to an international audience. The band's 2007 debut album, *Oracular Spectacular*, charted in the Top 40 in the United States and Top 10 in Europe. The album achieved gold record status in the United States and platinum in Europe. Connecticut's MGMT band has received numerous major award nominations, including Grammy nominations, and has an extremely loyal international fan base.

NICK FRADIANI

On May 13, 2015, Nick Fradiani was declared the winner of the hit TV series *American Idol*. As a result, Fradiani signed a contract with the *Idol* show

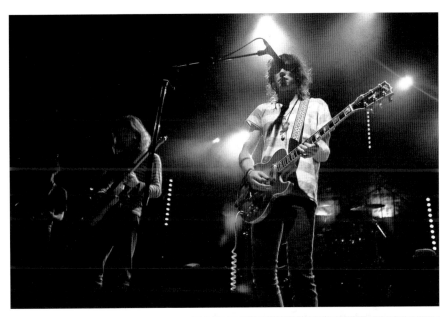

Above: MGMT at La Route du Rock, 2008. *Photo by Wikicommons contributor Bertrand (CC BY 2.0)*.

Right: Nick Fradiani. *Copyright Peter Hvizdak and the* New Haven Register.

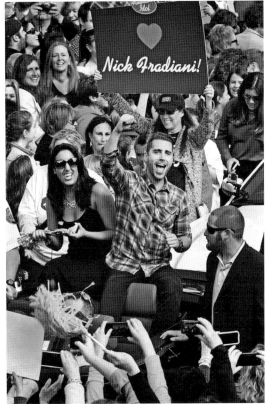

as a solo artist. Nick has since been involved in a number of impressive events. For example, Fradiani participated in the American Idol Live tour throughout the United States. He also performed live in Vancouver during the 2015 Women's World Cup Soccer tournament. Fradiani's winning song on American Idol, "Beautiful Life," was also the 2015 Women's World Cup Soccer official anthem. Nick currently resides in Nashville, Tennessee, where he has been busy recording songs and videos as a solo artist. Fradiani's album *Hurricane* became *Billboard*'s no. 1 Heatseaker album on August 22, 2016.

Nick Fradiani is a Guilford, Connecticut native. He graduated from Guilford High School in 2004. Prior to his *American Idol* experience, Fradiani was a member of Beach Avenue, a popular Connecticut pop/rock band. Nick was the lead singer of the band. He, along with bandmate Nick Abraham, wrote songs for the group. The other two members of Beach Avenue (Abraham and Ryan Zipp) have high praise for Fradiani's recent achievements. When asked for his reaction to Fradiani's success on *American Idol*, Beach Avenue drummer Ryan Zipp said, "We were there. We were rooting for him. I mean, that's your best friend up there and we were excited that he won. We're very proud of him!"

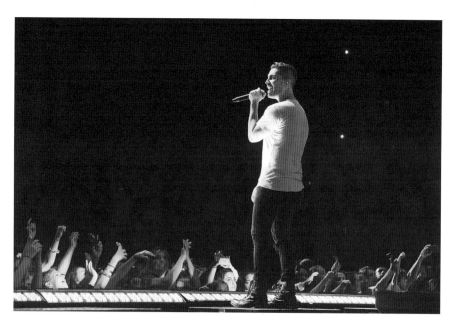

Nick Fradiani in concert. *Courtesy of Ryan Zipp; used with permission from Nick Fradiani Jr.*

And so, the tradition continues. Following in the footsteps of such popular singers as Fred Parris and Gene Pitney, Nick Fradiani is the most recent successful solo artist from the state of Connecticut.

GARY BURR

Gary Burr is an extremely successful singer-songwriter. In 1982, Burr's "Love's Been a Little Bit Hard on Me" was a no. 7 *Billboard* hit song for Juice Newton. The song was also a Top 10 hit on Connecticut radio stations (no. 6 on WDRC). He has written songs that became hits for many major country recording artists, such as Reba McEntire, Kenny Rogers, Tim McGraw, Garth Brooks, Randy Travis, Kelly Clarkson, Faith Hill and others.

Gary Burr was a member of the group Pure Prairie League for several years and has also recorded as a solo artist. He is currently a member of Blue Sky Riders, featuring Burr, Kenny Loggins and Burr's wife (and fellow songwriter), Georgia Middleman.

Burr was born and raised in Meriden, Connecticut, and graduated from Meriden's Platt High School. In 2014, Gary Burr was inducted into the Meriden, Connecticut Hall of Fame.

GATHERING OF THE VIBES (BRIDGEPORT, CONNECTICUT)

The annual music festival known as the Gathering of the Vibes (GOTV) grew out of the need by many to fill the void that was left due to the death of Jerry Garcia of the Grateful Dead in 1995. Initially named Deadhead Heaven—A Gathering of the Tribe in 1996, the festival name was changed the following year to the "Gathering of the Vibes."

Seaside Park in Bridgeport, Connecticut, has served as the host of the GOTV festival for eleven of the twenty years of the festival's existence. The GOTV festival is always well attended, attracting up to twenty-five thousand people each year for this four-day event. Wavy Gravy (of Woodstock fame) has served as master of ceremonies for this festival since 2002. Many major world-class artists such as the Allman Brothers, CSN, Weezer, Max Creek and Deep Banana Blackout have performed at these events over the years. The festival also showcases many talented local bands in and around Connecticut.

LOCAL/REGIONAL HIT MAKERS AND FAVORITES

THE REDUCERS

The Reducers were a long-running rock band from New London, Connecticut. The band formed in 1978, inspired by the English punk rock movement of the time. The four band members were Hugh Birdsall (guitar, vocals), Peter Detmold (guitar, vocals), Steve Kaika (bass, vocals) and Tom Trombley (drums, vocals). The Reducers released numerous LPs, CDs and 45s on their own Rave On record label, beginning with 1980s double A-side single "Out of Step"/"No Ambition." Ken Evans (of the Fifth Estate) was the manager of the Reducers in the 1980s.

Roger C. Reale collaborated with the Reducers on a three-song EP titled *Wake the Neighbors*, which was recorded in 1987. In 1977, Reale released the cult classic *Radioactive* LP album on Doc Cavalier's Big Sound record label. The album was recorded at Cavalier's Trod Nossel Studios (Wallingford, Connecticut). A longtime presence on the Connecticut music scene, Roger has also performed and recorded with the Manchurians.

The Reducers remained active for thirty-four years, inspiring a loyal, cult-like fan following.

BEACH AVENUE

Beach Avenue was the most talented band I ever played with. Nick Fradiani has an amazing singing voice. Nick Abraham is a very talented musician. Nick and Nick are also very good songwriters. Beach Avenue has always been good at live performances as well as recording. But most importantly, we are like brothers. It was always a very laid back thing with us, joking around 24/7. It's great chemistry between the three of us. We accomplished a heck of a lot in a very short period of time.
—*Ryan Zipp*

The pop/rock band Beach Avenue formed in Milford, Connecticut, in 2011. Nick Fradiani, Ryan "Zippy" Zipp and Nick Abraham were roommates in a shorefront apartment in Milford. The street they lived on is named Beach Avenue. Fradiani is from Guilford, Zipp is a Hamden native and Abraham is originally from Fairfield. Ryan Zipp was previously the drummer for Hamden's punk rock band Grover Dill.

A History

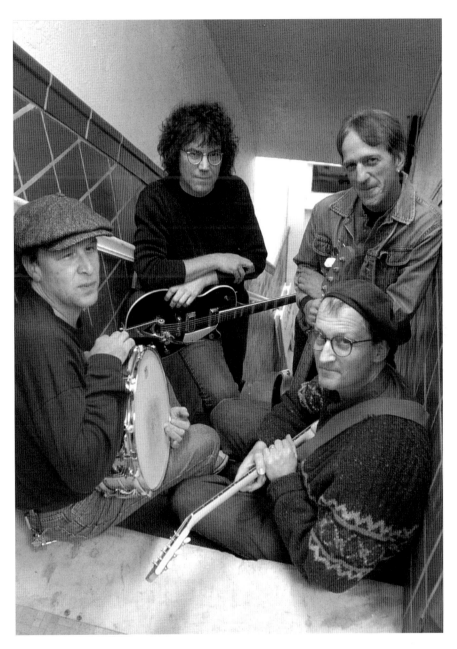

The Reducers. *Used with permission from the Reducers.*

Beach Avenue competed in the Battle of the Bands at Mohegan Sun (Uncasville, Connecticut) in 2011, where it took first place in the competition. Soon after, the band recorded its debut EP, *Something to Believe In*, at New Haven's Firehouse 12 Studio. Beach Avenue has performed as the opening act for a number of major recording artists, including Third Eye Blind and Jefferson Starship. The band has a very loyal regional following.

In 2014, Beach Avenue competed on the *America's Got Talent* TV show, making it to "Judgment Week" on the program. The guys performed their single "Coming Your Way" on the show. The song peaked at no. 53 on the iTunes Pop Singles Chart. It remained in the Top 200 for over two weeks, selling more than ten thousand copies.

On May 13, 2015, Nick Fradiani (Beach Avenue's lead singer) was declared the winner of the hit TV series *American Idol*. Despite all the hoopla surrounding his success on *American Idol*, Fradiani has made a point to involve his Beach Avenue bandmates in many performance events associated with his success on *American Idol*. Fradiani also participated in the American Idol Live tour throughout the United States.

For a complete interview with Ryan Zipp of Beach Avenue, see Appendix B.

Beach Avenue. *Courtesy of Ryan Zipp; used with permission from Nick Fradiani Jr.*

Beach Avenue in concert. *Copyright Peter Hvizdak and the* New Haven Register.

Hamden's Grover Dill band, including Ryan Zipp. *Courtesy of Ryan Zipp.*

THE SIN SISTERS

As a vocal group, when you blend together as one it's a beautiful, warm feeling.
—Patti Rahl

The Sin Sisters are a vocal group consisting of Kathy Kessler, Janice Ingarra and Patti Rahl. Kathy and Janice have known each other since kindergarten and were classmates at New Haven's St. Rose Elementary School and Hamden's Sacred Heart Academy high school. Patti also attended Sacred Heart Academy. In 1987, Kathy formed a group called Bobby and the Angels. Bobby was a band member, and the Angels were Kathy, Janice and Patti. The trio eventually ventured out on their own and became the Sin Sisters in 2011. They have performed as backup singers for the legendary Beehive Queen, Christine Ohlman.

The three have also shared the stage with major acts like NRBQ, Lou Christie and rapper Snoop Dogg. The Sin Sisters cover nearly all music genres, including classic rock, pop, Motown, blues, swing and even the standards.

For a complete interview with Kathy Kessler of the Sin Sisters, see Appendix B.

The Sin Sisters (*left to right*) Janice Ingarra, Kathy Kessler and Patti Rahl. *Courtesy of Kathy Kessler.*

A History

VILLAGE MAID BAND

The Village Maid Band was composed of former members of two popular Connecticut bands: Little Village and Arizona Maid Band (AMB). Bernie Palka (drums) played with both Little Village and AMB. Michael (Mick) Niewwinski (bass) was from AMB. Victor Cowles (guitar, vocals) also played with AMB.

Little Village was a hard rock band from the Hartford, Connecticut area. The band was very popular in the Connecticut region.

The Arizona Maid Band formed in 1973, and group members hailed from the Connecticut towns of Somers, Ellington, Stafford Springs, South Windsor and Enfield. AMB played mainly southern rock music. They were very popular on a local basis.

APPENDIX A
A TRIBUTE TO JOE SIA, WORLD-RENOWNED ROCK PHOTOGRAPHER (1945–2003)

Few photographers have made a more indelible imprint in the world of rock music than Joe Sia.
—*Sacred Heart University newsletter*

A book about Connecticut rock music would not be complete without the inclusion of Joe Sia. Rock fans may not recognize his name, but they certainly have seen his work.

Joe's photos have been used as covers and inserts for albums by such major recording artists as John Lennon (*Sometime in New York City*), Jimi Hendrix (*Live at Filmore East*), Eric Clapton (*Crossroads*) and Rod Stewart (*Never a Dull Moment*) along with many other notable artists.

His amazing photographic works have appeared in every printed media, including many highly regarded and popular national magazines and books. They have also been used in TV shows.

At the time of his untimely death in 2003, Joe was considered one of the most renowned and respected rock photographers in the world.

In a tribute to Joe, his alma mater discussed his impressive career in a university newsletter:

> *Few photographers have made a more indelible imprint in the world of rock music than Joe Sia. Joe's photographs capture the essence of a performer's style and reflect the rhythms of the artist's music. Sia is one of the most widely published people in his profession.*

Appendix A

Joe Sia and I were schoolmates at Sacred Heart University (SHU) in Fairfield, Connecticut. Before I got to know him, I would often see Joe walking around the campus, always with his camera in hand. We all knew he was the school photographer for SHU's yearbooks as well as other projects. What many of us didn't know was the amazing career he was about to embark upon.

Joe's interest in photography began when a friend gave him a Nikon Nikoromat camera. Joe was still a college student at the time. What began as a hobby soon developed into a profession. While attending the 1969 Atlantic City Pop Festival, the self-taught photographer began taking close-up photos of Joe Cocker. One of Joe's photos of Cocker was purchased by *Rolling Stone* magazine. The magazine editors were so impressed that they used it as a cover image. Several weeks later, Joe was assigned by *Rolling Stone* to take photos of the Woodstock Festival. It was there that Sia made his mark, taking incredible pictures of that historic three-day festival.

On several occasions, Joe shared with me his experiences at Woodstock. When asked what his first impression of Woodstock was, Joe described the scene as "truly mind blowing." He talked about having to abandon his car about fifteen miles away from the festival and hitching a ride with a guy on a motorcycle. After making his way through this "sea of humanity," Joe approached the stage and got to work. What is remarkable about the photos Joe took of Woodstock is not only the jaw-dropping close-ups of the performers but also the amazing images of the individuals who made up the vast crowd. Through his camera lens, Joe recorded an unforgettable story of this music event that very few, if any, were able to tell. Sia's chronicle of the Woodstock Festival has earned the praise of many people, including his peers, who consider it the premier photographic account of this historically important music event. In December 1989, our alma mater featured an impressive display of many of his photographs as a celebration of Woodstock's twentieth anniversary. It was a real thrill for him to share this photo display with so many others at the college he graduated from.

Joe photographed nearly every major artist of his time. I was privileged to see firsthand a small portion of his truly amazing photographic catalogue, having visited Joe many times at his home in Fairfield. He was particularly fond of his photos of Jimi Hendrix. Perhaps his favorite is the iconic photo he shot of Hendrix at Yale's Woolsey Hall in 1968. He called this photo *The Shadow*. In fact, this is the image Joe used on his

Appendix A

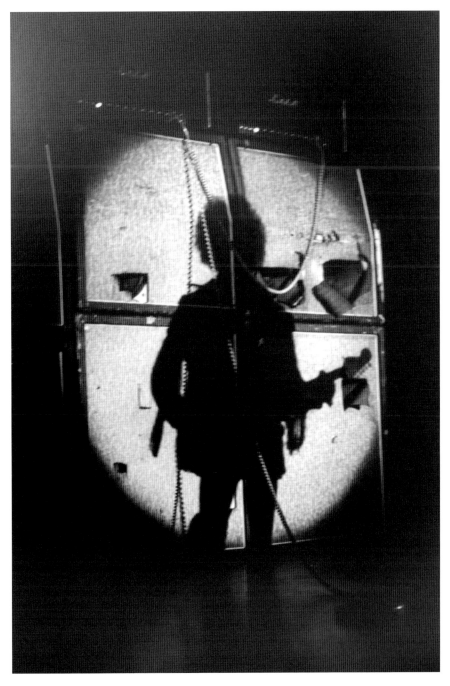

Joe Sia's iconic photo of Jimi Hendrix at Woolsey Hall, New Haven, Connecticut, November 17, 1968. *Author's collection, received directly from Joe Sia and signed, dated and numbered by Sia. Image used with permission from www.wolfgangsvault.com (Bill Sagan).*

Appendix A

business cards. When asked to describe Jimi Hendrix in concert, Joe simply replied "spellbinding." He also talked about the Connecticut music scene, describing it as vibrant and noting the great amount of talent produced by this state.

Joe Sia was a phenomenal artist and an extremely interesting man. I am forever grateful for the kindness and generosity he showed me and my family. I am proud to say Joe was someone I considered a good friend.

Above: Joe Sia's business card (received from Joe Sia years ago). *Author's collection, received directly from Joe Sia. Image used with permission from www.wolfgangsvault.com (Bill Sagan).*

APPENDIX B
INTERVIEWS WITH CONNECTICUT MUSIC ARTISTS

INTERVIEW WITH DOROTHY YUTENKAS OF DEBBIE AND THE DARNELS

FEBRUARY 8, 2016

TR: Thank you, Dorothy, for agreeing to this interview.

DY: My pleasure, Tony.

TR: Who were the group members of Debbie and the Darnels?

DY: I was "Debbie," the lead singer of the group. The two other group members were my older sister Joan Yutenkas and our neighbor Maria Brancati. Maria lived right around the corner from us.

TR: Where were you born and raised?

DY: Born and raised in New Haven, Connecticut.

TR: What schools did you attend?

DY: I attended St. Stanislaus Elementary School in New Haven. I then went to St Mary's High School, which was also in New Haven. I attended and graduated from New Haven's Albertus Magnus College. After that I attended Wesleyan University (Middletown, Connecticut) for my postgraduate degree.

TR: Did Joan and Maria also attend St. Mary's High School?

DY: Yes, all three of us went to St. Mary's High.

TR: When did you start singing?

Appendix B

DY: I actually started singing on stage in local talent shows when I was four years old. I began singing on the radio when I was nine or ten. I would sing on the New Haven radio station WELI as part of Bud Finch's *Youth On Parade Show* every Saturday. My mother kept me busy! [*laughs*]. I come from a very musical family. One of my uncles played the trumpet, another uncle played the accordion, my grandfather played the violin and my mother's sister Sophie played a full set of drums in a professional girls' group when she was in her teens. Seems like I was listening to music from the womb!

TR: When did you first start singing with Joan and Maria?

DY: Early on, Joan was more interested in dance. But she could also sing well, and we found out that we were able to harmonize very well. We would sit out on the front porch at our home and harmonize together. We would sing in church and at Christmastime, which is when we perfected our harmonizing. We then began singing with Maria. Maria sang in a lower range. The three of us seemed to click as a harmony group. At one point, we went to a party in East Haven. Jerry Greenberg was there. The three of us sang with his group at the party. Jerry turned to me and said, "How would the three of you like to make a record?" I said, "Yeah, sure." But he was serious. He said he had some connections and could make it happen. I was only about fifteen at the time, and Jerry wasn't much older. But he did make it happen, and Joan, Maria and myself recorded our first record at Vernon Records under the name the Teen Dreams. I wrote a tune called "Why, Why."

TR: The songwriter's name on the record *Why, Why* is shown as "Green." Who is Green?

DY: That actually referred to Jerry Greenberg. As I mentioned, I actually wrote "Why, Why" but because I was only fifteen years old and not a member of the union, the name Green was shown instead of mine. Being only fifteen, what did I know of these things at the time? But that was my song. Actually, "Why, Why" was supposed to be the flipside of the song "The Time" (which was written by Jerry Greenberg). But everyone liked the upbeat "Why, Why," and that side seemed to get most of the attention. The great saxophone riffs on "Why Why" and "Santa Teach Me to Dance" were done by Johnny Fisco. He was great! Johnny was with the band known as the Passengers.

TR: So Jerry Greenberg was the person who actually discovered the three of you?

Appendix B

DY: Yes. Jerry went on to become the president of Atlantic Records. We were managed by Sam Goldman. Sam Goldman, along with Jerry Greenberg, went on to become part of the history of the Five Satins.

TR: Were you still in high school when you recorded your songs?

DY: Yes, all three of us were still attending St. Mary's High School when we recorded the songs.

TR: So when you recorded your first songs, "Why, Why" and "The Time," you called yourselves the Teen Dreams? What caused you to change the name of the group for your subsequent recordings?

DY: We started out as the Teen Dreams. However, as my sister Joan got a bit older, I said, "Well that's not going to last." The name Teen Dreams didn't seem to fit us anymore. So we changed the group name to Debbie and the Darnels.

TR: Who came up with the name Debbie and the Darnels?

DY: I did. Dorothy and the Darnels didn't seem to sound right (a bit old-fashioned maybe).

TR: "Santa Teach Me to Dance" is such an infectious, catchy, upbeat song. Tell me a little about the song. Who were the Passengers?

DY: The songwriter for "Santa Teach Me to Dance" was Doug Lapham, a talented songwriter from East Haven, Connecticut. Doug also wrote "Mr. Johnny Jones." Backing us up on the instrumentation of the record was a Connecticut band known as the Passengers. Actually, Jerry Greenberg was a member of the Passengers. They also appeared with us at local music venues.

TR: As the song trails off at the end, I could hear you referring to some of the dance crazes at the time, namely: the Popeye, the Wiggle Wobble, the Locomotion and the Hully Gully. Were the dance references a part of how the song was written?

DY: Actually, that was me ad-libbing as the song was trailing off. I just began yelling out dances that were popular at the time.

TR: Well, it worked!

DY: Yes, it did.

TR: For some reason, I always found some similarity between "Santa Teach Me to Dance" (recorded in 1962) and the song "Hey Santa" by Wilson/Philips (recorded in 1993). Certainly not a copy of your song and the lyrics are different. Maybe it's the harmony or the idea of pleading to Santa for help with their boyfriend situation. Who knows? But I just found it a bit interesting that two Christmas songs recorded more than thirty years apart could have that bond. At least it was interesting to me.

Appendix B

DY: That is very interesting.

TR: "Mr. Johnny Jones" was a Top 40 hit on Connecticut radio stations. For example, it charted at No. 40 on Hartford's WDRC during the week November 6, 1962. Tell me a little bit about this song?

DY: "Mr. Johnny Jones" was our most popular song. We recorded that song, along with the flipside "Daddy," at Columbia Records. What a wonderful and exciting experience. For "Mr. Johnny Jones" we had an incredible studio band backing us up. They also added one extra girl to add a little more to the recording. I know the song was very popular in Connecticut because of all the airplay and feedback we received. But we were so busy performing all over the place that we had no idea how high the record charted, but we certainly were grateful that it did as well as it did.

TR: As just a bystander and a music fan of local groups like yours (whether in Connecticut or some other state), here's what I find remarkable. Let's use "Mr. Johnny Jones" as an example. For at least during the time that your recording charted in the Top 40 on Connecticut radio stations (and looking at the radio music surveys), your song beat out recordings from major artists, such as Dion, Nat King Cole, the Everly Brothers, Marvin Gaye, Connie Francis, Joey Dee, the Cookies ("Chains"), Paul Anka, Chris Montez and the Duprees.

DY: That is remarkable. I never thought of it like that.

TR: What other performing artists did you share the stage bill with?

DY: We performed a lot on the same bill as the Five Satins since we had the same manager (Sam Goldman). We performed with a number of artists who were popular at the time. We also were on the same bill as the actress Tuesday Weld when she was a teenager, but I'm not sure what the circumstances were.

TR: You also took part in the Harry Downie's Caravan of Stars in Danbury, Connecticut on January 24, 1964, along with a number of other local artists. One of the performers in the show was Ginny Arnell. Did you know Ginny Arnell?

DY: Yes. She was an East Haven, Connecticut girl. Ginny and I competed in talent contests when we were very young. She has a very nice voice.

TR: Do you recall where you were when you first heard your song on the radio?

DY: Absolutely. I first heard our song on the radio while I was riding in a car on a date. My sister Joan was in the backseat. Our song comes on the radio, and we start screaming and singing along with the song. There was a scene in a recent movie (I think it may have been *Dream Girls*) in which

Appendix B

members of a girl singing group heard their song for the first time on the car radio. The girls started screaming, stopped the car and began singing along with the song. That is exactly the way it happened for us. It doesn't get any better than that!

TR: Did you ever perform on the *Connecticut Bandstand* TV show?

DY: Yes, around 1963. We performed our songs on the show. After performing, we signed autographs for the other teenagers who danced on the show.

TR: What was the music scene like during the period of time when Debbie and the Darnels were a popular performing act? When you performed at various record hops or at other music venues, were the kids in the audiences dancing or just listening?

DY: The kids would be SCREAMING! It was nuts, just nuts. [*laughs*] We did a show in Boston on a very large stage and the announcer introduced us, "And here are Debbie and the Darnels!" And all the kids would start screaming, much like they did for groups like the Beatles. It sometimes got a bit scary for us, especially when the teenage boys would start grabbing at our legs and things like that. Girl groups such as ours sometimes would get a little frightened because it sometimes seemed to get a bit chaotic with all the screaming and such. Guys could get a bit aggressive, and we were a bit concerned about that at those large venues. There would be a few bodyguards for us, but not really professional, you know. We were only kids in our teens and weren't prepared for what seemed like bedlam at times.

TR: What was your touring area?

DY: All the way up and down the East Coast.

TR: What were your fondest memories of those days when you were recording and performing as Debbie and the Darnels?

DY: First of all, I would say it was when we recorded songs at the Columbia Records recording studios in New York City. They put you in a booth with the earphones on, and you have to produce. Also, performing at all the music venues large and small and the great reception we would get from our audiences. Yes, there were a few scary moments at a few large venues as I mentioned before, but for the most part it was so much fun.

TR: Debbie and the Darnels had that early sixties girl group sound. When you performed, did you have the same type of "moves" as you would see with groups like the Supremes, Shirelles and Marvelettes?

DY: Of course! I did the choreography for the group. We had the hand movements, the unison moves, the snapping of the fingers, all of that.

Appendix B

We even had matching shoes. And, of course, great '60s outfits. My mom made ALL our outfits. In fact, I still have one of the originals, a purple outfit. My mom was very supportive to us in so many ways. That was so very important to us, especially in our teenage years on tour.

TR: Your mom sounds like a terrific person with all the support she gave you and your sister and all the time making your costumes.

DY: She's terrific. And she's still around. She's ninety-four years old. I guess music just keeps you going.

TR: After Debbie and the Darnels broke up did you continue to sing professionally?

DY: Yes. I began performing solo and sometimes with a group in nightclubs and other music venues. It was a steady weekend job, and I was paid very well. I began singing Broadway tunes and all the great old standards. After Debbie and the Darnels broke up, my sister Joan decided not to pursue a music career.

TR: What are your current pursuits?

DY: I have been very involved in the teaching profession, in one manner or another. I was the first teacher voted "Teacher of the Year" at Cheshire High (1992). Up until 1999, I was the choral director at Cheshire High School. I now teach private voice, do some conducting and I'm involved in other musical activities.

TR: Besides your own songs, what were your favorite songs of the early '60s era?

DY: I loved the girl groups such as the Shirelles and the Marvelettes. What a great song "Will You Still Love Me Tomorrow" was. And songs like "Da Doo Ron Ron." I also loved songs by Ray Charles. In fact, we wanted to be the Raelettes at the time. [*laughs*] Also, a fellow by the name of Bobby Golia from Hamden, Connecticut, had a band, and we enjoyed singing along with that band. We especially liked to back up his band on Ray Charles's "Hit the Road Jack." We did some things at Yale University also.

TR: Looking back, what is your overall feeling about your experiences as a member of Debbie and the Darnels?

DY: It was the highlight of my youth! So much fun. In fact, it was a little bit more than fun—it was exciting and rewarding. But it was also a lot of work, with so much of our time devoted to practicing for upcoming shows and time spent in the recording studio. For me, it was an educational and eye-opening experience. I feel my prior music experiences have given me a unique perspective as a teacher—going from a rock and roll teenybopper to a mature nightclub performer, chorale director and now private voice teacher.

Appendix B

TR: Would you do it all over again?

DY: Oh sure. In fact, it's still a great feeling when people remember me as a member of Debbie and the Darnels. Especially, the guys from that era who say, "Oh wow, you were Debbie from Debbie and the Darnels!" [*laughs*] Kind of funny. But it was just so much fun.

TR: Your mom must have been proud of your achievements at such an early age.

DY: Yep, and she kept us safe. "Get those guys away!" [*laughs*]

INTERVIEW WITH CHRISTINE OHLMAN

MAY 12, 2016

TR: Welcome, Christine, and thank you for agreeing to this interview.

CO: Thank you, Tony.

TR: Where were you born and raised?

CO: I was born in the Bronx and came to Connecticut very soon after that. My family moved first to Meriden, Connecticut, and then to Cheshire.

TR: What high school did you attend?

CO: I attended Notre Dame Academy in Waterbury, Connecticut. My brother, Vic Steffens, went to Cheshire Academy.

TR: How did you first get involved in music? Did you sing at an early age?

CO: I've been singing for as long as I can remember. When I was little, I would constantly put on shows for the family, sometimes with my cousin. I remember standing in front of the mirror singing when I was just a little kid. I was always singing around the house and when I was in school. My parents couldn't shut me up! [*laughs*] This was probably the reason why I got involved in a band in the first place.

TR: What was the first band that you joined?

CO: My brother, Vic, was a drummer, and he had a band called the Wrongh Black Bag. I joined the band in 1968. Vic asked me to be the lead singer for the band. When I was a senior, we had a record on the *Billboard* charts. We actually were the opening band for the Wildweeds. Al Anderson and I go way back.

TR: What type of music did the Wrongh Black Bag play?

CO: Our music was blues oriented, along with rock 'n' roll.

TR: What songs did you record with the Wrongh Black Bag?

Appendix B

CO: We recorded "Wake Me Shake Me," which charted on *Billboard*. The song appeared on a compilation album called *Psychedelic Archaeology*. The flip side was "I Don't Know Why," which was released on a great compilation album called *All Kind of Highs* in 2012 and featured psych rock songs.

TR: What was your next band?

CO: We sort of morphed into a band called Fancy. By this time, some of the band members were writing their own music. Any covers that we played were usually songs out of the mainstream. We were oriented toward the blues.

TR: After Fancy, is that when you became a member of the Scratch Band?

CO: Yes. The Scratch Band, in my opinion, was way ahead of its time. This is one of the reasons why I think each of the members of the Scratch Band went on to achieve a level of success in the music business. G.E. Smith, Robert Orsi, Paul Ossola, Mickey Curry—all great. And I should mention that the original Scratch Band included Bill Durso and Ray Zeiner for a brief time. The two were very jazz oriented.

TR: After the Scratch Band, what was your next venture?

CO: The next band that I was in was called Christine Ohlman and the Soul Rockers. The band included musicians from the New Haven and Waterbury areas and featured soul music. The band lasted for two years.

TR: How did you become a member of the Saturday Night Live band? Are you still a member of the SNL band?

CO: I joined the Saturday Night Live band in 1991. G.E. Smith is the musical director on the show and was influential in my joining the SNL band. As I mentioned, G.E. Smith and I were members of the Scratch Band. Yes, I still am with the SNL band as the lead singer.

TR: This leads me to your current band, Christine Ohlman and Rebel Montez. What CDs have you recorded with the Rebel Montez band? Where did you record "The Deep End?"

CO: We have recorded six CDs and one DVD. The CDs were *Hard Way, Radio Queen, Wicked Time, Strip, Re-Hive* and *The Deep End*. The DVD is called *Live Hive*. *The Deep End* was recorded at Horizon Studios.

TR: I especially love the *Deep End* album and your collaborations with some major stars. Your duet with Dion on "Cry Baby Cry" brings back memories of some of those great collaborations of the '60s like Marvin Gaye and Tammi Terrell. I have to say, I have always thought Dion was the coolest guy on the planet.

Appendix B

CO: Thanks and I agree with you on Dion. He's had such a wonderful career and even to the present day with all these great blues songs he's putting out. Dion and I had a wonderful time recording for the album.

TR: Tell me a little bit about your song "The Cradle Did Rock."

CO: "The Cradle Did Rock" is about the first post-Katrina Mardi Gras in New Orleans.

TR: You mentioned Al Anderson and how the Wrongh Black Bag used to open up for Al and his band the Wildweeds. Have you ever performed with Al in concert?

CO: Yes. I actually performed with the reunited Wildweeds band in their 2011, 2014 and 2015 concerts. I sang the harmony parts of the Wildweeds' bassist Bob Dudek.

TR: Well, you're one of those people that seem to be able to bridge the music gap between the past and the present. Amazing how things sometime go full circle.

CO: It sure is Tony.

TR: Any new CDs in the works?

CO: Yes, I'm working on a new CD called *The Grown-Up Thing*. We're in the process of recording the album at Horizon Studios and possibly in Muscle Shoals, Alabama. There will be special guests like we had on the *Deep End* CD.

TR: What is it about Muscle Shoals and the studio there? Jimmy Cliff refers to it as a "Field of Energy." Have you ever felt this energy yourself when you're down there?

CO: Muscle Shoals is my second musical home. In fact, I'm going down there on Tuesday. The Tennessee River has the nickname the "Singing River" and they say that the river really influences the vibe. I can't explain it but I really do feel the energy myself. Over the years, some of the greatest work has been produced in that area of the country. Truly amazing and a great honor to perform and record in Muscle Shoals. Last year, I was privileged to be the grand marshal of the WC Handy Festival, which I played at for the last six years. I actually rode in Sam Phillips's blue Cadillac, which Elvis use to ride in.

TR: What was your involvement with the *Vinyl* TV series?

CO: I sing on several episodes, including a duet with Elvis Costello. Voice only.

TR: How would you describe your music?

CO: Dave Marsh has labeled my music as "contemporary rock R&B," and I would agree with him on that.

TR: What, if any, music artists are you compared to?

Appendix B

CO: I'm not sure. I'm often compared to Dusty Springfield, but I'm not sure I can say that since I worship at her feet. The late great multiple Tony Award–winner Cy Coleman compared my sense of timing to Peggy Lee. He didn't compare my singing to Peggy but rather my timing.

TR: Do you still perform at the New Orleans Jazz Festival?

CO: Yes. I was just there performing last month.

TR: What would you say has been your peak moment or moments so far?

CO: There have been so many special moments in my career. Let's see. The Bob Dylan thing at MSG was the first really big show that I was on, so that is a great memory. An Evening of Duets with Mac Rebennack (Dr. John) was amazing. Also, Carnegie Hall with Ian Hunter, Central Park Summerstage fronting Big Brother and the Holding Company in a tribute to Janis Joplin, many nights with Rebel Montez and riding in that Cadillac last summer as grand marshal of the entire festival in the parade was really something. I would say those are a few of my many very special moments for me.

TR: What is your message to someone thinking of forming a band or becoming a well-known singer?

CO: You really have to do it for the love of the work. If you get into it for any other reasons, it's a very hard business, and you will likely hit some major snags. The money will follow, but first you have to love the work. I would also advise anyone who is contemplating getting into the music industry to be sure you have a sense of history and what you are embarking on in their music genre. Make it a lifelong path of study, to look back to understand the genre and learn new things about it. If you're in country music you should at least know who Loretta Lynn is and even people before her such as Kitty Wells. If you're in pop music, you should know Dusty Springfield. If you're in soul, you should know not only Aretha Franklin but also artists like Mavis Staples and Candi Staton of Muscle Shoals fame. Someone thinking about becoming successful in this business should make a point to really know about these people, not just whatever is currently on the radio.

TR: Do you find that it's not always the case that people have that sense of history about the music genre they wish to pursue?

CO: Sadly, I don't think it's ever the case.

TR: How would you personally sum up your music career?

CO: Whatever I am and whatever I have become as a musician is the sum total of all the different music influences that I have absorbed in my life.

For more information see www.christineohlman.net.

APPENDIX B

INTERVIEW WITH RYAN ZIPP
OF GROVER DILL AND BEACH AVENUE

FEBRUARY 17, 2016

Seems like yesterday I was this little kid watching some local Connecticut band with my face sweating up against the barricade. I never imagined being part of a successful band, touring the country, playing music in front of thousands of people or to a national TV audience. And I got to do that in a band with my best friends! Kind of crazy when I think about it.
—*Ryan Zipp*

TR: Thank you for agreeing to this interview, Ryan.

RZ: My pleasure.

TR: Where were you born and raised?

RZ: I was born in New Haven and raised in Hamden, Connecticut

TR: What schools did you attend?

RZ: West Woods School (through fourth grade), Helen Street School (fifth and sixth), Hamden Middle School (seventh and eighth grade), Notre Dame High School (West Haven, Connecticut) and Fairfield University (Fairfield, Conncecticut, class of 2004).

TR: Growing up in Hamden at an early age, who were your musical influences—groups or solo performers. Who influenced you?

RZ: I definitely grew up as a punk rock kid. My best friends and I were into the punk rock scene. In the beginning, it was more extreme punk, kids with the Mohawk hairdos, the punk jackets and all. That was the stuff that my friends and I began listening to and gravitating toward. There was a place on Center Street in New Haven called The Tune In, which became kind of a Mecca of punk rock. The Tune In was an awesome spot. I was lucky to experience that scene because great punk and alternative groups that later became famous came through and played there. We spent a lot of weekends there during our high school years, absorbing all this great music. There was so much energy in the room when these bands played live with hundreds of kids having fun and going crazy. There was also a ska thing going on, which was different, but it kind of mixed with the scene. That is when I got a taste of this kind of music and when I knew it was something I wanted to do myself. So, it didn't take very long before my good friend Eric and I figured that we could play this kind of music even without formal training or experience. The music itself was rough

Appendix B

around the edges, and as a musician, you didn't have to be perfect. So Eric and I began playing music in my garage and basement, terrorizing my parents. [*laughs*] We weren't good when we started, but you have to start somewhere. And it evolved from there. We were very young at the time, fourteen years old.

Because of the lack of venues in Hamden, we kind of did our own thing. We would make our own scene to get kids to come to our performances. We would rent out halls, make our own flyers, anything to get the kids to hear our music. At the time that we first recorded there were no computer programs like Pro Tools or whatever, which everyone has now. So we recorded at this place in Cheshire, and we had to be as creative as possible to promote our recordings and concerts. I remember we would photocopy stuff and cut it up. We would sneak into Eric's mom's church and use the church's photocopy machine. That's how we would make flyers for our shows and even covers for our CD. We didn't just post our flyers at music venues. We would make up these flyers for our group and go to these other shows (some were big shows) and personally distribute them to as many fans there as possible. As we handed out the flyers, we would say "Hey, check my band out, check my band out." Even if 5 percent of that worked, it was worth it because we gained new fans and advertised our upcoming concerts. We would hit multiple shows a night. So those are some of the ways we made our own scene. Punk rock was always a DIY (do it yourself) thing and we certainly followed that concept for our band. And so simple things like personally handing out our flyers really helped. It's something that you really don't see a lot today because everything you need is online. But I think groups may be missing this personal reaching out approach.

TR: How old were you when you played your first real gig?

RZ: I played my first real gig at Toad's Place on Broadway in New Haven. I was fourteen years old. I remember being pumped about that since Toad's was and is such a famous music venue. But the Tune In, for me, was like the official spot during my early years. That was the place. That was definitely the punk rock spot.

TR: How did you first get interested in the drums?

RZ: It's kind of funny because for me the decision to choose the drums over any other instrument happened when I was in the fourth grade at West Woods School. At that time, we had to play in band class, and we had to choose an instrument to play. Two of my best friends chose the saxophone, so, of course, I wanted to play the saxophone. I was a little guy

back then. So the music teacher told me she didn't think my hands were big enough for the saxophone. So she handed me a set of drumsticks. I was bummed out at the time. But if it weren't for this, I probably wouldn't have played the drums. So that started it all. Everything is kind of a reaction to something else. Funny how things like that happen.

TR: Where did you get your first drum set? What was the name of your first drum kit?

RZ: I purchased my first drum set at George's Music in Hamden. I must have been about twelve years old. It was a Sunlight drum set. At the time it was the coolest thing for me. I still have it.

TR: You still have it?

RZ: Yeah, actually it's on top of my dad's bar. I have no idea what happened to my other drum sets, but I did keep my first one. Must be a nostalgic thing. It was a very basic, entry-level drum kit. The symbols sounded like garbage can tops. But you have to learn on it, you have to start somewhere.

TR: What drum set do you play with now?

RZ: It's called an SJC custom drum set. Actually, I was one of the first who purchased their drum set. Now a lot of big names have purchased them. It's a top-of-the-line drum kit. It's all custom. You get to pick everything, every part, every color, the finish, everything.

TR: Where did you get your drum lessons? I assume you got drum lessons?

RZ: No, never got drum lessons.

TR: You never got drum lessons?

RZ: No, I just played. When I began I was bad, then I got less bad, then decent. [*laughs*] It kind of progressed over years, you know what I mean? It was part of the punk rock mentality—"grip it, rip it." Like throwing the kid into the water to make him swim.

TR: When was the first time you actually performed in public?

RZ: The first time I performed in public was at an assembly at Hamden Middle School. We threw a band together. We did "Smells Like Teen Spirit" by Nirvana. But we changed the words to "Smells Like Team Y Spirit." The kids and faculty liked it, probably because we did something a little creative.

TR: When did you actually begin playing in your first band?

RZ: In 1996. I was fourteen years old, and we were freshmen in High School. We called the band Grover Dill.

TR: What was the significance of the name Grover Dill?

RZ: Ever see the movie *Christmas Story*? Grover Dill was the little bully in the movie. I used to be a little guy and a lot feistier and competitive then. My

buddy Eric would joke around and say I was like that Grover Dill kid in the movie, so the name just stuck.

TR: What was the lineup for Grover Dill?

RZ: Eric Schrader on guitar and vocals, Andrew Roy bassist and me on drums. Later, our buddy Pete Fertiguena on guitar and vocals.

TR: What kind of songs did Grover Dill play?

RZ: Punk rock. It was fast aggressive stuff, three or four chords, screaming vocals. We played mainly original music with a few covers thrown in. A very rough garage, basement sound.

TR: How did Grover Dill build up a following?

RZ: By just playing out. Taking any gig we could possibly get. Everything from teen centers to hall shows to Toad's Place, anything we could get. We got all our family and friends to come out, with those color tickets, you know. And some local radio stations played our music. Anytime you can get your name mentioned, a song played on the radio or a clip played, it definitely helps, and people think a bit more highly of your band. So our name was out there, and people knew who we were. Also, we got to know the owner of the Tune In (Fernando Pinto), and he liked us. He would tell us these great stories about bands and let us into shows for free. We would help him post flyers for other bands. So when shows came around, he would make a point of finding a place on the stage for us to play our music. We got to be friends with other band members. I mean that's what it came down to and still comes down to. It's all about making connections and networking. Bands can be equal in many ways, but someone is going to give you the edge because they think you're cool and they want to hang out with you. Many bands can get anyone to come out and play with them, but they want to have a fun time on the show and have another band on that's cool. That's one thing I learned, the importance of networking. So building a following for us was just going out and getting fan by fan.

TR: How long did Grover Dill last?

RZ: 1996 to 2004. It was an amicable breakup. We just felt that it ran its course. I finished college, and we broke up five months later in the fall.

TR: Did Grover Dill play any large shows?

RZ: Radio station 104 played our songs. We did three of the Radio 104 Fests outside the Meadows in Hartford, Connecticut. We played in front of 15,000 people one year and about 7,500 another year. We also got a sponsorship through Subway sandwich company, which headquarters in Milford, Connecticut. They signed us on and paid for a van, a trailer

Appendix B

and our gear. They also got us on some radio festivals and arranged some tours for us. So it was a great opportunity for us that not many bands got.

TR: What would you say was the strength of Grovel Dill?

RZ: It was a live band more than a recording band. I would say the last two CDs that we put out before we broke up were our best musically. But our peak *buzz* was earlier than that. The most buzz that the band had was our live concerts. But it never took us to the next level, if you know what I mean. However, we did well for a local band, doing our own shows drawing hundreds of people, sometimes performing in front of thousands of people. For a while we opened up for all the big alternative/punk rock bands that came through Connecticut. We played a lot of sold-out shows at various important venues in the state. Very popular punk bands at the time such as Green Day, Blink 182, 2 Skinee Js, Alien Ant Farm, groups like that. As punk rock got a bit more polished and became sort of pop punk, our sound went in that direction also.

TR: So how would you describe your band Grover Dill?

RZ: It was like high energy with these shows. Kids came to jump around and have a good time. So Friday and Saturday nights they are going to our shows, better than staying at home drinking and doing nothing.

TR: What did you learn from the Grover Dill experience?

RZ: It taught me a lot. It taught me what to do and, even more importantly, what not to do. I learned a lot about the right way to do promotion, gain fans, working hard to get things done. We really had to do it all on our own. If there was no venue you had to create a venue by renting a hall and get people to go to your events. It taught me the business side of having a band. For me personally, I was always the business-minded one, running stuff for the bands. We couldn't afford to hire someone, and we couldn't rely on anyone else, so I would learn how to do websites, how to schedule events, get involved in the promotion and business dealings. All of this helped me out with my other bands, such as Beach Avenue. Established artists would have someone that they hired with business skills. But, as a local/regional band, we had to learn all those skills ourselves the hard way. Because there was no one else, I became our band manager, band promoter, just about everything.

TR: So what was your takeaway from being in Grover Dill?

RZ: Driving around the country in a van with my best friends, going from one gig to another. Playing large and small shows in different states. We played California a few times. Played three dates on the Warped Tour. Played a show on the Santa Monica pier looking out over the water,

which was cool. We played all over. We managed to sell thousands of CDs overall, so it was pretty good. We would stop people after the concerts, "Hey, did you enjoy the show, wanna buy a CD?" [*laughs*] Lots of hustle to sell your music back then. There was no iTunes then so we weren't getting the bottom line sales. We did struggle to start up Grover Dill in Connecticut, promoting ourselves, making a name for ourselves on the radio and live concerts. We used to play three shows every weekend, two shows a night. After each gig, there would be a rush to pack up our stuff. "You got everything, you got everything?." Then we would hop in the van, go to the next show, unpack and throw the stuff up on the stage again. I mean it was part of our lifestyle, and we didn't mind it. And that's what I tell people when they ask me how I got successful in my music career with my band. I tell them you just gotta do what you gotta do. Sounds simple, but it's true. If you're like me and you love music and you love to play, you'll find a way, but you really have to work at it, you really have to love it. In college, I majored in business with computer studies. While other students were doing basic local internships in the summer, I was recording CDs and touring the country. Real-life experience, I guess. Also, I was responsible for managing and booking. At the time I had one of those old flip phones (before iPhones) and an old plug-in relic computer that we paid minutes for. I remember on one of our tours, a show got canceled. People were saying, "What are we going to do now?" So they were amazed that I could use this old computer to reach out and to reschedule. It was such a huge thing to have this computer in the van. In a way it was a blessing that we didn't have the sophisticated computer programs that we have now. Even though it was a bit tough sometimes, I was able to learn by teaching myself what worked and what didn't work when it comes to recording, scheduling and promoting our music. Now that we have all this great technology, I find I can use all my prior experience, appreciate what I had and build on it instead of just randomly clicking on some links.

TR: How did Beach Avenue form? Who formed the band?

RZ: Between late 2004 and 2010, I sat in occasionally with a few bands, you know, just jamming with a bunch of people and maybe recording a bit with them. But nothing really serious, just an opportunity to keep playing with friends. In 2010, I played in a group that participated in the battle of the bands at Mohegan Sun (Mashantucket, Connecticut). Also that year, I rented a house for me and the other band members. The house was located on Beach Avenue in Milford, Connecticut. Soon, Nick Fradiani moved in with us because he was friends with our band's vocalist.

Appendix B

At the time, Nick was playing cover gigs and bars. But what he really wanted to do was perform some original stuff that he had written. So our guitarist Nick Abraham and I encouraged him to perform his original stuff and told him we would play with him. Nick didn't seem to think it would happen. So we didn't pursue it. Early in 2011, the guy running the Mohegan Sun event e-mailed me and asked me if we want to submit again (they only pick eight from previous submissions). So I tell the guy that the band that played with at Mohegan broke up. But then I tell him, "I have a great new band I started up." So the guy says "Ok, submit those tapes." What I didn't tell him was that I made this all up. There was no new band! [*laughs*] So, like, literally I took two demos of Nick's songs, and I slapped a band name on the cover. I chose the name when I looked out the window and saw the name of our street, Beach Avenue. I also made up a bio of my "new" band to make it look good. There were about three or four hundred bands submitted. Lo and behold, I get an e-mail back from the same guy saying they picked us for the final eight to go to Mohegan and perform. So I had to call Nick, who was in Las Vegas with his buddies. I tell him "Dude, we have to make a band quick!" He seemed shocked and said, "What are you talking about?" So I explain that we were chosen to perform at Mohegan and needed to form a band because of this. Nick laughed and said, "OK, I'm in." So we quickly formed the band and rehearsed a bit. We put together five songs for these gigs, three originals and two covers. When we got up to the sound check for the first show, other band members came up to us and said, "Hey you guys sound great, how long have you been together?" They were surprised when I told them we only were together for about a month and this was our first gig together. We won the first round, we won the next round and then we won the whole thing. For the winning round, we performed "Iris" by the Goo Goo Dolls. We knew we nailed it because the judges stood up and started clapping for us, which was cool. So, literally, these were the first three shows we performed ever as a band, and we won the whole thing. Our band got a cash prize that we used to record our first EP (*Something to Believe In*), which we recorded at the Firehouse 12 recording studio on Crown Street in New Haven. We were also awarded a headlining gig at the Mohegan Sun Wolf Den. We did so well there that they had us back a number of times, and it became kind of a regular gig. Wolf Den is a nice venue. A lot of major artists perform there, nice dressing room downstairs, and they fed us well. So the band just started on a whim. I made it up out of thin air, but it all worked out.

Appendix B

TR: Who were the band members of Beach Avenue?

RZ: Nick Fradiani, lead singer and acoustic guitar, Nick Abraham lead guitar and me on drums. Also, Nick Fradiani Sr. (Nick's dad) accompanied our band for our live shows.

TR: In 2014, Beach Avenue participated in the TV show *America's Got Talent*. How did that go?

RZ: We made it to Judgment Week. Initially, we were asked what we were going to play on the show. They seemed surprised when I told them that we were going to do our original stuff, because they preferred that bands play covers. We felt strongly about this. Our thinking was that even if we lasted only thirty seconds, it would be thirty seconds of our own music. So we performed our original tune called "Coming Your Way," which went over well with the crowd, and the judges liked it. That was done at the Dolby Theatre in Hollywood. What was good about that experience, besides playing live to a national audience, was that the show did a five-minute segment on the background of the band, with pictures of our house on Beach Avenue and stuff. So because of this exposure, "Coming Your Way" began charting on iTunes and reached something like no. 53. Not only that, but also people began searching our older stuff, and our first EP began charting as well. So then we performed "Feel the Beat" on their Radio City, New York episode. But that was kind of weird because there was no audience for that show. When there's no crowd, there's not a lot of energy. We didn't make it any further, but for us it was OK because we gained twenty thousand new fans online and sold like ten thousand copies of our songs.

TR: Other than being the drummer for the band, what were your other responsibilities?

RZ: Manager, booking/scheduling agent, paid the taxes [*laughs*], everything on the business end of the band. I was the business guy of the band

TR: Who produced your songs? Who are the songwriters for Beach Avenue?

RZ: We're self-produced. We do it ourselves. The songwriters are Nick Fradiani and Nick Abraham.

TR: Where has Beach Avenue performed?

RZ: Mainly in Connecticut. We were only around for a couple of years before *American Idol* kind of changed things. Of course, we did a lot of online stuff, YouTube and whatever. Being on the *America's Got Talent* show increased our audience and sales nationally without touring.

TR: Has Beach Avenue performed on stage with well-known national bands? If so, what were those experiences like?

Appendix B

RZ: Sure. We opened for bands like Third Eye Blind, STYX, Jefferson Starship, REO Speedwagon, mainly as they came through Connecticut.

TR: When Beach Avenue opened up for these major artists what was the reception like for your band?

RZ: I have to say that Beach Avenue always went over very well. We played a show in Hamden, Connecticut, right after being on *America's Got Talent*, and the crowd went crazy. We almost got a better response than the major act. In fact, the line to our merchandise table was so long it was blocking people from getting near the stage. We played in front of thousands of fans and always managed to win them over, whether we were an opening band or the headline band. If a band is good, it won't have a problem with reception from fans because you can make stuff happen. Considering we were a band for a very short time before we began playing live, I think we did well.

TR: What is the music genre of Beach Avenue?

RZ: Pop rock.

TR: Since your Grover Dill days, how has technology changed the music business, from your perspective?

RZ: Technology has changed so much, and the music experience has shifted since my Grover Dill days. Back then, there was no Facebook, no MySpace, no iTunes, no sophisticated technology. Of course, that has all changed very rapidly over the course of the last twenty years with all the computer upgrades and all. Our Grover Dill band didn't have what bands have now. You can do a lot more online now. For example, with Beach Avenue, we were able to amass many followers online without playing national gigs. We recorded songs right from our house in Milford using this new technology. We also recorded acoustic cover videos. I would produce the videos, make them look good and put them up. People found our songs and videos online and then looked at our earlier stuff. They have an opportunity to purchase our music online directly through our website or iTunes or wherever. A totally different way of doing things since the time we formed Grover Dill. But as I mentioned previously, personal connections and networking are still very important to gain a following.

TR: What's your message to someone who is thinking about forming a band?

RZ: Always work on getting better in all aspects. It's not just the music; the music is only a part of it. Yeah, the music has to be there, but it's so much more. Your music is a product. Your music is like this bottle of soda. [*holds up a bottle*] You have to figure out, well, who likes this soda, how are you going to get to these people to get to drink your soda, where

Appendix B

are these people, how are you going to reach them, what's the best way to reach them? You have to make your stuff stand out and be different. The marketing side is more important than ever because you have so many more people recording because of technology, not even using a recording studio and owning cameras that can do awesome things. You can record a song or a music video that sounds OK right in your bedroom. But in a way, that may be the easy part. Now you have to find a way to stand out, even if it means getting out of your comfort zone. You just never know when and where your break is going to come from. Your break might come from playing live and getting attention. Or, your break might come from a record company guy who randomly stumbles on your YouTube video. It's the right place at the right time kind of thing, like so much in life. You can have the most talented band in the world but you may never make it out of the basement. There's really no foolproof formula. What I tell people who ask how to get noticed is that you always have to *kill* your performance. You need to give it 100 percent at all times. You never know when someone of importance in the music field is out there. If you're not at the top of your game on any one occasion, you just blew it.

TR: On May 13, 2015, Nick Fradiani won *American Idol*. What was the reaction of the other members of Beach Avenue, namely you and Nick Abraham?

RZ: We were there. We were rooting for him. I mean, that's your best friend up there, and we were excited that he won. We're very proud of him!

TR: What was the impact of Nick Fradiani's win on *American Idol* on the status of the Beach Avenue band?

RZ: After winning *American Idol*, Nick signed a contract with the *Idol* show as a solo artist. As long as he is under contract, the three of us (Nick, Nick and myself) cannot perform as Beach Avenue. Having said that, Nick Abraham and I do get calls to back up Nick for some of his gigs. Nick Abraham and I have played all over the country doing radio promos and shows with Nick. For example, we backed him up during his national *American Idol* tour. We also accompanied Nick onstage for his live performance in Vancouver during the 2015 Women's World Cup Soccer tournament, which was very cool. This weekend, I will be going down to Nashville to help out with Nick's latest video, which I'm looking forward to. So, even though we haven't played as Beach Avenue for a while, the three of us have opportunities to perform together and work together. And most importantly, get the opportunity to hang out together. Throughout it all, the three of us remain close friends.

Appendix B

TR: What would you say was the strength of Beach Avenue?

RZ: I would have to say the strength of the group lies with the band members and what they brought to the table. Beach Avenue was the most talented band I ever played with. Nick Fradiani has an amazing singing voice. Nick Abraham is a very talented musician. Nick and Nick are also very good songwriters. Unlike them, I'm not a guy that can sit down and start writing songs. I'm just the drummer in the band. But I'd like to think my drumming is solid, staying in the pocket driving the song, keeping everything on time and together and providing fill in parts when needed. A drummer is just one piece of the band but, if done right, an important piece of the band. I leave the singing to others in the band except for the occasional "hey" chant. [*laughs*] Also, as I mentioned, I handled the business side for the band, which I believe is extremely important. And so we all have our specific jobs that we know we are good at. A band is a unit. And if everyone concentrates on their strengths and if they all do their jobs well, then you have a successful band. It's not going to work if everyone is trying to do everything. And Beach Avenue has always been good at live performances as well as recording. But most importantly, we are like brothers. It was always a very laid back thing with us, joking around 24/7. It's great chemistry between the three of us. We accomplished a heck of a lot in a very short period of time.

TR: Up to this point, what would you say was the peak moment or moments in your music career?

RZ: There have been different moments when I've had to catch my breath, you know what I mean? When I played in front of fifteen thousand people in 2002, I'm looking out and they're all clapping and going crazy. Playing live on national TV to an audience of millions of people as we did on *America's Got Talent* or backing Nick up for his Vancouver performance. When people lining up for an hour to get your autograph or to take a picture with you and I'm asking myself "Why? Why do they want my autograph?" Knowing that what I do in a band, I can make people happy because it's a release for them, getting away from the mundane and everyday stuff. Being able to do what I love after twenty years, and on a steady climb, makes me feel good. But, as I mentioned before, the best part for me was sharing all these great experiences with band members who are my best friends. To me, those are the moments I cherish!

TR: How would you sum up your achievements so far?

RZ: Seems like yesterday I was this little kid watching some local Connecticut band with my face sweating up against the barricade. I never imagined

being part of a successful band, touring the country, playing music in front of thousands of people or to a national TV audience. And I got to do that in a band with my best friends! Kind of crazy when I think about it. Sitting at my drums in some TV studio with all these cameras around me or staring out at thousands of concert-goers, I sometimes reflect on how it all began for me in my basement at home and how I got to this point in my music career. I have appreciated every new experience on this wonderful ride.

INTERVIEW WITH KATHY KESSLER OF THE SIN SISTERS

MARCH 24, 2016

TR: Where were you born and raised? What schools did you attend?

KK: I was born and raised in the Fair Haven Section of New Haven, Connecticut. I attended St. Rose Elementary School in New Haven and Sacred Heart Academy High School in Hamden, Connecticut. Janice Ingarra also attended these same two schools. I've known Janice since kindergarten.

TR: Did you sing in school?

KK: Janice and I were in a gospel choir at St. Rose Church when we were in seventh and eighth grade at St. Rose school.

TR: When was the first time that you sang publicly?

KK: It was in my senior year in high school. I wanted to be in the *Wizard of Oz* play at Sacred Heart Academy so I auditioned for the part of Dorothy. When I was back in class, I hear over the loudspeaker, "Murphy get down to the office now" (Murphy was my maiden name). I thought I was in trouble since I was always getting myself in trouble there. The head nun told me that I would have gotten the lead role in the play had I not been such a clown in school all the time. She did give me a bit part in the play. More importantly, the nun asked me to participate in an upcoming father-daughter function at the school. So I got to sing "Somewhere over the Rainbow" in front of the entire school in the auditorium. Because of this, my parents arranged for me to get voice lessons in New Haven with the famous opera voice coach Hilda Riggio. By the way, Janice got the lead role of Dorothy in the play [*laughs*] and I kid her all the time about that.

TR: What was the first group you sang in?

Appendix B

KK: I sang with a number of groups for a short period of time. I would say the Motor City Band was the first group that I performed with for a good amount of time (1981–1984). Two guys and myself were the lead singers of this band, and we performed throughout Connecticut. We sang all the Motown hits.

TR: Who were Bobby and the Angels?

KK: After leaving the Motor City Band, I decided to form my own group. So I put an ad in the paper. I already got my brother-in-law to be the drummer in the band. And Janice also agreed to be in the group. Patti Rahl responded to the ad. Patti auditioned, and we all agreed that she should be part of the group. Patti also attended Sacred Heart Academy. We called ourselves Bobby and the Angels. Bobby was a guy in the band, and Janice, Patti and I were the Angels. The three of us were the lead singers in the band. We sang a lot of Motown and swing music. Bobby and the Angels were together from 1987 until 1993.

TR: When did you join the Spectacles?

KK: Immediately after Bobby and the Angels, Janice, Patti, and myself joined the Spectacles. We sang a wide range of music, including classic rock, Motown and swing. We were with the Spectacles for twelve years.

TR: When did the Sin Sisters form?

KK: We became the Sin Sisters in 2011.

TR: How did they come up with the name the Sin Sisters? Who named the group?

KK: At rehearsals, Christine Ohlman would refer to us as the sisters of sin. A former band member also did the same thing. I guess it was a take on the Bobby and the Angels name. On stage, Christine would introduce us as the Sin Sisters. And the name just stuck. So we went from the Angels to the Sin Sisters. [*laughs*]

TR: What are the vocal ranges of the Sin Sisters?

KK: I am the high voice range, Janice is middle and Patti is low voice range. I think it's referred to as soprano, mezzo soprano and contralto. Something like that.

TR: Who are the backup musicians for the Sin Sisters?

KK: Ricky Jordan (lead guitar), Jimmy Ledoux (drums), Ed Montesi (keyboards), Ed Soufer (bass). Also, Patti's husband (Don Rahl) has backed us up at times on bass guitar.

TR: Where was the first place that the Sin Sisters performed?

KK: It probably was when we performed on the *Liberty Belle*, the little boat that took off from Long Wharf. That was kind of cool.

Appendix B

TR: What well known groups or bands have the Sin Sisters performed with onstage?

KK: We opened up for a bunch of good artists such as NRBQ and Lou Christie. We were also on the same venue as Snoop Dogg and other major acts. Of course, we also performed with Christine Ohlman as her backup singers. We also performed at the Mystic Connecticut Blues Festival with Christine. We shared the stage with great performers like James Cotton, Johnny Winter and James Montgomery.

TR: What was the biggest venue that you performed in?

KK: We performed at the B.O.M.B. Fest in May, 2011 as backup singers for Christine Ohlman and her band (Rebel Montez). That was at the XL Center in Hartford, Connecticut. The Mystic Blues Festival was also a big deal. Smaller venues which were great included performances at Café Nine and Toad's Place.

TR: What is your touring area?

KK: Mainly Connecticut, although we do occasionally perform at events in New York, Rhode Island and Massachusetts.

TR: What is it like performing with "The Beehive Queen" Christine Ohlman?

KK: She's cool. She's a real pro who knows what she's doing. She really keeps us on our toes, or else! [*laughs*] Christine lets us express ourselves artistically, which we really appreciate!

TR: Have you or the Sin Sisters ever recorded?

KK: Yes. We recorded "The Storm" as backup singers to Christine Ohlman. "The Storm" is featured on Christine's *Strip* CD and on her *Re-Hive* CD. The recording took place at Wallingford's Trod Noessel Studios. You can also find our group backing up Christine on YouTube on such songs as "Our Day Will Come," "The Grown-Up Thing," "Born to Be Together," "The Storm," "The Cradle Did Rock" and many others. Also, I did some radio commercials and jingles for Chevrolet, Longaberger baskets and things like that. [*laughs*] These were done at Vic Steffens' Horizon Recording Studio in West Haven, Connecticut. Vic Steffens is Christine Ohlman's brother.

TR: Who is the manager of the Sin Sisters?

KK: Lisa Reisman is our manager and promotes our group.

TR: What would you say is one of your fondest memories as a member of the Sin Sisters?

KK: It would have to be our association with the Branford Tree Lighting Festival. Branford is our hometown, and our hometown always embraces

the Sin Sisters. For many years, we have been a part of the festival. Every year, we ride on the best float in the parade, singing our songs, from Branford High School to the green. Thousands and thousands of people line the streets. We then perform right before the tree lighting. It's a big deal in the town and a very special honor for us.

TR: What is your message for anyone who is thinking of forming a group like yours?

KK: Things have changed so much in terms of playing live gigs. It's getting harder to find places to play because, for cost purposes, owners of establishments opt for recorded music instead of live bands. I would tell anyone that was thinking of forming a band that they would have to do it for the love of music. Because that's what it really comes down to—the love of music. Take whatever gig you can get. Even if it pays little or no money, take the gig. Build up your reputation, work hard, practice constantly, promote yourself, get your name out there and hope that someone discovers you and your band. Most of all have fun.

INTERVIEW WITH KEN "FURVUS" EVANS OF THE FIFTH ESTATE

The following interview is reproduced with permission from Mike Dugo (www.60sgaragebands.com).

60sgaragebands.com (60s): You had previously been a member of Three Hits & A Miss. How long was that band together? Did you record?

KE: The band was together for about two years and did not record. But for me the real early band that got me going was The Coachmen. This was from '58 to '61, so I was 14 when this already existing group of twenty-year-old guys hired me.

60s: The D-Men recorded four demos at Dick Charles Studio in '64. Other than "Miserlou" and "Don't You Know," what were the other songs recorded'

KE: "That's What They Say About You"—not sure of the other.

60s: The group also cut five more songs at A&R Studios in New York. Do you recall these sessions?

KE: Yes—pretty much. We recorded "That's What They Say About You" (I don't think it was ever released), "Messin' Around" (written by Rick

Appendix B

and me and released as the B-side to "(No No) I Just Don't Care"). The other was "No Hope For Me," which became the B-side of our second release which we rerecorded ("Don't You Know") and which I believe made bubbling under noise, and was a 1010 WINS (NYC) Murry the K pick of the week after winning his call-in contest. "Messin' Around" was the original title of the song later released as "Moussin' Around." Why they changed the title before release I am not sure except I vaguely remember that it had something to do with a joke Soupy Sales had done at that time and a song he released around that. The real title according to me—one of the writers—is "Messin' Around!" These sessions were all particularly memorable to me especially being a drummer. At that time with the limited number of tracks available if we didn't record in live mode, everything at once, we recorded (for separation and control purposes) in layers a few instruments at a time—usually bass and drums first and maybe a guitar if I was lucky. Trying to put feel into these pieces often without so much as a scratch vocal track was difficult at best and nearly impossible at times, although by the time we later recorded "Ding Dong The Witch Is Dead," we were pretty good at this. Its original track is just bass and drums, and it felt good enough to break the top ten in New York City—and almost nationally.

60s: What do you recall about the D-Men's appearance on HULLABALOO?

KE: The biggest thing was—with our sound and style—that they had us on at all! We truly had a garage sound then (basement really—that's even lower), with a lot of what later would be known as a punk attitude, but for us it was real—not prefabricated. We just didn't know any better I guess. All the acts on HULLABALOO had hits and were usually in the Top 10. We had just released our first single, but were somewhat well known around the Metropolitan area. We had been on several other TV shows and had continuous live playing dates in and around NYC, but nevertheless we were all surprised.

60s: Do you recall which other shows the band appeared on?

KE: Several others and a very popular New York City TV rock show hosted by Clay Cole. We did this show several times. These were pre-taped and as I recall we were on a taping session with The Rolling Stones just as they were beginning to get known in this country. They had just done their thing and had finished with the dressing room we were now using. All I can recall was the rather "heavy air," shall we say, left behind by The Stones. We also did quite a number of other TV shows around the country, but the one that sticks out was a local TV show we did down in Philadelphia,

Appendix B

I believe. We were to lip-synch it, so to make it a bit more interesting we plugged our guitars into each other and I went out into the back alley and brought in a bunch of trash cans to pound on for drums. It was probably the birth of trash music as it is played today. We also remember being on other TV shows in Philadelphia and also in South Carolina...Greenville I believe. Also in Kansas City and then at least twice on *Upbeat* in Ohio, once with our friends The Music Explosion, and also with another of the Greenwich Village bands, The Velvet Underground. We did most of these shows several times. It was always a good sign when you got invited back. We usually did.

60s: What prompted the band to change names to The Fifth Estate?

KE: Our manager (might as well lay one on him) had suggested the D-Men idea, probably thinking it was memorable and "cute" or something like that. We went with it for a while, but it really didn't fit, certainly wasn't "cute," and was often spelled wrong. Many spelled it The Demon. This lost us a lot of church hall gigs, which were common when we were starting. So we decided to "upgrade." The Fifth Estate was a take-off of the Estates system (sort of class system) in France after the French Revolution, which worked its way down from the leader, then clergy and then nobles, being the First, Second and Third Estates. The press became known as the Fourth Estate. The Fifth Estate then was the people, the common people, and the populous.

60s: What were the primary differences between the periods when the band was known as "The D-Men" compared to as "The Fifth Estate"?

KE: There was a flow between those periods without missing a beat let's say, but The D-Men were the earlier form that evolved into The Fifth Estate. So the D-Men experienced all the early growing pains and The Fifth Estate had most of the fun.

60s: Would you say you were more popular as The D-Men, or as The Fifth Estate?

KE: The D-Men were known in the East and in New York City in particular and our local fans in Fairfield County were just incredible. As The Fifth Estate, we had more radio success and the hit with "Ding Dong" and became nationally known, traveled and played more widely all over the country several times with bands like The Turtles, The Lovin' Spoonful, and a major package tour with names like The Easybeats, The Music Explosion, The Buckinghams and Gene Pitney.

60s: Are there many songs in the vaults that were never released? Have any live tracks survived?

Appendix B

KE: Many did not make it and remain in the Abbey Road vaults, I believe. In fact, my favorite and the favorite of many if not most people who really know the band is "Tomorrow Is My Turn" (maybe this holds a hidden meaning?) and that is not on there, except for a bit of a demo of the track only. Plus, the final and best recording of "Number 1 Hippie On The Village Scene," which is a gas-gas-gas as far as I am concerned, is not on there. There are many that we cannot get the masters for, as the cost of what is being looked for does not seem justified at the moment. Now that the band has been reintroduced, as it were, with the retrospective "Ding Dong The Witch Is Back," available through Boston Skyline Records (Boston, Massachusetts) it would be great, I think, if the ultimate Fifth Estate CD could be released. The retrospective was just that. It was put together for collectors primarily. It shows the many different things the band could do and the different writing approaches Wayne and Don took. It really was a monumental effort. A new CD would simply be a "best of album" of 20 or so of the best cuts (some unreleased) from a relatively good, very creative '60's rock & roll band, that may not have gotten for one reason or another as much attention then as it could have. Yeah…there are live tracks. We have some around. In our minds at the time they were not so much intended as recordings to be released as much as just to allow us to hear ourselves live at future practice sessions. We couldn't tell at all how we sounded live while playing since monitors did not exist. If the sound system speakers where turned in towards the band so the singers could hear each other, the mikes would just feed back. We really had to know our parts and hope for the best. Things were especially interesting for me when we played in a big place and I was up on a riser behind the amps down in front. Then I didn't even have that much to listen to. It was only drums that I could hear on many nights. We played six sets a night, six nights a week for months at the Downtown in Greenwich Village, our Hamburg Star-Club I guess. This was before our major tours and it really prepared us for these larger venues. This and those live tapes really helped us and held us together.

60s: The D-Men/Fifth Estate recorded some really strong/excellent songs ("I Just Don't Care," "Love Is All A Game," "So Little Time") yet it is "Ding Dong! The Witch Is Dead" that the band is primarily remembered for today. What are your thoughts on that?

KE: Thank you for your kind and unusually perceptive comments and question. Now you have come to the heart of it! Is it as simple as a novelty tune that kills a band? I don't think so. I think it is more that the creativity

Appendix B

and therefore novelty of the band was not fully understood before "Ding Dong," and without this context for a fan base to understand against—"Ding Dong" was so different that people did not know what to make of it, nor did the radio people then understand where we were coming from with follow-ups. Not knowing the band they wanted more "Ding Dongs." Imagine if The Beatles had not fully surfaced until a point where "Rocky Raccoon" was their first major hit. Would things have gone differently? Maybe somewhat, though probably not in the long run because they were so freakin' great. But with us, more marginal talents to be sure, it did make a huge difference that people did not already know that we were a legitimate (whatever that means) hard rocking band with punk and pop rock instincts and with a very high dose of creativity. Many of the styles and sounds we played we made up. "So Little Time" was the heaviest thing anyone had heard to that point. These were not common styles and sounds at the time. We were creating all the time. All are influenced from what went before to be sure, but many, as they were played by us, were leaps forward (although there were some that were definitely leaps backwards too—I think we buried most of those). Although most sound common today, many of these styles and beats ("No No I Just Don't Care"), sounds (eight string guitar in "That's Love"), and musical combinations (a renaissance dance piece plus a movie score in "Ding Dong") had not previously existed, at least not that we were aware of anyway. One thing that has always confirmed all this in my mind is that Brian Epstein, The Beatles manager, knew of us before "Ding Dong" and became serious about signing us. This, unfortunately for us, was ended by Brian's untimely death. But prior to his death we were checked out by him and invited to parties put on in New York City by Nemporer, the U.S. arm of his management business. We also understood that George Martin rather liked what we had done with "Ding Dong" by combining classical music, harpsichord and rock. Actually another reason he may have liked it is because it probably sounded so familiar yet still different to him. This was partly because on that one I didn't make up anything, I simply stole Ringo's beat on "Nowhere Man." But on all this we will never know. Woulda, shoulda, coulda. Ahh, now that *is* Rock & Roll.

60s: What were your personal thoughts when first hearing "Ding Dong"? Bubblegum/novelty or not…the song is admittedly catchy.

KE: It's neither bubblegum nor novelty. I'd say it's creative! When I first heard "Ding Dong" or "The Witch is Dead" as I prefer to call it, played by Wayne on piano only, what stood out to me was the Renaissance

dance section in the middle, which I thought was a marvelous vehicle for Wayne to showcase his harpsichord skills, which were considerable for a 19/20-year-old. I then tried to figure out what kind of rock beat would pull all these diverse elements together and as I have already said, I simply ripped off Ringo's "Nowhere Man" beat. I hope he forgives me. Management certainly tried to sell it under the label of bubblegum, but it didn't fit. It was too complex and sophisticated for that market. But it is true that radio programmers treated it as a novelty and they had no idea where the band was coming from or how creative it was when with the follow-ups they simply wanted more of the same, another "Ding Dong." For this reason I don't feel they ever gave the follow up releases that were a more "average us" a good listen or a fair chance. It wasn't what they wanted and already expected, so that was that.

60s: Would you have been satisfied with the band's accomplishments had The Fifth Estate never recorded Ding Dong?

KE: Wow—this "Ding Dong" thing is going to be ringing in my head tonight. I haven't thought about it this much in quite a while. But, to answer the question, no—I am glad we did it. We may never have had the opportunity to do many of the other things we did do if it wasn't for that song, but as I said I would have liked that hit after we had had a few others first. Hey, who wouldn't? But I would have sacrificed a Top 10 "Ding Dong" hit for, let's say, a Top 20 hit of one of our less quirky rock tunes. This could have been and probably would have been better in the long run for the band if it ever had happened. But that's a big IF! Who knows…we might still be playing today if it did. But to give up the success we had due to "Ding Dong" without having another hit in its place, no way!

UPDATED INTERVIEW WITH KEN EVANS OF THE D-MEN & THE FIFTH ESTATE.

On May 2, 2016, I interviewed Ken Evans as an update to the interview conducted by Mike Dugo of www.60sgaragebands.com

TR: Thank you for agreeing to this interview.
KE: It's a pleasure, Tony.
TR: Ken, Tell me a little bit about yourself and the other Fifth Estate band members. Where did you grow up? What schools did you attend?

Appendix B

KE: All five original band members are from Stamford, Connecticut. Wayne Wadhams, Ricky Engler and myself are from the Springdale section of Stamford. Bill Shute is from the Ridges section of Stamford. Doug Ferrara is from Stamford's Glenbrook section. I went to K.T. Murphy Grammar School and Stamford Catholic High School. Incidentally, I was a schoolmate and friend of Jimmy Ienner (founding member of the Barons) at K.T. Murphy School. I got my undergraduate degree from UConn and my law degree from the New England School of Law. (I practiced law and entertainment law in Connecticut until the early 2000s.). Ricky also graduated from Stamford Catholic High. Wayne and Bill attended Rippowam High. Doug graduated from Stamford High School. Chuck Legros was also a band member for a brief time in 1966. Bob Kline is a member of our reunited Fifth Estate band. Bob replaced me when I left the Fifth Estate in late 1969. Bob is from Stamford and attended King School. Both Bob and Chuck are from Stamford. We all grew up in close proximity in Stamford neighborhoods, and we have always been close friends, kind of like brothers.

TR: Growing up, who were the drummers you admired?

KE: Alvin Stoller, Louis Bellson (double bass guys) and, of course, Buddy Rich.

TR: How would you describe the D-Men band? Did you have a good fan following?

KE: The D-Men band was known as a very good live band. We were not a straight-up subdued pop band that AM radio would love. We were a high-energy rock 'n' roll band. We wrote our own material, and we were a very creative, independent band. Even before we changed our name to the Fifth Estate, the D-Men got a lot of radio airplay, especially in the Northeast. As we kept going our music took on a sound more geared to FM radio. The D-Men had a very large local following. Our fan club consisted of thousands of fans from New York to New Haven. The local fans were fantastic and very supportive. At our first gig at Ezio Pinza Theatre in Stamford, the fans stormed the stage, which was very intense. This happened at other concerts also. We performed in a lot of concerts throughout the Northeast. We were also comfortable in the recording studio. We learned how to step up to the microphone and play our music straight through. Our band never needed a backup group or studio session musicians. So what you hear on the recordings was pretty much how we sounded in concert. We put out a lot of music, and we had no difficulty recording.

Appendix B

TR: What was it like playing in Connecticut in the early days?

KE: Connecticut was a great "proving ground" for rock 'n' roll groups. Bands like ours liked the fact that Connecticut was located between New York and Boston. Bands would play in places like Stamford, New Haven or Hartford. And then, if you made it big there, you could very well end up in places like New York or Boston, where the music and radio markets where bigger and more influential. Connecticut has always been a good place to "earn your chops." There always was a good, solid rock basis in Connecticut. Many people don't understand that.

TR: Murray the K once banned the D-Men songs on his WINS radio show. What happened?

KE: Murray the K had this weekly call-in contest. The fans were to call in and vote for their favorite bands. One week, the choice was between the Animals, the Dave Clark 5 and the D-Men. Because we had such a large following in New York City and Connecticut, all our fans called in and flooded the lines. So we won the contest. However, Murray the K felt that we had somehow "rigged" the contest (which we didn't) and stopped playing our songs. The funny thing about all of this is that later on when our songs like "The Witch Is Dead" hit it really big in New York, Murray the K loved them and played them constantly, not knowing that the Fifth Estate was really the D-Men band that he had previously banned on his station! [*laughs*]

TR: How did your band get signed to a recording contract?

KE: We were playing at the Paradise bar in Stamford, that was across from our practice hall on Camp Avenue. Kevin Gavin, our first manager, signed a management deal with us. After the usual demos, he got us a deal with United Artists (and its subsidiary VEEP record label). The label changed our group name from the original band name, the Decadants (knowingly misspelled) to the D-Men.

TR: The D-Men performed on *Hullabaloo* in March 1965. Looking at the video of the D-Men on that show, there seemed to be lot of energy between the band and the audience.

KE: You're right. The D-Men was a very energetic band. Everywhere we played, we felt a great deal of energy in the crowd and a real connection with our audience. The show was co-hosted by Brian Epstein and Michael Landon. Dionne Warwick was one of the performers on the show. If you look closely at the YouTube video, you will see that our band even got Michael Landon and Dionne Warwick dancing to our music! [*laughs*]

TR: How would you describe "Ding Dong! The Witch Is Dead?"

Appendix B

KE: It was a creative merge of rock and classical baroque. Definitely not a novelty song as a few critics would have you believe. In fact, it wasn't that different than what George Martin was doing with the Beatles, since Martin had just begun incorporating the harpsichord in some of their songs. That song had a very legitimate reputation when it was going to no. 1 all over the place. Over time, people began to appreciate the baroque classical music we incorporated into "The Witch Is Dead" and some of our other songs. Michael Praetorius was a prolific classical composer of the seventeenth century. We incorporated Praetorius and other classical composers in our music, and people began to take notice. Yet we always basically remained a rock 'n' roll band, especially in live shows.

TR: I heard that "The Witch Is Dead" was sung in several languages. Did the band members actually sing in those languages?

KE: Yes. We sang "The Witch Is Dead" in five different languages, phonetically, thanks to crash courses from the Berlitz people.

TR: Obviously, "The Witch Is Dead" was a huge hit in the United States (charting at no. 11 on *Billboard*) and an international hit as well. The song was also a number one hit on local radio stations across the country. Did any of your other songs chart outside the United States?

KE: Yes. We actually had hits all over the world. For example, "Morning Morning" was a hit record in Australia, "Heigh Ho" was a Top 40 song in Canada. "That's Love" was big in Brazil. And, believe it or not, we were a hit in Turkey and other places that you would never associate rock music with, at least in those days.

TR: Speaking strictly as a drummer, what would you say is your favorite D-Men or Fifth Estate song?

KE: As a drummer, I would have to say it is "Night on Fire," which is included on our *Fifth Estate Anthology* CD. We recorded that song at Doc Cavalier's Syncron Studio (now known as Trod Nossel) in Wallingford, Connecticut.

TR: What is the connection between the Fifth Estate and the rock band AC/DC?

KE: Harry Vanda and George Young of the EasyBeats were also co-producers of the early AC/DC albums. (We toured with the EasyBeats for months.) George is the brother of AC/DC's Angus Young. I knew Harry and George very well and had dinner with them many times. At one such dinner, they mentioned that they were inspired by the Fifth Estate's use of bagpipes in our song "Do Drop Inn." Because of this, they decided to incorporate bagpipes in AC/DC's hit rock anthem "It's a Long Way to the Top (If You Wanna Rock 'n' Roll)." They got that right! It surely is!

Appendix B

TR: Did the Fifth Estate share the stage with other Connecticut bands or artists?

KE: Absolutely. Several Connecticut artists and bands that we performed with that immediately come to mind are Gene Pitney, the Bluebeats, the Wildweeds, the Barons and the Shags. In the Stamford area, there was a very good local band that we were friendly with called the Wheels. That band had a drummer by the name of Bob Kline who ended up taking over for me when I left the Fifth Estate. The group also had a guitarist by the name of Mick Leonard who joined the popular Connecticut group called the Simms Brothers. My best drummer friend was Greg Chesson from Stamford. Greg studied with Louis Bellson, performed with Buddy Rich's band, toured with Woody Herman's Herd and was a drummer with the fantastic Wayne Cochran and the CC Riders. We jammed together all the time in high school. Also, some of our very early vocals that can be heard on our album *Surf, Rock & Fuzz* were inspired by the Connecticut folk group the Highwaymen.

TR: What would you say was the strength of your band?

KE: The strength of the band was that we did things ourselves and in our own way. Whether it was the D-Men or the Fifth Estate bands, we did things on our own terms. Our sound evolved from surfing instrumentals in '63, to pop/rock tunes in '64, to edgier rock 'n' roll in '65, adding more R&B in '66 and adding more harpsichord and psych in '67. All without losing our rock and roll dance band center EVER—even today! We kept things interesting by venturing into very creative, innovative paths such as merging baroque and rock music. I was fortunate to be in a band with guys that I grew up with and who were very talented. One of the things I'm most proud of is that our band lasted a long time, from a rock band's perspective, from 1963 until 1970.

TR: What were some peak moments in your career?

KE: I have to say that right now is a highlight. We had seven wonderful years together as a band. And, after all these years, we are back together, recording, performing and I'm co-producing with the great Shel Talmy. Receiving favorable comments from Shel Talmy is and always will be the highlight of my musical career. During the course of our career we performed with so many great bands and artists it's hard to point to any one moment. Certainly, the Gene Pitney Tour was a highlight. Also, the tour we did with the Turtles and the Lovin' Spoonful was great. As the D-Men, we did a sold-out show at Fairmont Memorial Hall in Philadelphia with an audience of thousands and thousands of people. The fans wouldn't let us

get off the stage! An exhilarating rock 'n' roll show. We ended up playing for two hours, with ten encores. We incorporated a lot of harpsichord live in that show. So many memories!

TR: How would you sum up your achievements as a musician?

KE: As a little kid playing drums in my parents' basement, I never dreamt that there would be a time when I would be performing on the biggest stages in the world and to tens of thousands of people. I started playing out at age fourteen, playing in small clubs and teen centers from New Haven to Mamaroneck, New York. We called those first dates the Post Road tours. Before I knew it, our band was playing in arenas and stadiums to sixty thousand fans. As a musician, I got to play some complex and difficult things, which not many drummers had the opportunity to do at the time. To get to the point of playing to crowds of that size and hold your own as a musician, is a fantastic feeling. And then to have records that made it big on the national and international music charts! Just a tremendous feeling!

For more information on the D-Men and the Fifth Estate visit www.thefifthestateband.com and www.YouTube.com/The Fifth Estate Band.

INTERVIEW WITH RAY LAMITOLA OF SOUTH MICHIGAN AVENUE

DECEMBER 10, 2015

TR: Where were you born and raised?

RL: I was born and raised in Waterbury, Connecticut.

TR: Growing up in Waterbury at an early age, who were your musical influences—groups or solo performers—who influenced you?

RL: It would have to be the male vocalists at the time. Guys like Dion, Bobby Rydell and later Lou Christie. I liked Christie's high voice, thought it was great. I liked their style and their sound. And also their vocal range. They were different than the "softer" sound of guys like Bobby Vinton.

TR: And the girls liked them.

RL: Oh yeah, that they did. They had the cool hairdos and all.

TR: How did you first get interested in the guitar?

RL: At the time (and I guess still today) the guitar was very cool. A lot of kids early on (at least in Waterbury) played the accordion, believe it or not. But

Appendix B

I thought the guitar was the really cool instrument to play. I remember I begged my father for a couple of years. He finally agreed, providing I practiced every day, which I did.

TR: I assume, like me, purchasing a guitar was a big deal for your parents, mainly because of the cost. Was that the case?

RL: Sure. Like I said, I had to convince my father that I would practice every day. I knew it was a bit of a financial burden for him, so I was committed to living up to my end of the bargain, and I did practice every day. I found that the guitar was a tough instrument to learn at an early age. My grandson is taking guitar lessons now. He's only seven years old. It's hard to get even a few notes out when you are only seven. Finger placement, holding the strings down and playing notes and things like that. Tough to do at that age.

TR: The male vocalists you mentioned, from what I remember, didn't really play any instruments when they performed. They were known more for their singing and vocal style. So who would you say made you want to play the guitar, as opposed to any other instrument?

RL: That would have to be Duane Eddy and Elvis. Those are the guys that got me interested in the guitar.

TR: Do you have any brothers or sisters and were they any influence on your musical interests? I ask this because I grew up sort of at the tail end of the peak period of guys like Elvis and Jerry Lee Lewis. My older brother was a big fan of both those guys, probably more so with Jerry Lee. My brother would bring home these great records, and he and his friends would listen to all these new recordings at the time. Even though I was three years younger (which was a huge age difference at the time), I really developed an appreciation for their music.

RL: Same here. But in the case of my older brother, it wasn't until later on that I learned about all these great bands from hanging around him. He had a keen knack of predicting which bands would become big time. This got me interested in rock bands early on in the '60s when the rock bands first came out. It just changed everything for me.

TR: What was your first guitar?

RL: My first electric guitar was a Les Paul Jr., which I wish I still had today because it's priceless.

TR: Who and where did you get guitar lessons from?

RL: Carl Scarzella, who was a jazz guitarist, down at Mecca music. There weren't many places to go for lessons at the time. It was convenient since it was downtown on the bus route, around were Bauby's was. Once a

week, I took the bus down, and my father would pick me up on the way home from work. Lessons were a bit boring because it was just learning chord formations, scales and things like that. Didn't really play songs when I was taking lessons. It seems kids today learn songs much quicker than I did.

TR: So how did you put it together to play songs?

RL: Once I learned chord formations and how to strum, I tried to play songs I heard on the radio. When I was about ten, I was on the radio, WWCO, and I played "Lady Luck." I sang and played "Lady Luck." [*begins singing "Lady Luck"*] I just loved singing and playing in front of people. I was attending Our Lady of Mount Carmel grammar school at the time. Someone there may have encouraged me to go on the radio show, I'm not sure.

TR: The Lloyd Price song, around 1960?

RL: Yep, that's it.

TR: So when did you actually begin playing in your first band?

RL: Around 1964 or 1965, I had heard one of the local kids who lived down the street where I lived, Hans Avenue, had formed a band and he was looking for a guitar player to replace the kid who was leaving the group. The kid who started the band was a guy by the name of Mario Infanti. He had me rehearse with the band, and Mario and I hit it off right away, and I joined the band. Mario called his band the Flares.

TR: What kind of songs did the Flares play? Where did the Flares perform? Who were the band members?

RL: We would play songs like "Louie Louie" and other songs that were popular at the time. Also, '50s rock 'n' roll. Our first real gig was at a place called Gugie's Supper Club in Waterbury. We played in the bar area, and we had to have an older person with us because we were all underage. I was the oldest in the band at age fifteen. We also played in other local Connecticut clubs such as the Shack. I remember, at one place, we were scheduled to open up for Frank Sinatra Jr. and then be his backup band, but he never showed up! [*laughs*] We also played in the Battle of the Bands in Waterbury. We came in second place. In the summer of 1966, we picked up a nice gig at an establishment for a week. They even paid for our stay at a nearby hotel. Around this time, we were playing songs by groups such as the Kinks—great band! The Flares consisted of Mario Infanti on lead guitar and vocals, Carmen Farino on drums, Ron Migliarise on bass and me on rhythm guitar and vocals.

TR: When did the Flares break up?

Appendix B

RL: The Flares disbanded in 1967. I graduated from Sacred Heart High School (Waterbury) that year. The other band members decided to go their own way. It was an amicable breakup.

TR: How did you become involved with South Michigan Avenue?

RL: In 1967, my first year at Sacred Heart University (Fairfield), I met Jerry Rorabach, a drummer and founding member of the Metones, which was a popular group in and around Waterbury. Jerry was looking for a guitarist, and he asked me to join the group. We changed the name of the group from the Metones to South Michigan Avenue (after the song by the Rolling Stones).

TR: Who were the band members of South Michigan Avenue, and what instruments did they play?

RL: As I mentioned, Jerry Rorabach was the band's founding member and drummer. In 1968, Jerry left the band. Carmen Farino, the drummer from our former group the Flares, joined our band. For a short time in 1969, we added Thom Serrani (from SHU) to help out on vocals. Tom had a really good voice, kind of a BJ Thomas voice. Soon after, Tom graduated from college and left the band. Years later, Tom became the mayor of Stamford, Connecticut. The last couple of years, our keyboardist left, and we replaced him with Peter Kucas. And so, over the years, South Michigan Avenue included Jerry Rorabach on drums, Joe Mullen on bass, Carmen Farino on drums, Ray Garbitini on keyboards, Peter Kucas on keyboards, Tom Serrani on vocals and me on lead guitar and vocals.

TR: What was the touring area for South Michigan Avenue?

RL: We played a lot of clubs and places in New York, towns like Brewster and Carmel. We played in a lot of clubs in Connecticut and New York, such as Carol's Barn, Brewster Lanes, the Hullabaloo and the Shack. But our home base was Gugie's Supper Club on West Main Street in Waterbury, which we played on a regular basis. That was a great spot, like playing in New York. Other Connecticut groups like Stonehenge, the Shags, the Electric Elves played there. I also remember the Last Word performed there. We got to know members of some of the groups such as Yesterday's Children, who had a local hit called "To Be or Not to Be." But we were never in competition with them, I guess because we played in different places than they did.

TR: What was the music genre of South Michigan Avenue?

RL: We covered many of the major groups at the time, as long as it fit our style and we were able to perform the songs well. Grand Funk Railroad hit the scene in 1969 or 1970. For some reason, my voice seemed to fit

Appendix B

Mark Farner's voice pretty well, so we had success playing a lot of Grand Funk, driving hard rock. As things progressed, we played a lot of Santana. We had a B3, which fit in nicely. Couple of years later, we would cover groups like Kool and the Gang and CCR.

TR: Did you ever play on the same stage as any national groups or performers?

RL: We opened for the Happenings when they played a concert at Sacred Heart University. We also opened for the Chambers Brothers. Our band decided to perform Steppenwolf's "Magic Carpet Ride." Only problem was I knew it didn't fit my voice. So we called in Mario Infanti who was previously with the Flares. Mario did a great job with the vocals on that song.

TR: What would you say was the strength of South Michigan Avenue?

RL: Our strength was we didn't do anything we couldn't do. We were all decent musicians. We had a nice song selection. If a song came out that we liked we would try it, but if it didn't meet our expectations, we didn't do it. We were a cover band, but we were a good cover band. There were a lot of really good bands in the '60s and '70s in Connecticut.

TR: When did South Michigan Avenue disband?

RL: We played until 1986.

TR: Looking back, what would you say was the best part of being in a band?

RL: I feel I was fortunate to be in two bands where everyone got along. We were like brothers, and the camaraderie was great. I don't care if you're small time or big time, the hardest thing is to stay together as a band, to check your egos and get along as a group. When my son Michael was twenty and learned the guitar on his own, we started playing together acoustically. We played in a restaurant at Farmingbury Hills Country Club, and the place was packed. Playing next to my son Michael—it doesn't get any better than that. My son convinced me to play on my own. Which I have been doing.

TR: The '60s and early '70s are known to be a somewhat crazy time for many bands. Fun but a little bit crazy. Don't you think?

RL: Yeah, especially for some groups I guess. Especially if the band members weren't getting along or if there was a lot of booze or drugs involved, I guess. But I can honestly say that the groups I was in did not get into that stuff. We all got along very well. That's not to say we didn't have some interesting and fun moments. I remember driving back from New York, we had a really big red truck with our name boldly painted on it. I was driving on Route 684 at three o'clock in the morning, the other guys are

asleep and the New York state police pulled us over. I guess we looked suspicious with our really long hair and our big red truck. The New York state cop comes up to the door with a flashlight and points to a paper bag I had between the front seats. He asked what's in the bag. I told him Girl Scout cookies. The cop thought I was being a wise guy and was about to pull us out of the truck when I explained that my daughter was selling Girl Scout cookies. He was convinced when he opened the bag and saw Thin Mints and Do-si-dos cookies. He got a kick out of it. He then told me that I should have one of the tires checked because it looked like it was going bald. After that the cops would flash their lights at us when we drove by, as a friendly gesture. Then one night we get a flat tire on the highway. The same cop came by laughing and said to me, "I told you so".

TR: Good story. You had said that you had to beg and convince your father to buy you a guitar when you were young. Do you think he was glad he did? Do you think he was proud of you?

RL: Oh yeah, he became my biggest fan. I was second only to Neil Diamond; he loved his music. I swear if my father had the opportunity to choose who his next son would be, it would be Neil Diamond! [*laughs*]

TR: Looking back, what would you say was the peak of your music career? What was a big highlight moment for you and your band?

RL: For me, I'd have to say it was in the early '70s when we covered Grand Funk Railroad and Santana. I thought we really nailed those songs. A highlight for us was New Year's Eve 1971, when our band played in the Grand Ballroom of the New Yorker Hotel overlooking Times Square. That was really something special. Also, in those days, bands had really big equipment. One day, I remember looking at our setup, and if you didn't see us standing there you would think someone like Sly and the Family Stone was on stage. We had the B3 with the big Leslie speakers, the dual showmen, speakers all over the place and a clear set of drums. It was cool to look at.

TR: In closing, how would you sum up your achievements as a musician?

RL: I'm just a typical small-time musician. I guess my story is similar to many many others who wanted to play in a band just for the love of it. I started a long time ago, went through a lot of phases, worked hard at it, played with a lot of good musicians and loved doing it. I always considered myself to be a decent musician. I never thought I was in the same category of some of the greats from our state and never pretended to be anything other than what I am. I'm just proud to be among the many thousands of good musicians that came out of Connecticut.

APPENDIX B

INTERVIEW WITH GINNY ARNELL

The following interview with Ginny Arnell (conducted by Kyler S.) is reproduced with permission from Rare Rockin' Records.

KS: Ginny, you first started your recording career as a duo with Gene Pitney under the name of "Jamie & Jane." What is your favorite "Jamie & Jane" record, and what was it like working with Gene?
GA: My favorite Jamie & Jane record is "Strolling Though the Park." It was fun working with Gene. He never went anywhere without his guitar. He was always thinking about new songs to write. He was a very slim, aggressive, handsome and talented young man who was going to achieve success at any cost.
KS: A very good song of yours that got lost by the wayside is called "Tell Me What He Said" from 1960 on Decca Records. It was written by the legendary Jeff Barry. Do you have any remembrances or opinions on that one?
GA: Yes, "Tell Me What She Said" was a very exciting song to sing. I remember singing it with a lot of passion with great backup singers and a super arrangement.
KS: Skipping ahead to your MGM years, the first single you recorded for that label is one of my favorites, entitled "I'm Crying Too." Any info behind the recording or song?
GA: "I'm Crying Too" had a unique sound. We recorded in a New York studio later in the evening. We had quite an orchestra come in, but the most exciting part was seeing them bring in the beautiful harp. It added a beautiful sound to this great song. Two other great songs I recorded in NYC were "Carnival," the classic, and Neil Sedaka's "Mr. Saxophone," vintage Sedaka.
KS: Your biggest hit came next, "Dumb Head." It went to #50 in Billboard and went higher in a lot of local charts. What was it like for you during those times knowing your record was being played and bought around the country?
GA: It was like a dream come true! I remember driving with my Dad when it came on the radio. We pulled over and screamed with delight—like we never heard it before. I was a teenager and all I wanted to do was sing. Just to know that kids all over the country were listening to my records was a beautiful feeling. My Mom, Dad, and Sister were so very excited for me. Could this really be happening??? But they never let me forget that School came first, and it did!

Appendix B

KS: The B side of "Dumb Head," called "How Many Times Can One Heart Break," is an excellent pop song as well. We would love to know any info or opinions about this great track!

GA: "How Many Times Can One Heart Break" was a very good song, too good to be a "B" side. I didn't have any songs in the "can" so everything I did was released.

KS: You appeared on *American Bandstand* when "Dumb Head" was in the charts. What was it like?? Maybe you could tell our readers about the funny incident that happened during the taping.

GA: *American Bandstand* was a highlight in my career. I was a big fan of the show. A funny thing happened when I was getting ready to lip sync the record. They put on a Bobby Rydell record, "Wild One," instead of "Dumb Head." So I stood there, smiled and waited for the producer to put on the right record. We all laughed about it and moved right along. I'll never forget it. I also recorded "Dumb Head" in Japanese where it was released and was a big hit. You can hear this cut on the CD released on Poker Records.

KS: "I Wish I Knew What Dress To Wear," the follow up to "Dumb Head," is one of the best girl-pop records ever made, in my opinion. Although it was not as big of a hit, it is still remembered today as one of your best recordings. Please tell us anything you remember about this iconic record.

GA: Yes, "I Wish I Knew What Dress To Wear" was one of my best recordings. The record company believed it was going to be a big hit too. They put a beautiful colored sleeve on the 45 with my picture on it. That was another highlight of my career. I was fortunate to get really good material, but it did pose a problem, my A&R men said I never made a bad song, so therefore it was hard to pick a "B" side.

KS: Once again, the B Side was just as good as the A Side! "He's My Little Devil" was the song you heard if you flipped "I Wish I Knew What Dress To Wear." It sounds almost like the type of song Gene Pitney would write. Do you think that "He's My Little Devil" should have been saved for a future A-Side instead of being relegated to the flip side of "I Wish I Knew...."??

GA: Yes, "He's My Little Devil" should have been saved for a future A-side. The DJs didn't know which side to play and in the long run, it hurt "My Little Devil."

KS: My favorite record of yours is called "Let Me Make You Smile Again." It has all the elements of a great 60s pop recording!! I feel that it should have been a major hit. What do you think?

Appendix B

GA: "Let Me Make You Smile Again" was a powerful arrangement and I sang it with meaningful passion. It had a great set of lyrics too. Any of my records could be released and enjoyed today as well as they were 46 years ago. I believe my records are timeless and unforgettable once you hear them a few times. Hope I'm not being toooo partial!!

KS: Your album, "Meet Ginny Arnell", was released in 1964. It contained your hit singles and some new recordings. It is quite sought after today. Do you have a favorite song from the album, or any memories recording it?

GA: Yes, I recorded this album in Nashville in a morning recording session. The musicians and backup singers were the same people that worked on Elvis' sessions. The Jordinaires, Chet Atkins and Floyd Cramer to mention a few. They all couldn't believe that I could sing like I did so early in the morning. They forgot that I wasn't out drinking and smoking all the night before like they were!!!!!!! I think "Yesterday's Memories" was a favorite cut of mine.

KS: Your next single, "Just Like A Boy," makes me think of the Motown sound, Mary Wells in particular. Is that what you were going for when you were recording it?

GA: The Motown sound was hot and we certainly wanted to get on that bandwagon. I thought we had a great sound that could compete with anything that was out then.

APPENDIX C
NOTABLE CONNECTICUT MUSIC VENUES, CONCERTS AND RARE BEHIND-THE-SCENES PHOTOS

OAKDALE THEATRE

WALLINGFORD

A very popular music venue in the region for over sixty years, attracting major national performers.

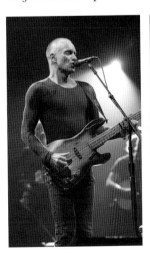 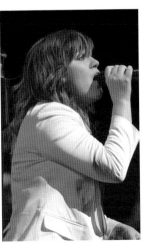 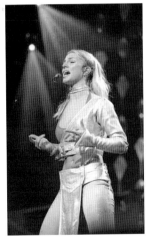

Left: Sting performing at the Oakdale Theatre in 1999. *Middle*: Kelly Clarkson performing at the Oakdale in 2012. *Right*: Britney Spears performing at the Oakdale in 1999. *Images courtesy of Live Nation/Oakdale vice president of marketing, Connecticut and Upstate New York, Jim Bozzi.*

Appendix C

Other Oakdale performances:

- Ringo Starr & His All Stars, July 27, 1995
- Brian Wilson performed *Pet Sounds* in its entirety to celebrate the fiftieth anniversary of the legendary album, September 27, 2016
- The Doors/Wildweeds, September 23–24, 1967
- Gordon Lightfoot, August 1, 1993
- Bonnie Raitt, August 12, 2016
- The Shags, 1968
- Alicia Keys's very first show of her initial concert tour, January 22, 2001

WOOLSEY HALL

YALE UNIVERSITY, NEW HAVEN

Jimi Hendrix Concerts: November 17, 1968

Perhaps the most memorable performances at Yale's Woolsey Hall were the two concerts by Jimi Hendrix on November 17, 1968. In the words of famed rock photographer Joe Sia, live performances by Hendrix were "spellbinding." Joe would know, since Hendrix was one of his favorite photographic subjects, and as a result, he became close to this important artist. Sia's iconic photo of Jimi Hendrix at Woolsey Hall has been showcased in print media as well as album cover art (See page 149).

Popular Connecticut artist Paul Rosano reflects on Hendrix's Woolsey Hall concert:

> *I have vivid memories of The Jimi Hendrix Experience concert at Woolsey Hall. Hendrix was just riveting. There he was with Mitch Mitchell on drums and Noel Redding on bass. I knew they were going to be loud, but I had no idea how loud. Whenever Hendrix hit his wah-wah foot pedal it was absolutely ear-shattering. Jimi opened with "Sgt. Pepper's Lonely Hearts Club Band" and quickly segued into "Fire." He closed with "Purple Haze." I clearly remember those white boots with his pants tucked in and the scarf tied around his leg. I believe he had worn the fringe jacket*

Appendix C

in the first show, but he had removed it for the second concert. Hendrix did a lot of his trademark moves, playing behind his neck, and at times seemingly with his teeth. An unforgettable experience. It was the only time I would get to see Hendrix play live. Two years later, I was devastated by the news of his death. One of the true greats was taken from us. Soon there would be more.

BUSHNELL MEMORIAL

HARTFORD

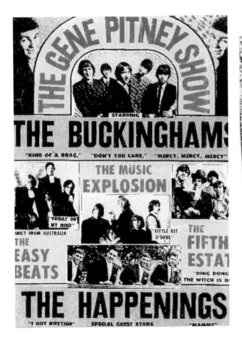
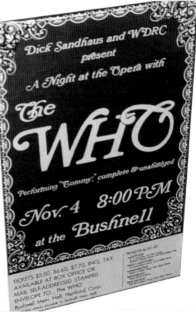

Left: Gene Pitney performed in his home state of Connecticut numerous times. In 1967, he headlined *The Gene Pitney Show* at the Bushnell Memorial. *Courtesy of Ken Evans of the Fifth Estate.*

Right: The Who performed at the Bushnell on November 4, 1969. *Dick Sandhaus, BetterCheaperSlower.com.*

Appendix C

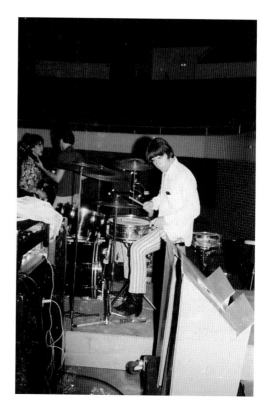

Right: Dickie Diamond (Easybeats), Marty Grebb (Buckinghams) and Ken Evans (Fifth Estate) jamming prior to a performance in a twenty-thousand-seat arena in Madison, Wisconsin. These musicians also performed with their bands at the Bushnell in 1967. *Courtesy of Ken Evans of the Fifth Estate.*

Below: Members of the Music Explosion, including Jamie Lyons (*center*). *Courtesy of Ken Evans of the Fifth Estate.*

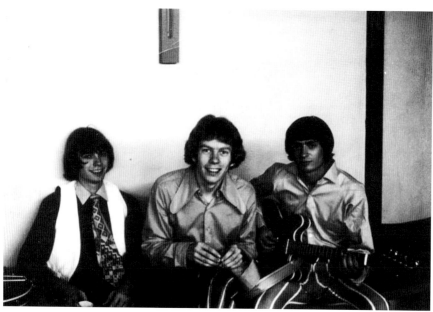

APPENDIX C

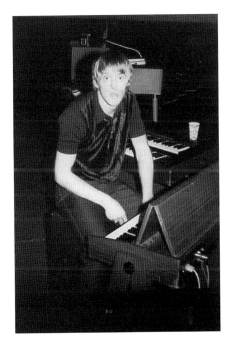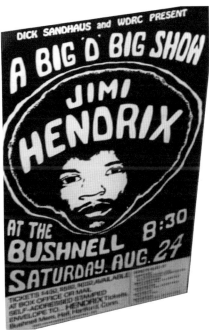

Left: The Easybeats ("Friday on My Mind") performed in Hartford, Connecticut, in 1967. Pictured here is Harry Vanda of the Easybeats. *Courtesy of Ken Evans of the Fifth Estate.*

Right: Jimi Hendrix performed at the Bushnell on August 24, 1968. *Dick Sandhaus, BetterCheaperSlower.com*

NEW HAVEN ARENA

NEW HAVEN

Jim Morrison Arrest

One of the most famous (or infamous) events in rock history occurred at the New Haven Arena on December 9, 1967. On that date, Jim Morrison was arrested—on stage—during a performance with the Doors. He was charged with obscenity and breach of peace but was soon released. It is believed to be the first time that a rock star was arrested on stage during a performance.

Appendix C

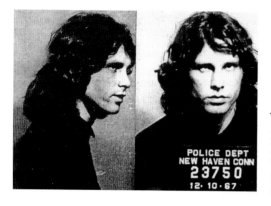

Jim Morrison's mug shot, New Haven Police Department. Morrison was arrested on December 9, 1967, on stage at the New Haven Arena while performing with the Doors. *Public domain.*

Other concerts at the New Haven Arena include

- The Young Rascals, May 7, 1965
- The Rolling Stones, November 4, 1965. The Stones were scheduled to perform on June 18, 1964, at the New Haven Arena, but the show was canceled—due to the lack of ticket sales

TOAD'S PLACE

NEW HAVEN

One of the country's premier music venues, hosting major national recording acts as well as local artists.

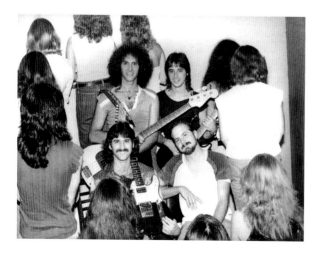

Napi Browne, backstage at Toad's Place, 1980. *Courtesy of Paul Rosano.*

Appendix C

THE PROPOSED POWDER RIDGE FESTIVAL

MIDDLEFIELD

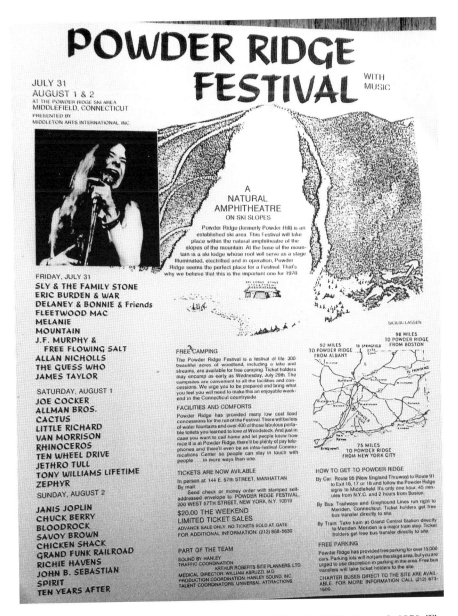

Poster of the controversial Powder Ridge Music Festival, July 31, 1970–August 2, 1970. The proposed large festival was banned and never materialized. *Author's collection.*

Appendix C

STAPLES HIGH SCHOOL CONCERTS

Westport's Staples High School hosted many concerts featuring major recording artists. Here is a sample of the great bands that performed at Staples High. Included are rare, one-of-a-kind photos taken backstage or at the home of Ellen Sandhaus and her brother Dick Sandhaus.

THE BEAU BRUMMELS

1965 concert at Westport's Staples High School

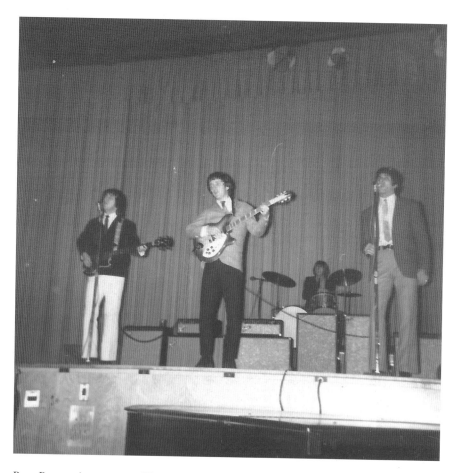

Beau Brummels on stage at Westport's Staples High School, December 19, 1965. *Copyright Ellen Sandhaus.*

Appendix C

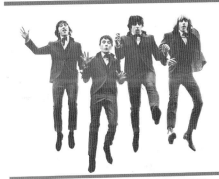

Right: A Beau Brummels poster for a performance at Westport's high school on December 19, 1965. *Dick Sandhaus, BetterCheaperSlower.com.*

Below: Beau Brummels performing at Westport's Staples High School, December 19, 1965. *Copyright Ellen Sandhaus.*

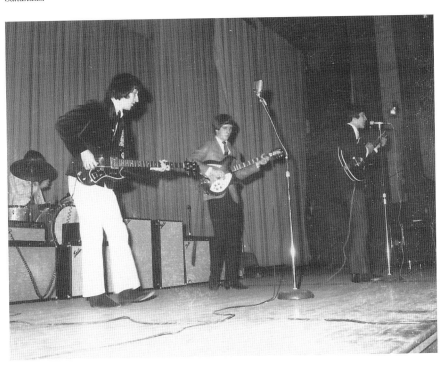

Appendix C

THE ANIMALS

1966 concert at Westport's Staples High School

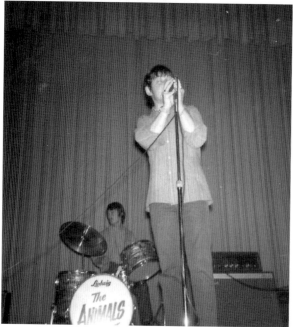

This page: Eric Burdon and the Animals on stage at Westport's Staples High School, 1966. *Copyright Ellen Sandhaus.*

APPENDIX C

THE RASCALS (YOUNG RASCALS)

1967 concert at Westport's Staples High School and photos taken at Sandhaus home.

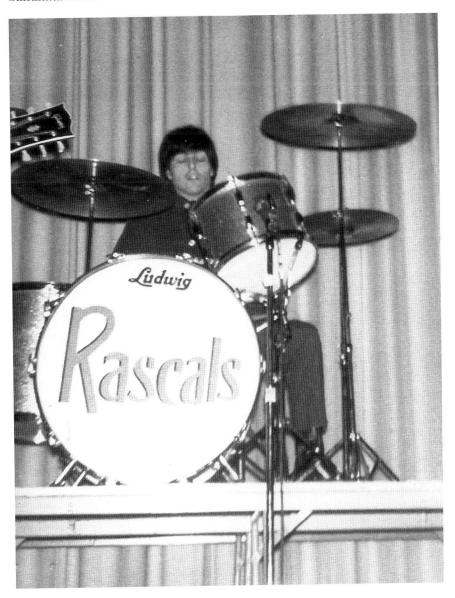

Dino Danelli of the Rascals on stage at Staples High, 1967. *Copyright Ellen Sandhaus.*

Appendix C

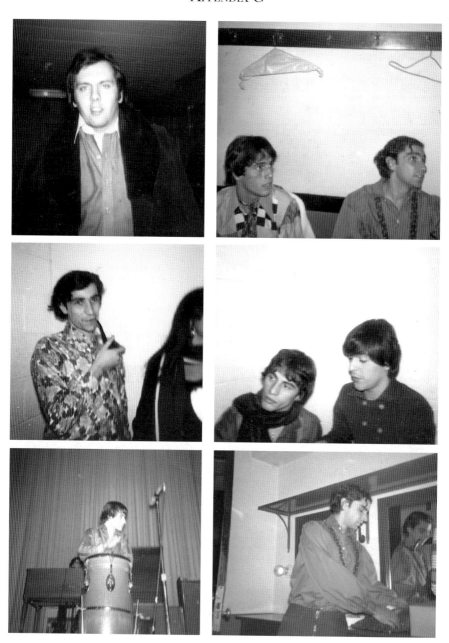

Clockwise from top left: The Rascals' Gene Cornish backstage after Staples High concert, 1967; the Rascals' Eddie (*left*) and Felix at the Sandhaus home, 1967; the Rascals' Eddie (*left*) and Dino at the Sandhaus home, 1967; the Rascals' Felix Cavaliere backstage after Staples High concert, 1967; the Rascals on stage at Westport's Staples High, 1967; Felix Cavaliere with his pipe relaxing after concert at the Sandhaus home, 1967. *Images copyright Ellen Sandhaus.*

Appendix C

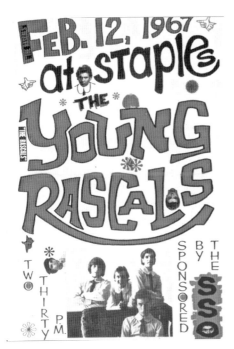

Left: A Rascals poster for their performance at Westport's Staples High School, 1967. *Dick Sandhaus, BetterCheaperSlower.com*

Below: The Rascals on stage at Staples High, 1967. *Copyright Ellen Sandhaus.*

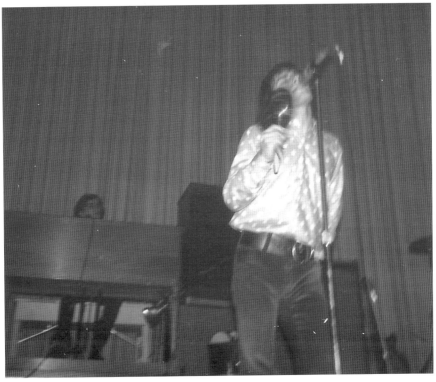

Appendix C

THE YARDBIRDS

1966 concert at Westport's Staples High School and photos taken at Sandhaus home.

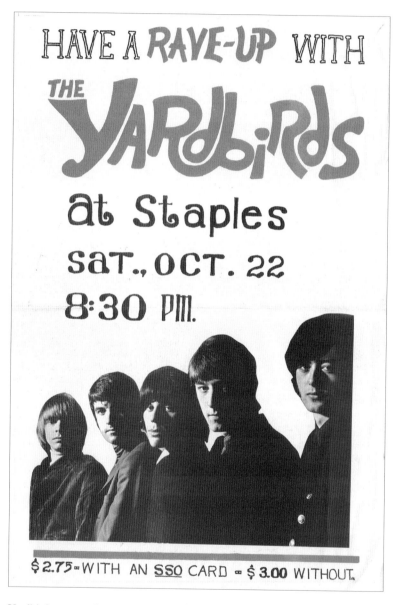

Yardbirds poster advertising Staples High concert, October 22, 1966. *Dick Sandhaus, BetterCheaperSlower.com.*

Appendix C

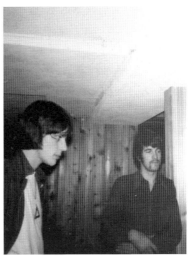
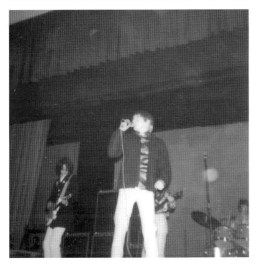

Clockwise from top left: Yardbirds Chris Dreja, Jimmy Paige and Jim McCarty take tea in the Sandhauses' basement post-concert, October 22, 1966; Jeff Beck (double exposure photo) after Staples High concert, October 22, 1966; Yardbirds Jeff Beck and Jim McCarty at the Sandhauses' house after the Staples High concert, October 22, 1966; Yardbirds (*left to right*) Jimmy Paige, Keith Relf, Chris Dreja (*hidden*) and Jim McCarty at Westport's Staples High, October 22, 1966; Yardbirds Jimmy Paige and Jim McCarty at the Sandhauses' house after the Staples High concert, October 22, 1966. *Images copyright Ellen Sandhaus.*

APPENDIX C

BLUES PROJECT

1967 concert at Westport's Staples High School

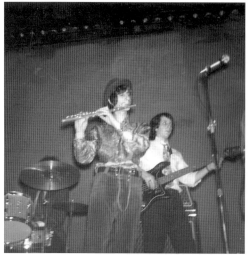

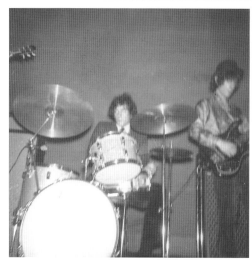

Clockwise from top left: Blues Project in concert performing "Flute Thing" at Westport's Staples High School, June 8, 1967; Steve Katz of the Blues Project framed by his tambourine, June 8, 1967; Blues Project in concert at Westport's Staples High School, June 8, 1967. *Images copyright Ellen Sandhaus.*

THE SHACK

- The Blue Beats
- The Wildweeds

Appendix C

MOHEGAN SUN

UNCASVILLE

- Gene Pitney, March 30, 2003

HAMDEN CONCERTS

HAMDEN

- The Turtles, July 9, 2010
- Huey Lewis, KC101 concert

NEW HAVEN GREEN CONCERTS

- Little Richard, June 27, 1998

HARTFORD CIVIC CENTER

- Elvis Presley, August 21, 1977
- Paul McCartney, September 27, 2002 (Back in the U.S. tour)
- Rolling Stones, November 10–11, 1981; March 28–29, 1999; October 5, 2002
- Billy Joel, March 28, 2006

MEADOWS MUSIC THEATRE

- Bob Dylan and Paul Simon co-headliners, July 24, 1999

Appendix C

SACRED HEART UNIVERSITY

FAIRFIELD

- Elton John, November 22, 1970 (his first tour and one of his first U.S. concerts)

WEBSTER BANK ARENA

BRIDGEPORT

- Elton John, November 8, 2013

YALE BOWL

NEW HAVEN

- Janis Joplin, July 12, 1969

DILLON STADIUM

HARTFORD

- The Rolling Stones, June 27, 1966
- The Beach Boys, June 25, 1965

RENTSCHLER FIELD

EAST HARTFORD

- The Rolling Stones, August 26, 2005

Appendix C

ACTORS COLONY

SHELTON

- Gene Pitney, April 10, 1965
- The Five Satins and Debbie and the Darnels, November 27, 1962
- The Playmates, October 4, 1961

HARRY DOWNIE'S CARAVAN OF STARS

DANBURY

- Debbie and the Darnels and Ginny Arnell, January 24, 1964

STATE THEATRE

HARTFORD

- The Nutmegs, November 20, 1955 (Rhythm & Blues Revue)

"TEEN TEMPO '66" SHOW

MILFORD

- Van Dykes, the Shags, Fred Parris and the Restless Hearts, August 25–26, 1966

WATERBURY AUDITORIUM

- Enrico Caruso (famous tenor), March 13, 1920 (non-rock)

Appendix C

FOXWOODS THEATRE

MASHANTUCKET, CONNECTICUT

- Frank Sinatra, November 11, 1994 (non-rock)
- Gene Pitney, February 8, 1998

BIBLIOGRAPHY

BOOKS

Bologna, Sando. *The Italians of Waterbury*. Portland, CT: Waverly Printing Company, 1993.

Schmidt, Randy L. *Little Girl Blue*. Chicago: Chicago Review Press, 2011.

ARTICLES

Billboard. "Reviews of this Week's Singles." July 20, 1959.

Bridgeport Post. "Dimes Drive Show in Danbury Tonight." January 24, 1964.

———. "East Havener Has Hit Disc." January 19, 1964.

———. "Final Sunday Show at Oakdale Tent." September 23, 1967.

———. "Highwaymen to Sing at Danbury College." September 12, 1962.

———. "Hootenanny Here Stars Odetta, The Highwaymen." July 21, 1963.

———. "In and Around Our Town." February 7, 1971.

———. "Jim Gallant Signed for Teens Dance." December 20, 1958.

———. "Pleasing Teenagers at Boys Club Day." August 27, 1959.

———. "Police Halt New Haven Show, Arrest Lead Singer, 4 Others." December 11, 1967.

———. "Record Hop Wednesday." July 14, 1964.

———. "Rock Group, An Enlarged Steam, Signs Recording Pact with NY Producer." January 24, 1971.

Bibliography

———. "Rockville Singer Weds Hometown Sweetheart." January 29, 1967.
———. "Steam 'Steams' to Gold Platter." March 29, 1970.
Bridgeport Telegram. "Mitchum Whammos Back." May 24, 1966.
DeLauro, Rosa L. "Honoring New Haven Native Fred Parris." *Congressional Record* 161, no. 60 (April 23, 2015). https://www.gpo.gov/fdsys/pkg/CREC-2015-04-23/html/CREC-2015-04-23-pt1-PgE568-3.htm.
Fairpress (Westport, CT). "Shooting the Stars." January 5, 1990.
Gargan, Scott. "Born and Raised: 10 Things You May Not Know about John Mayer." *Connecticut Post*, March 20, 2015.
———. "Jose Feliciano Staying 'Viable,' Playing Acoustic Show in Fairfield." *Connecticut Post*, March 27, 2014.
Sacred Heart University Campus Notes. "Elton John and the Elves Perform at SHU." November 23, 1970.
———. "Joseph Sia." November 27, 1989.
———. "Sia's Camera, Career Clicked at Woodstock." January 29, 1990.
Samberg, Joel. "Remembering Karen Carpenter 30 Years Later." Last modified February 4, 2013. www.npr.org.

PERSONAL COMMUNICATIONS

Amann, Charles (expert on the 1950s and 1960s music scenes and *Bandstand*). E-mail correspondence with author, July 2013.
Bouley, Jane (Branford Historical Society). Discussion with author on Montowese House, Highwaymen and Bob Dylan performances at Indian Neck Folk Festival, September 2016.
DeCarlo, Gary (musician). Personal communications with author, November 23, 2016.
Dunaway, Dennis (musician). E-mail correspondence with author, November 22, 2016.
Evans, Ken (musician). Interview and personal communications with author, November 20, 2016.
Freed, Judith Fisher (estate of Alan Freed). E-mail correspondence with author, October 27, 2016.
Kessler, Kathy (singer). Interview and personal communication with author, July 15, 2016.
Lamitola, Ray (musician). Interview and personal communications with author, November 30, 2016.

Bibliography

Ohlman, Christine (musician). Interview and personal communications with author, November 22, 2016.

Parris, Emma (wife of Fred Parris). Personal communications with author, 2016.

Quadrato, Walter (Brass City Records). Personal communications with author on local music scene, May 22, 2014.

Sia, Joe (rock photographer). Personal communications with author on Connecticut and national music scenes 1960s to 1990s, 1995.

Yutenkas, Dorothy (singer). Interview and personal communications with author, July 16, 2016.

Zipp, Ryan (musician). Interview and personal communications with author, September 28, 2016.

WEBSITES

allmusic.com
classicbands.com
discogs.com
garydecarlo.com
las-solanas.com/arsa/surveys.php
newspapers.com
rarerockinrecords.blogspot.com
60sgaragebands.com
theprincesandprincessesofdance.com
thetrickismusic.com

INDEX

A

Academics, the 39, 78
Alice Cooper 18, 119, 121, 123
American Bandstand (TV show) 38, 39, 49, 57, 100, 113, 192
Anderson, Al 72, 74, 86, 157, 159
Arnell, Ginny 39, 56, 57, 58, 66, 154, 191, 193, 213

B

Ballads, the 63
Barons, the 58, 74, 181, 184
Barries, the 62, 73
Beach Avenue 138, 140, 142, 161, 165, 166, 167, 168, 169, 170, 171
Beau-Belles, the 64
Blue Beats, the 94, 95
Bolton, Michael 111
Brad Davis (TV program) 95, 106, 114
Bram Rigg Set, the 94, 95, 96, 97, 114
Brass City Records 23, 24
Bridge 105
Burr, Gary 139
Bushnell Memorial 94, 95, 197

C

Carpenters, the 62, 73, 74
Cavaliere, Felix 76, 77, 78
Connecticut Bandstand (TV program) 22, 38, 39, 58, 60, 62, 63, 78, 107, 155
Cookie and Charley 38, 62

D

Dae, Tommy 47, 109
Debbie and the Darnels 39, 51, 58, 90, 92, 151, 153, 155, 156, 157, 213

Index

DeCarlo, Gary 43, 45, 82, 112
DeNicholas, Art 59, 104, 106
"Ding Dong! The Witch Is Dead" 31, 43, 76, 88, 178, 182
Dio, Andy 39, 58
disc jockeys, radio stations 27
D-Men, the 27, 31, 76, 86, 88, 175, 176, 177, 178, 180, 181, 182, 183, 184, 185
Down Beats, the 105
Dunaway, Dennis 18, 121, 123
Durso, Bill 99, 158
Dylan, Bob 39, 42, 65, 117, 125, 160, 211

E

Ed Sullivan Show, The (TV program) 23, 65, 80, 106
Epstein, Brian 179, 182
Evans, Ken 27, 43, 58, 74, 76, 86, 88, 140, 180

F

Famine 112, 113
Feliciano, José 128
Fifth Estate, the 27, 43, 58, 74, 86, 88, 140, 175, 177, 180, 181, 183, 185
Five Satins, the 18, 42, 49, 51, 52, 54, 56, 63, 90, 92, 94, 153, 154, 213
Flares, the 102, 187, 188, 189
Fradiani, Nick 18, 136, 138, 139, 140, 142, 166, 168, 170, 171
Fraser, Jeri Lynne 47, 83

Freed, Alan 17, 27, 31, 35, 55

G

Gallant, Jim 22, 39, 58, 60, 63, 78
Goldman, Sam 90, 92, 93, 153, 154
Greenberg, Jerry 59, 90, 104, 152, 153
Grover Dill 140, 163, 169

H

Hart, Rocky 60, 62, 63
Hendrix, Jimi 110, 147, 148, 150, 196
Highwaymen, the 42, 78, 80, 184
Hullabaloo 76, 88, 106, 182

I

Indian Neck Folk Festival 39
"In the Still of the Night" 42, 43, 51, 54, 56

J

James, Billy 39, 106, 107
Jasper Wrath 113, 114
Jensen, Kris 82

K

Koob, Roger 39, 59

Index

L

Leka, Paul 43, 52, 81, 82, 112, 114

M

Marie Sisters, the 63
Mattatuck Music Record Store 23
McCann, Peter 112
Me and the Rest 107
Meat Loaf 111, 112
Midnite Movers 114
Mitchum, Robert 55, 56
Montowese House 39, 42
Morrison, Jim 86, 199
Murray the K 27, 182
music surveys 25
music venues (Connecticut) 27

N

NAIF 100
"(Na Na Hey Hey) Kiss Him Goodbye" 43, 44, 45, 82, 112, 113
Napi Browne 98, 114, 119
New Haven Arena 51, 77, 93, 106, 199, 200
1980s, the 26, 52, 114, 117, 140
1950s, the 26, 45, 49, 62
1970s, the 74, 110, 114, 116
1960s, the 25, 26, 45, 57, 65, 67, 83, 88, 104, 107, 111
"No Good to Cry" 83, 86
novelty songs (Connecticut) 45
Nutmegs, the 51, 55, 213

O

Oakdale Theatre 93, 96, 195
Ohlman, Christine 18, 86, 88, 114, 119, 121, 144, 157, 158, 173, 174

P

Parris, Fred 42, 49, 51, 52, 54, 59, 82, 104, 139, 213
Passengers, the 59, 90, 152, 153
Pitney, Gene 18, 56, 62, 63, 66, 67, 68, 83, 94, 139, 177, 184, 191, 192, 211, 213
Playmates, the 45, 46, 54, 55, 213
Pulse 96, 97, 114
Pyramids, the 39, 63

R

radio stations 25
Rascals (Young) 76, 77, 93, 106, 200, 205
record hops 19
record stores 22
Reducers 140
Remains, the 106
Richards, Keith 123, 124
Robinson, Dick 27, 47
rock 'n' roll's impact on society 19
Rolling Stones, the 102, 123, 124, 176, 188, 200, 212
Ron and His Rattletones 39, 46, 60
Rosano, Paul 98, 114, 196

INDEX

S

Saturday Knights, the 108
Shack, the 98, 187, 188, 210
Shags, the 92, 93, 94, 96, 97, 104, 111, 184, 188, 196, 213
Sia, Joe 147, 148, 150, 196
Simms Brothers 115, 184
Simon, Paul 125, 211
Sin Sisters, the 121, 144, 172, 173, 174, 175
sock hops 19
South Michigan Avenue 102, 185, 188, 189
Squires, the 108
Staples High School 77, 106, 202, 204, 205, 210
Steam 43, 45, 82, 112, 113
Stonehenge 115, 188
Syncron Studios 86, 96, 98, 99, 111, 114, 119, 183

T

Toad's Place 111, 114, 124, 162, 164, 174, 200
Tommy and the Rivieras 107
Tonight Show, The (TV program) 80
Toto 123
Trod Nossel Studio 86, 96, 98, 106, 111, 119, 140, 183

V

Village Maid Band 145

W

Wildweeds, the 18, 72, 74, 83, 86, 121, 157, 159
Woolsey Hall 148, 196
Wrongh Black Bag, the 86, 88, 119, 121, 157, 159

Y

Yesterday's Children 104, 188

Z

Zeiner, Ray 86, 158

ABOUT THE AUTHOR

Photo by Mary Ellen Blacker.

Tony Renzoni is a rock 'n' roll enthusiast. He has been an avid collector of rock memorabilia for many years, amassing a record collection of over ten thousand vinyl records. One of his hobbies has been researching the national and local rock 'n' roll music scene, in Connecticut.

Tony had a thirty-eight-year career with the federal government. As district manager in Connecticut's Fairfield County, he oversaw the operations of four field offices, serving over 100,000 beneficiaries. Tony wrote over one thousand weekly columns that were published in the *Connecticut Post* newspaper and on the Connecticut Post website. Tony was a recipient of more than forty awards, including his agency's highest honor award.

A lifelong resident of Connecticut, Tony lives on the Connecticut shoreline with his wife, Colleen. Tony Renzoni is a graduate of Sacred Heart University in Fairfield, Connecticut.

Visit us at
www.historypress.net

This title is also available as an e-book